INTERIOR VIEWS

INTERIOR VIEWS

Design at Its Best

Erica Brown

Introduction by Paul Goldberger

A STUDIO BOOK

The Viking Press · New York

First published in 1980 by The Viking Press
625 Madison Avenue, New York, NY 10022

Published simultaneously in Canada by
Penguin Books Canada Limited

Library of Congress Cataloging in Publication Data
Brown, Erica.
 Interior views.
 (A Studio book)
 1. Interior decoration—History—20th century.
 2. Interior decorators—Interviews. I. Title.
NK1980.B73 729 80-14077
ISBN 0-670-39978-7

Printed in Japan by
Dai Nippon Printing Company, Ltd., Tokyo

Set in Fairfield

Acknowledgments

Without the help, encouragement, and sheer hard work of my research assistant Melanie Fleischmann this book would never have got off the ground. Her help in collecting and organizing material was indispensable.

My thanks go to all the photographers whose work appears in these pages, but I owe a special debt to Carla de Benedetti in Italy, Michael Dunne in England, and Jaime Ardiles-Arce in America.

My friends and former colleagues at *The New York Times Magazine* encouraged and sympathized when necessary, and Condé Nast Publications kindly allowed me to publish some photographs from their archives.

Mary Velthoven, my editor at The Viking Press, has been a gentle, but firm, presence throughout, and Michael Shroyer, the art director, has occasionally sacrificed for text the white space so beloved by his profession.

Finally, my thanks go to the interior designers. Without them and their talent, this book would not exist.

—Erica Brown

Contents

TO MICHAEL BROWN

Foreword

The late architect Louis Kahn once said that the ideal client is not one who knows precisely what he wants but instead one "who knows what he aspires to." I suspect that many of the designers whose words are quoted and whose works are illustrated here would agree: they seem to feel that the role of the client in the creation of any work of design is crucial, but that things work best when the client articulates general goals and leaves the designer free to make most of the decisions about what things will actually look like.

The forty designers included here are frank on this subject, as they are on many others, and that makes for this book's strength: they talk to Erica Brown as a colleague, not as a journalist, and their remarks are pleasantly revealing. We are seeing these designers as they see themselves, and if they are not always the most insightful or most objective critics of their own work, no matter: there is much to be gained from letting them talk through these pages, as they try to verbalize concepts that, for most of them, are fundamentally intuitive. Few of these designers have real "systems"; they are working in a world that hangs delicately between an art and a craft, but there is just enough art to it to make it impossible to do by formula.

There are no formulas, anyway—this moment in the history of architecture and design, so free of the sort of all-encompassing theory that has preoccupied so many past eras, is inhospitable to dogma. We have no sense of a single right way to do things now, and the breadth of design views represented here appropriately captures this spirit. It is not quite "anything goes"—but it might be called "Anything goes if you do it well enough and can explain it convincingly."

What is most striking is how much the designers reveal of themselves and their work through the words they choose in these conversations. John Saladino comes off as proud, almost haughty, without irony yet possessed of a certain eased assurance at the same time; his work contains these same contradictory qualities. Joe D'Urso's remarks suggest a man who is crisply logical, matter-of-fact, and yet deeply pensive, and here, too, the designer's character parallels that of his work, as again it does with Mario Buatta, who comes off as jovial, comfortable, gracious, and full of common sense.

There are certain common threads that run all the way through. Virtually every designer admits to hating mathematics (many claim that they would have become architects but for this) and most of them, including the most *au courant*, state that they disapprove of trendiness. And all of them, no matter how lavish their work, decry pretension, which they tend—correctly—to define as too many things that are too expensive thrown together with too little sense of order and proportion.

The designers here do not agree on much else, but that is at it should be—this is not a book to tell us about a particular style, or to suggest that there is any proper way in which interior design should be executed. It is a book to offer insight into the way the profession of interior designers (or decorators, as some prefer to be called) sees itself—and, even more important, how it sees the rest of us as well.

—Paul Goldberger

There are two myths about interior designers that are common currency. One is that they are a group of dilettantes who decree from lofty perches what is "in" and what is "out" and pluck from thin air fabrics and furniture to create total—and expensive—luxury almost overnight. The other is that what designers do has no relevance to the world at large.

Let's dispel the second myth first. True, only a very small minority of us will ever directly use the services of an interior designer. Most of us furnish our homes piecemeal over the years according to the changing size of our incomes and family. But the innovations of the world's best interior designers filter down to the numerous less-well-known designers at work in every city and eventually to the stores as well. What we see around us and what we have to choose from when we buy furniture is, to a large extent, based on the standards set by a few people at the apex of their profession. What we see of their work in books and magazines—how they handle color, scale, and architectural problems—can also guide us in our own apartments and homes. As several of the designers in this book have said, part of their job is to prevent their clients from making expensive mistakes. We can all learn from their example.

As for the first myth—that of the designer as dilettante—most people in the profession only wish it were true. Their lives would be much easier. Unfortunately, reality sees to it that they spend as much of their time in mundane pursuits—working to stay within budgets, cajoling suppliers who don't deliver on time, fighting

Introduction

shippers who damage goods in transit, trying to understand clients who can't, or won't, make up their minds —as they do on the creative part of their work.

But it's easy to see how the myths gained substance. Though the profession of interior designer is a new one, its ancestry can be traced back to yesterday's well-born arbiters of taste—to men and women of fashion from Louis XIV in France, through the Prince Regent in early-nineteenth-century England, to Syrie Maugham, Sybil Colefax, and Elsie de Wolfe, designers who exerted their influence on both sides of the Atlantic in the 1920s and '30s.

Interior designers are also the descendants of architects and craftsmen—of Le Vau, the architect of Versailles; Georges Jacob, the premier cabinetmaker during the reign of Louis XVI; and John Nash, whose Georgian terraces still epitomize elegance in England. They are the heirs of Chippendale, Hepplewhite, and Sheraton, perhaps England's greatest furniture designers and cabinetmakers; and of Le Corbusier and the leaders of the Bauhaus school—Walter Gropius, Marcel Breuer, and Ludwig Mies van der Rohe—all of whom were both architects and designers of furniture.

By the 1930s, it was no longer enough to be just the possessor of an inborn talent or else a trained designer of buildings and individual pieces of furniture. More was needed. In America, people such as Ruby Ross Wood, Rose Cumming, Mrs. Henry ("Sister") Parish, and Billy Baldwin combined their natural sense of taste and style with a knowledge of architecture, periods, and materials and made interior design a profession and a business as well as an expression of beauty.

The profession flourished but continued to change. In the 1950s and '60s, people with some formal architectural training entered the field and interior decorators started to metamorphose into interior *designers*. Not only did they draw floor plans, they were prepared to move walls and redefine spaces.

Most people working in the profession today eschew the word "decorator," partly because of its amateur connotation but mostly because it is no longer a true job description. Today's interior designer doesn't just take a room at its face value and color and furnish it. He or she takes space and proportion as the starting point and will, if these are bad, make major structural changes to improve the bones of a room. For the past few decades, many Italian interior designers have also been qualified architects—a combination that is beginning to catch on in America after years of architects refusing to condescend to the frivolity of decoration and decorators condemning architects for designing unlivable spaces. Today, whether the architect is a designer, the designer an architect, or the two work together, there is an integration of ideas that benefits both the space and the people who live in it.

The best interior designers embrace all aspects of their professional ancestry—and more. Not only must they have the talent and know-how to design an overall scheme, they also need a working knowledge of an enormous assortment of "nuts and bolts" (plumbing,

electrical wiring, local building and fire ordinances, to name a few) to turn the idea into a physical reality. They must also be psychologists. Interior design is built around the client. Detailed and very personal information about the clients' likes and dislikes and the way they live—or would like to live—must be drawn out from people who very often have only the vaguest idea of what they like or want. The interior designer must get inside the client's head and stay there for the duration of the job.

Having found out what the client wants, and having decided on the basics of the design, the poor designer must add yet another hat to his collection—that of the hard-headed businessman. Unfortunately, there is no magic wand that will wave everything into its appointed place at the appointed hour. Suppliers, upholsterers, cabinetmakers, contractors, and painters (all of whom have their own set of priorities and other clients) must be dealt with on a day-to-day basis and organized so that they follow each other in their proper order. Otherwise, the job will not be brought in on time and budget.

It is the people who somehow combine all these attributes—and excel at them—who are the subjects of this book. Like you and me, they come with all shades of opinion and embrace a wide variety of styles. They live and work in different countries, are the products of different cultures, and came to their careers via many different routes. Each one's work is unique. Each may solve the special problems each job brings via different thought processes and in completely different styles, but all agree on one thing: a room must *work* for the purpose for which it was intended and for the people who will live in it.

It is those designers who have the special talent to take a multitude of often contradictory and intangible parts and from them produce a functional yet beautiful whole whom you will meet in this book. Their words, as well as pictures of their work, are allowed to speak for themselves. This is, above all, a personal book, devoted to the philosophies and opinions of those designers whose work is recognized as being of major significance and of influence far beyond the confines of the actual houses and apartments in which it exists. I have also included the work of some young designers who I think will be important forces in the future.

We live in a time when there is no one right way to live. Our options are wide open whether we prefer the traditional, the minimal, or anything in between. The components for all are available. The knack is in putting them together. Unfortunately, there is no cut-and-dried process for doing this; no set rules that guarantee success. It is a question of thinking, seeing, and feeling, and translating these conceptions into practical—and beautiful—reality. This book puts you inside the minds of the experts who can do this.

INTERIOR VIEWS

"Sister" Parish and Albert Hadley

Very few people are legends in their own lifetime, but in the world of interior design Mrs. Henry Parish II is one of them. For fifty years her name (she is almost universally known as "Sister") has been a byword for easy, comfortable, and, above all, very personal rooms whether they are in a country cottage or the living quarters of the White House.

With her absolute command of every detail of decorating, she makes her interiors not only look like the people who live in them but actually give the impression that those people could not look better anywhere else. A "Sister" Parish design is always appropriate.

Mrs. Parish became a decorator when she married at nineteen and furnished the first home of her own. Her first job came soon after, and she quickly joined the ranks of such between-the-wars arbiters of style as Ruby Ross Wood, Syrie Maugham, Sybil Colefax, and Elsie de Wolfe. They all had to fight the popular misconception that still lingers on—that decorators were frothy creatures who specialized in carrying out impractical ideas at great expense.

Over the years, "Sister" Parish has been as responsible as anyone for helping to disprove that myth by demonstrating that a good decorator must also be a good designer. Although there is often a liberal use of color,

pattern, and shape in a Parish design, there is never anything fussy, overdone, or cosmetic about it. Every one has good bone structure.

In 1962, Mrs. Parish began to have serious thoughts about retiring and started looking for a partner who could eventually take over the business. At about the same time, Albert Hadley left McMillen Inc., another old-established, prestigious American design company. "We started to talk," says Mr. Hadley, "and we've never stopped."

Today, the firm of Parish-Hadley still has two very active partners. Retirement is not on Mrs. Parish's agenda. Though their backgrounds are different (Mrs. Parish started work before interior decorating, let alone design, was considered a profession; Mr. Hadley is a graduate of the Parsons School of Design), they both share the same design philosophy.

"You can't design by formula," says Albert Hadley. "It's all a question of the discerning eye. Some things work together and others don't. That knowledge comes from background, education, and experience. The easiest and simplest solutions are often the best ones. A lot of things can go wrong if one is too serious and tries to be different for the sake of being different. There is no such thing as something that hasn't been done before. That doesn't mean one can't use elements of fantasy or even outrageousness, but they must be used with knowledgeable taste. It's a question of what combinations exist that will make an interior work in a very personal way."

Both partners agree that it's no longer enough to simply make pretty rooms, and that, although architecturally poor rooms can be camouflaged to accentuate the positive and eliminate the negative, it is vitally important to make structural changes where necessary. Both feel strongly that having a clean, peaceful, architecturally right space is, in the long run, what gives any room its integrity.

"Whatever the budget," insists Mr. Hadley, "it's often more important to make an alteration than to buy an expensive piece of furniture. We'd rather leave out, or cut down on, something to make the background right. The most important thing is to make a room work. If you can't do that, you're lost before you start."

As far as Parish-Hadley is concerned, good design is predicated on honesty and quality, and the firm resents the criticism sometimes leveled at it that it is more expensive than any other. "We do do some of the most

expensive work," admits Mr. Hadley, "but that's because we happen to have some clients who can afford to indulge their very expensive tastes. But taste and style is not dependent on the dollar. You do have to spend a certain amount in order to achieve anything, but that doesn't mean that a designer will spend x-amount-plus to do what could be achieved for x-amount-minus. The cost depends on how much you, the client, can afford."

Parish-Hadley's insistence that an interior be totally supportive of its owner obviously necessitates a close working relationship with each client. Long discussions are the first part of any job, and clients are encouraged to clip pictures of furniture and rooms they like from magazines and be honest about which of their possessions they like or dislike. Parish-Hadley never impose their ideas on a client—rather, they expose the client to their suggestions.

They compare the way they work to painting. They start with a rough sketch—the basic concept of what they consider will best suit the client—and then gradually fill in the canvas. Because they spend so much time studying the client and the space before they start—"There's no point in just drawing out a lot of abstract ideas"— more often than not, their first suggestions are accepted, but there is a lot of give-and-take. "If we've shown dark brown for walls and the client isn't enthusiastic, we work on it together," says Mr. Hadley. "It's much more important that he be happy than that we get the color or chintz we like."

But color and fabric come toward the end of any room plan. First comes the furniture layout that will establish the pattern of living. This layout is not plotted down to the last detail. The large pieces that must sit at rest in a space and that are the backbone of the design must find their correct places before work can progress. Smaller pieces are treated almost like art or sculpture: they can be moved and shifted on the spot until they find their right places.

"There's always a certain amount of trial and error," says Mr. Hadley. "But it is important to have a clear concept of what one is trying to accomplish and then stick to it as closely as possible. Beyond that, there must be freedom to make some changes as we go along. This freedom demands just as much discipline as a prescribed floor plan that's adhered to in every detail, but it is a discipline that gives a more imaginative and creative result. The one thing I don't want is any element to be 'in between.' Furniture should either fade into the overall scheme or be an absolutely fascinating piece that's noticed straightaway. Even in a minimal scheme, space must be punctuated—either by hyphens or exclamation marks."

The rooms shown here have the coherence and comfort Parish-Hadley insist on. They are all the kind of rooms the firm is renowned for—what Albert Hadley calls "proper," meaning that they reflect the lives and taste of people who feel comfortable with objects and possessions. No attempt was made to pare them down.

Today Albert Hadley sees their clients—and therefore their work—changing. "I think the house-clearing most of us have gone through in the last ten years has helped us look at our surroundings in a fresh way. A lot of the movement toward stripping things down and keeping only what is needed or has a special meaning has come from the need for low maintenance in the home. But I also think people feel younger somehow if they don't have as many things pulling them down and holding them back. Too many things often make for an older point of view."

1. *When its owner enclosed this porch leading from a dining room to a garden, Parish-Hadley decorated it literally as a garden room with casual wicker furniture and a collection of bird and flower prints. The plants and flowers come from the owner's greenhouse and are always very much a part of the design of the room.*
2. *The walls of a guest room/sitting room were painted red and glazed to make a background for a collection of nineteenth-century pictures of dogs. The fabric used for curtains and to cover the chair also has animals in its design, and a rather fanciful nineteenth-century-style pelmet was hung at the window.*
3. *Because the clients wanted this bedroom to be light and fresh, Parish-Hadley chose simple cotton fabrics. The carpet design is a variation of that of the fabric used on the beds and it holds together the other patterns —a floral print on the sofa and a small geometric design on the chair.*
4. *This room in a modern apartment was conceived as a background for possessions—hence the subdued dark color of the walls. Parish-Hadley designed the parquet floor. Above the sofa is an eighteenth-century French painted panel flanked by candelabra of the same period. The chandelier is Waterford.*

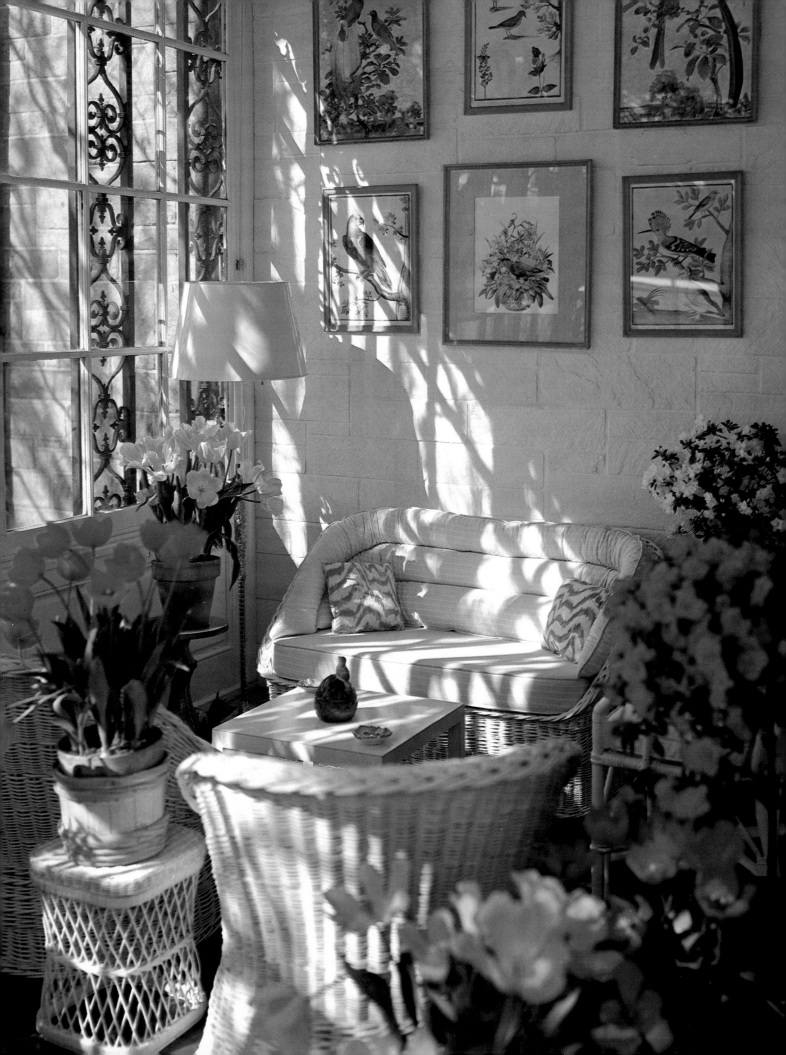

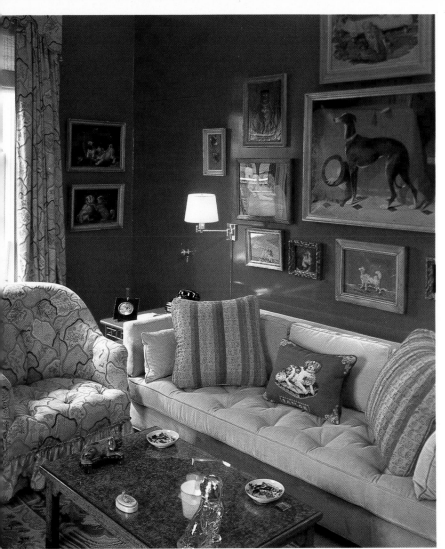

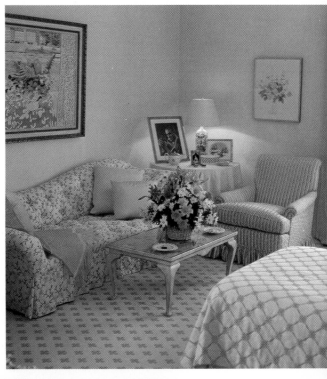

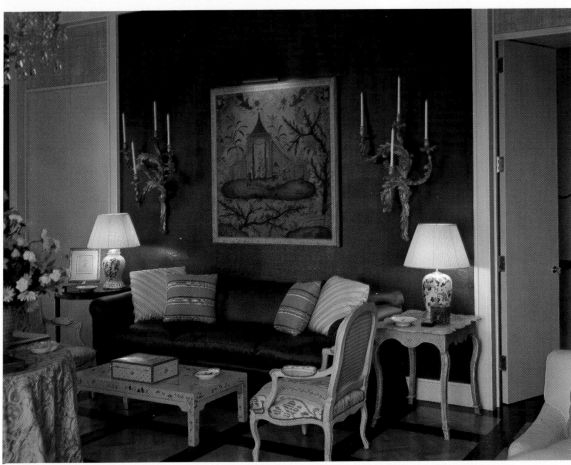

Ward Bennett

To call Ward Bennett simply an interior designer would be to grossly underestimate the man and his achievements. At various times in his life he has been a fashion illustrator and designer, a sculptor, and a jewelry designer, and for the last thirty years he has been a designer of interiors and their furnishings.

He has been successful at each calling. He designed clothes for Hattie Carnegie, among others. The Whitney Museum showed his sculpture and the Museum of Modern Art his jewelry. He has been a seminal influence on many of America's brightest young designers, and he has taught architecture to architects, even though his formal education ended when he left school at thirteen.

Ward Bennett shrugs off this impressive list of successes. "I think if you can design anything well, you can design everything well," he says. "I don't think designers should limit themselves to one narrow category. Leonardo didn't."

Ward Bennett started his career in 1930 as a delivery boy in New York's ladies' lingerie industry. He took a few night classes in fashion sketching, and a year later, at the age of fourteen, he was hired by Saks Fifth Avenue to draw bridal gowns. By the time he was seventeen, he was being sent to Paris to sketch the couture collections, and he lived there for almost two years in 1936 and 1937. He started to design clothes, and, he says, "I had success at a very early age. In the middle of the Depression, I was making two hundred dollars a week." By 1942, however, he decided to get out of the fashion business.

He spent two years studying with painter Hans Hofmann and then sculpted for five years. He accepted his first commission as an interior designer while he was sculpting, "probably because I needed the money. I had always done my parents' house for the joy of it, and this apartment—a New York penthouse—was for a relative, my sister-in-law's sister." As soon as it was finished, it was published in *The New York Times*. Very soon thereafter, he opened his first interior design office. His design vocabulary was as present in that first apartment as it is in his current work. "I built on a greenhouse and did banquette seating. The flooring was cork—a material I still like. I built in lighting and bookcases, and I put together a collection of Picasso drawings and African sculpture for the clients."

The vocabulary may be a constant in his work, but everything else is a variable. He makes clients think very hard about whether he is their choice before he accepts them. But after that, "things evolve. I'm doing one apartment where an Oriental flavor has crept in—it started with two black Oriental trunks I found—and there is a marvelous eighteenth-century iron bed. I wouldn't use it myself, but it is a beauty and I think it's right for the client. Another apartment belongs to a couple who love American Indian rugs and sculpture. That apartment will have a very different ambience from the other, and neither will be like mine."

Mr. Bennett takes what he describes as "an intuitive, intellectual, and cultural" approach to his work. "You should walk into a place and feel its ambience, not see that it has been done by some decorator in pastel this or lace that. I strongly disagree with, and disapprove of, most people who are doing interiors today. They are part of a big and fashionable industry—selling rugs and towels, color combinations, and pewter and bamboo. That's not for me.

"I'm interested in the architectural approach, with a great cultural aspect to it—whether it's literature or music or whatever. Money is not that important. I do well, but I've never done anything because of money. I have no employees—I hire free-lance people, such as draftsmen, engineers, and model makers as I need them—so I don't have to take work to keep a staff going."

This freedom to accept only the work he wants is very important to Ward Bennett. It allows him to lead the kind of life that most appeals to him and that has had the greatest influence on his work—the life of an artist.

"Artists were very important to me. I met Matisse and Picasso and Giacometti when I lived in Paris, and I loved the way they lived. Each one lived quite differently, but usually there'd be lots of plants and an old rug or something around. There was a certain kind of disorder and spontaneity. Matisse and Picasso lived in a total mess but it had a marvelous beauty to it. Even now, for me to stack a pile of books beside a chair pleases me.

"In my apartment, the paintings just sit against the walls. Their transience pleases me. I move things around all the time, and I hate to have pictures stay in one place, because then you stop seeing them. I remember once going to Philip Johnson's house in Connecticut and noticing that the places for the ash trays were marked on the tables with red dots so they could always be put back in exactly the same spot. That's very spooky. I love disorder. But I'm very conscious of that disorder and the relationships of things to each other."

But a love of considered disorder does not mean a love of complexity. On the contrary, for Ward Bennett, simplicity is everything. He starts every job by eliminating as much as possible, removing, if necessary, every nonsupporting wall. "Obviously I keep interesting and good architecture. But if it's not interesting, I'm apt to destroy it to see if I can make it better."

Then, he likes to make a model of the room and furniture. "I've always preferred designing with models rather than drawings. That's how I work with my furniture designs. I make a model first and only at the end is it drawn to facilitate production. It's very similar to the way I worked in fashion. I'd design on a mannequin and drape and cut right into the fabric rather than sketch first. I always start with the human body and make whatever I am designing fit it. Fit is everything, and that applies to clothes, furniture, or knives and forks."

If he doesn't design the furniture for a room himself, Bennett uses modern classics by such designers as Mies van der Rohe and Le Corbusier. To gauge their scale and how they will work *in situ,* he cuts paper patterns and tries those in the room first.

The apartment shown here in New York's land-mark apartment building The Dakota belongs to Mr. Bennett. Now, it is a duplex in the attic of the building. When he bought it, it was a warren of servants' rooms. Basically, the apartment is a pyramid built around the building's flagpole. Old double-sash windows were replaced with single panes, and a two-story window was installed in the sloping roof which forms one side of the pyramid.

All the major pieces of furniture were designed by Mr. Bennett except for an old office swivel chair and a Le Corbusier chaise from which he removed the pad. "I love to see the skeletons of furniture. That's why I love eighteenth-century French furniture. You always see the complete frames of bergères and fauteuils."

About the paintings and objects he has picked up on his travels through various parts of the world, he says, "I have too much stuff. But these things mean very much to me, and I'd rather live with them than pick up things in some gallery because I needed something to fill a hole." It's impossible to think of Ward Bennett doing anything so ordinary.

Color photographs by Jaime Ardiles-Arce.
Photograph of Ward Bennett by Michael Pateman.

1. *Stripped down to its sloping walls, the living room of Ward Bennett's apartment was carpeted in elephant gray. Seating is provided by layers of leather-covered mattresses and pillows. The steel staircase leads to the upstairs library/dining room. In the foreground is a Le Corbusier chaise stripped to its bones.*
2. *The worktable, designed by Mr. Bennett, is a slab of black granite on a stainless-steel base. The swivel chair is old, as are the Victorian folding chairs. The small round tables are the rims of car wheels topped with metal.*
3. *This window, built into the sloping roof of The Dakota, spans two stories. The floor of the upper level was deliberately stopped short of the window to emphasize its sweep.*
4. *The apartment building's flagpole forms a central support for the dining/work table. The ash chairs were designed by Mr. Bennett and are hand-carved from solid blocks of wood.*
5. *The pyramid shape of the apartment clearly shows in this picture of the living room and the library/dining room above it.*

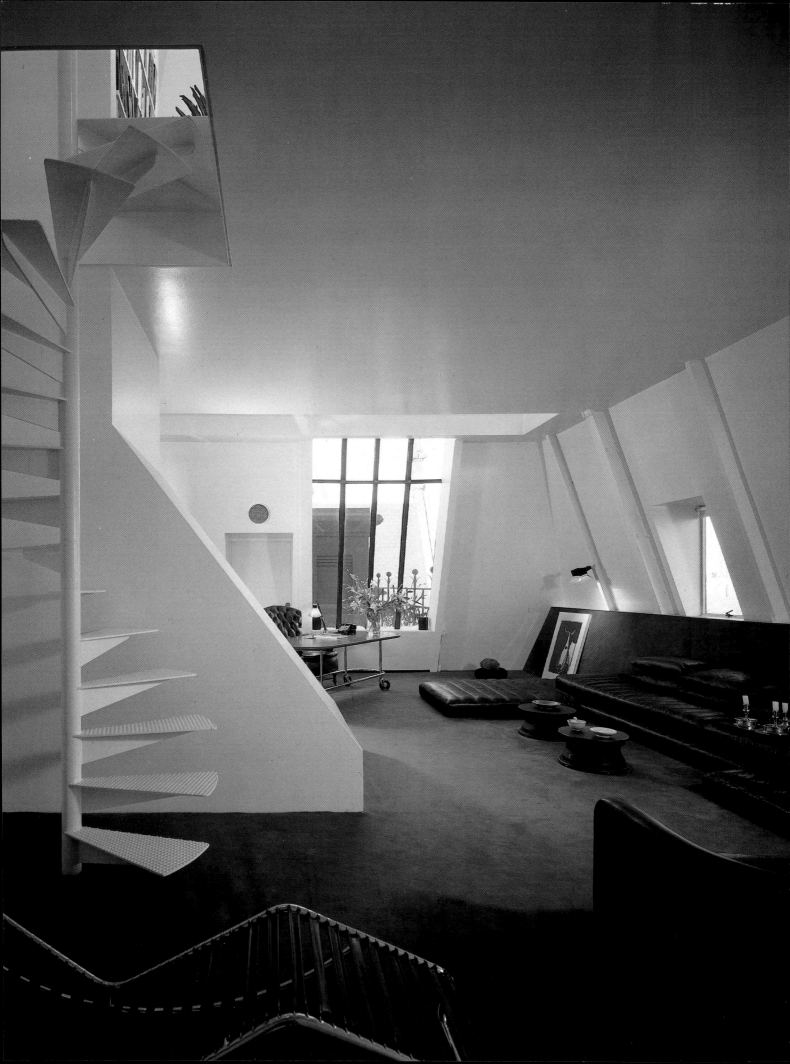

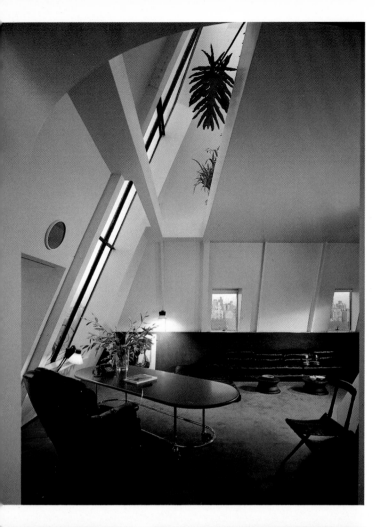

2

3

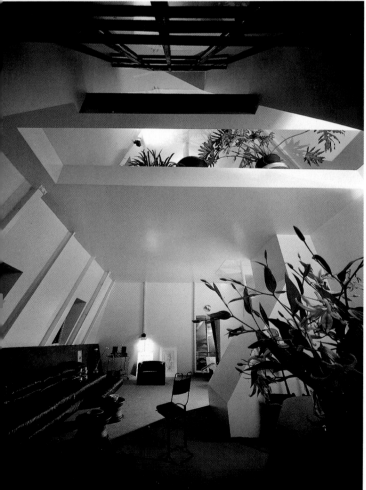

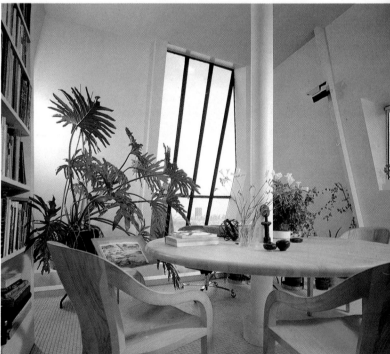

4

5

McMillen Inc.

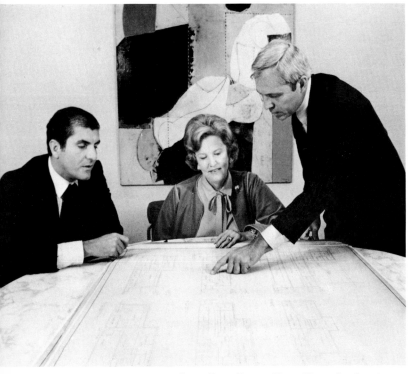

Luis Rey, Betty Sherrill, and John Drews

McMillen Inc. is like no other design company in the world. Founded in 1924 by the now-legendary Eleanor McMillen Brown (who is still Chairman of the Board), it has consistently produced work that has been the yardstick by which American design is judged. As a company it has stood for continuity: Mrs. Brown's original philosophy of design is as strong an influence now as it was fifty-six years ago. But McMillen has also stood for change, for the talented and diverse individuals who are its designers have always kept abreast of innovations. As a result, McMillen's work over the years has covered a broader range than that of any other American firm.

Today, in addition to Mrs. Brown, McMillen is made up of six decorators, two vice presidents (John Drews and Luis Rey), and a president, Betty Sherrill. All have their own clients and work autonomously, as has always been the McMillen way. Each works mainly in the idiom he or she prefers—for Mrs. Sherrill and Mr. Drews that is the traditional; for Mr. Rey it is the architectural. But each designer is at home in any discipline.

"We are all trained professionals," says Mrs. Sherrill. "Almost all of us are graduates of Parsons School of Design, and if an architect drops out of a job, we are capable of stepping in and finishing it." Though Mrs. Sherrill says there is no substitute for talent, she is also a strong advocate of formal training. "People who don't have it must find design a struggle. We often do houses that we never see. We work from floor plans and what the client tells us. We visualize the scale, the furnishings, and the colorings. Sometimes we get to see the house after it's finished, and, sure enough, it looks exactly the way we thought it would. You can't do that without training."

Or without knowing the client extremely well. "That's an important part of any job," says Mrs. Sherrill, who still has clients she first worked for when she joined McMillen twenty-nine years ago. "You have to like clients to work with them. Even with a new client, you're either friends with them by the end of the first day or it's not going to work. I take a great interest in my clients' lives—not as gossip, but in how they live. And I try to keep up with them as they change."

The versatility that McMillen fosters is nowhere more apparent than in the design of the apartment shown here. In many ways the epitome of a traditional interior, it was done by Luis Rey.

Mr. Rey, a Peruvian who was trained as an engineer and whose interest before he came to McMillen was purely in architecture, has strong feelings about traditional design. "I'm not interested in it," he says. "I admire it a great deal, and without its existence no one could do anything. But I'm not interested in doing it; I'm not interested in living with it. I find it boring. It's been done to such a high level by other people, and I see no reason to repeat what others have done. As designers, we should be trying to create something new and different."

But he was interested in this job. "It was exceptional. It was very detailed, and I did take a contemporary approach." Indeed, a close look reveals this. There is a lack of clutter in both accessories and furniture. The rooms were first designed, and then decorated.

But the great delight for Mr. Rey was the clients. "There was a lot of respect and admiration on both sides. They were very responsive and they had beautiful things to work with." Some of these things McMillen had bought for this couple twenty years previously. Others

they had collected themselves. Prime among these is a large and superb collection of botanical and bird prints.

A big part of the work was in grouping the prints, and the final arrangements are the result of designer and client working closely together. "I would say, 'There are too many in this room,'" says Mr. Rey. "The client would listen and ask why—he wasn't going to just sit there and agree—and then we'd discuss where to put them. I wanted to group them together for greater impact, but it was the client's idea to use the particular grouping in the breakfast room instead of wallpaper."

The other public rooms of the apartment came together quite easily. "They were in good condition. The apartment dates to about 1910, so the rooms were large and had good moldings. The drawing room stayed the color it was when the clients bought it. We washed the walls and had to repaint and reglaze two of them. After that, the rug, which they already had, set the colorings. I knew I wanted the dining room to be a dark color because we were leaving the windows, which lead to a terrace, uncurtained and a lot of natural light came in."

The big challenge came when a series of maids' rooms had to be gutted to make a separate master-bedroom wing and bedrooms and bathrooms for the clients' children. Mr. Rey was in his element here. "I love to start a design with a problem," he says. "I think architects get into trouble sometimes because they have no limitations. To me, the more limitations exist, the more creative one becomes. The more choices you have, the easier it is to get lost. But if you have a problem, you have the key—everything follows from the way you solve it."

The solving of problems well is, as far as Luis Rey is concerned, what interior design is all about. "The most expensive part of design is the mistake. Many people can recognize beautiful things individually, but it takes a special talent to be able to put them together beautifully. Too many people try to do it by themselves, and by the time they realize they can't, it's too late. Then they come to a professional already unhappy and having spent a lot of money. Using a designer who will avoid mistakes need be no more expensive than buying furniture at a department store."

But what about McMillen's reputation for concentrating on great American tradition, great houses, and socially registered clients and not doing small jobs? That, says Mr. Rey, has changed as America has changed.

"There are many young people who don't have a lot of money but aren't afraid to come to us. They don't necessarily need that traditional image, but they still want the security we can give them."

Betty Sherrill agrees but says, "We are not saying no one can live without an interior designer. However, I do find that when people do try to do it on their own they'll buy one-hundred-dollar-a-yard material and use it all over the place where we might have made a pillow out of it. They're so unsure of themselves all they know how to do is to get the expensive thing. That's not interior design."

Color photographs by Richard Champion.

1. *Because of the enormous amount of natural light that floods into this dining room through uncurtained windows, McMillen vice president Luis Rey gave it dark brown shiny walls. The combination of light and dark throws the painted breakfront and Japanese Momoyama screen into high relief.*

2. *At first Mr. Rey wanted to strip the library of the oak paneling with its Tudor-style strapping and detailing. But his clients insisted on keeping it—a decision Mr. Rey now thinks was right.*

3. *The breakfast room is a perfect octagon—four plain walls, each alternating with a door or window. The walls are "papered" with the owner's collection of eighteenth-century watercolors of birds by the French artist Francois-Nicolas Martinet. The parasol hanging over the table hides spot lighting fixtures.*

4. *The drawing-room walls remain the color they were when the owners moved in. Other colors were picked up from the eighteenth-century Aga rug. K'ang Hsi porcelain birds stand on the mantel on either side of a portrait by Sir Henry Raeburn.*

5. *In the remodeled wing, one of two master bath/dressing rooms has a marble vanity surrounded by mirrors. A fifteenth-century Gothic mille-fleur tapestry with a unicorn hangs above a couch.*

6. *Botanical prints decorate the master bedrooms with its soft pink striéed walls and silk curtains. Louis XVI chairs flank a commode of the same period; the silk rug is an eighteenth-century Heriz.*

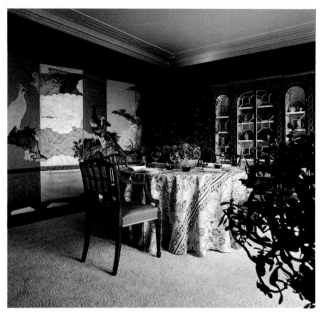

1

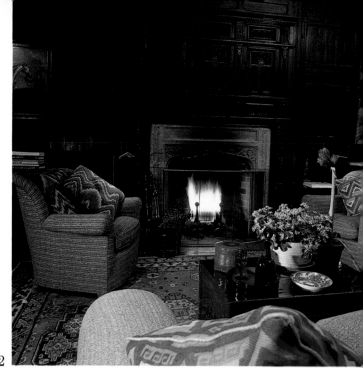

2

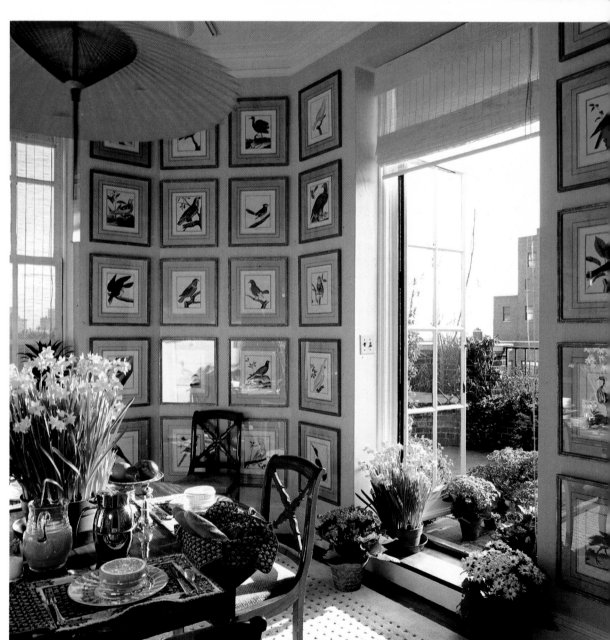

3

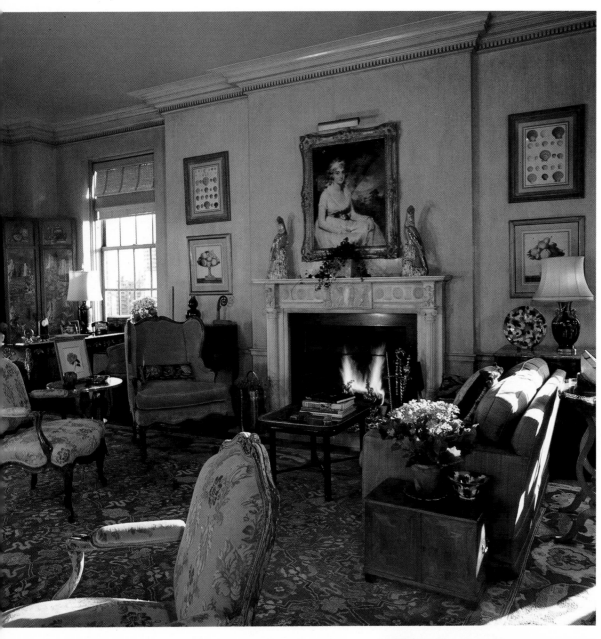

4

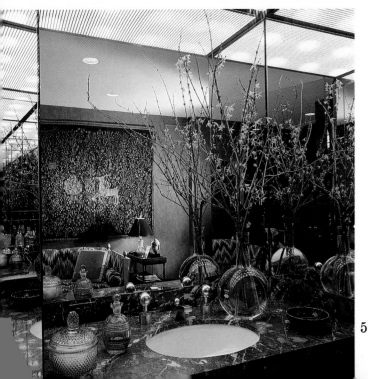

5

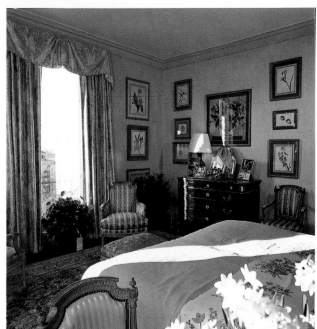

6

Joseph Paul D'Urso

Newark, New Jersey, and Manchester, England, would never rank high on anyone's list of places to go for artistic inspiration. But both cities were vital influences on the work and thinking of Joseph Paul D'Urso, one of America's top exponents of what has come to be called the minimalist school: sculptured spaces, white walls, gray and black industrial carpeting and fittings, stark efficiency.

In between life in Newark (where he grew up) and Manchester (where he studied design for eighteen months) came four years studying interior design at New York's Pratt Institute. "Of course," he says, "I was more interested in architecture—in structure and space—than in interior design, but I didn't have the math to get into the architecture department. I was terrible at drafting and geometry and trigonometry. As it happens, I don't think I missed anything, as the interior design department was under an architect when I went there in 1961 and most of the teachers were architects.

"But the fact that I'm not an architect did become something of a cause for me when I first started working. Lots of architects look down their noses at interior designers. I've always considered myself their equal and well able to hold my own. The title itself doesn't mean a thing. It's the passion, the involvement, and the working experience that really count."

Joe D'Urso's first work experience came after he graduated from Pratt in 1965 and went to England to study for two years. "I went to the Royal College of Art for six months and then got the opportunity to work on designs for a monorail in Manchester. My time there was a reinforcement of everything I felt about design.

"Like Newark, Manchester was full of the kind of buildings I love—very direct, engineered, and focused on structure and purpose. I don't like buildings that have a historical or aesthetic self-consciousness. The project also involved an early industrial building with a glass facade cascading down and skylights turning into walls. That theme, of glass and light, is involved in everything I do."

There are those who look at Joe D'Urso's work and see in it its own self-consciousness. "Minimalists," these critics say; "they all do the same thing over and over again."

Not so, says Mr. D'Urso. "That's a very superficial and not very learned way to think. The problem is that most people take the term to mean there's nothing there, when in fact the opposite is true. We are accomplishing everything and producing a very rich experience very economically. Matisse could make you sense the human figure in one line, and I find that much more exciting than the many lines needed by other artists."

Like the minimalist artists he admires, Joe D'Urso is preoccupied with space—its structure, volume, proportions—and its purity. "I think that living today, especially in New York where we're constantly bombarded with objects and sounds and visual things, demands pure architectural space with light, plain levels and surfaces to soothe the spirit."

Nor is what he does repetitive. "It depends on how subtle you want to be. Take ten squares that are all red but in slightly different shades. At a quick glance they all look the same, but the more you get into them, the more differences you see. I never feel that by using the same materials over again I'm being redundant. The varieties in each job—the different client, the different budget—are extensive enough to make each exciting for me. I never say, 'Here I am, doing another apartment with gray carpet and white walls.' And I expect anyone who looks at my work to understand that.

"A client of mine once said that if someone buys a Picasso, they want it to look like a Picasso. But people expect an interior designer to be different each time. To me, that's a contradiction. People should expect my work to look like a Joe D'Urso; something that is a logical, sequential development of me.

"I always try to be objective. I analyze the space and

the particular program of the people who are going to live in it. My solutions are based on reason, within the context of the budget. When someone asks why I did something I want to have a better reason than 'I liked it that way.' I want a reason that is more analytical than aesthetic; a reason that is objective and impersonal, because, after all, I'm not doing the work for myself, I'm doing it for someone else.

"I don't find it necessary to know a client. I like to think that many people from many cultures can relate to a space I design and that each will get something emotional from it. That, to me, is the true test of a beautiful space. It shouldn't be filled with objects and specific cultural symbols.

"Of course, any design I do will be able to incorporate some of the client's own things—but only those that are really important to them. I have the feeling that too many people live in storerooms, not in space. We all have personal objects, but I always pose the questions: Why do you have this? Do you really need it? Do you really love it? Who's going to take care of it? That's really what people come to a designer for. They're looking for the discipline that will give them good habits.

"Clients who come to me know my work in the sense of knowing what they won't get. Most of them are strong people who respond to other strong people. I'm not a dictator but I do have the courage of my convictions. Clients come because they want my expertise, my discipline, my point of view, and my ability to solve problems."

With the house shown here, Mr. D'Urso didn't have to make many structural changes except on the lower level. The family who owns the house needed more storage everywhere, but the big challenge was to make the lower level work. "They were spending a lot of time there, and it was the most depressing space in the house. There was no daylight, and that is very important to me. I brought it in with the greenhouse I built on one end. After that, the most important thing was to make the space comfortable and flow throughout the house.

"Of course, you can do that by knocking down walls. Those perceptive moments when you realize that taking out a few walls will give you a whole new conception of space are very rewarding.

"But you have to think about the visual consequences of the decisions you make very early on. Unless you really limit your palette and make it work for you, nothing else can work. Materials—knowing what they do best in what circumstances—are very much linked to what you conceptualize. I'm very interested in the maintenance of things and being sure that they work, so the things I use are the things I know will work. People might criticize that and say it's not very adventurous, but one can still be adventurous within the framework of the things one understands.

"I don't ever see myself without gray and black and white, though I haven't eliminated other colors. If you were to give someone the basic tools to do a drawing you'd give them a piece of white paper and a pen and ink which would probably be black. Somehow, those two elements are so comfortable and basic and universal and abstract that it's what's done with them that becomes meaningful. If you gave someone a piece of pink paper and brown or red ink, the colors would make their own demands. By choosing solutions or means of expression that are very abstract I'm giving people more options than most styles of design offer."

Color photographs by Peter Aaron/ESTO.
Photograph of Joseph Paul D'Urso by Duane Michaels.

1. *The interplay of planes and surfaces is an important facet of Joe D'Urso's work. Here, doors and wall panels pivot on their axes to be angled at will so that they look like free-form slab sculpture.*
2. *The living area is a three-sided carpeted banquette piled with chintz- and suede-covered pillows. Ceilings and walls are lacquered high-gloss white. The Formica table provides storage space. The chair is a Le Corbusier design.*
3. *The basement family/media room includes an Advent VideoBeam television set and contains a series of wide seating platforms all covered in black poplin. The sides of the platforms and the floor are covered in gray tile.*
4 *and* 5. *Natural light reaches a first-floor corridor via a greenhouse built on at one end of the basement.*
6. *An open well lets extra light into the basement from a skylight above the dining area. As in all D'Urso's work, lines and angles are precise.*
7. *A black-granite dining table designed by Mr. D'Urso and Mies van de Rohe chairs sit under a skylight. At the rear is the kitchen.*

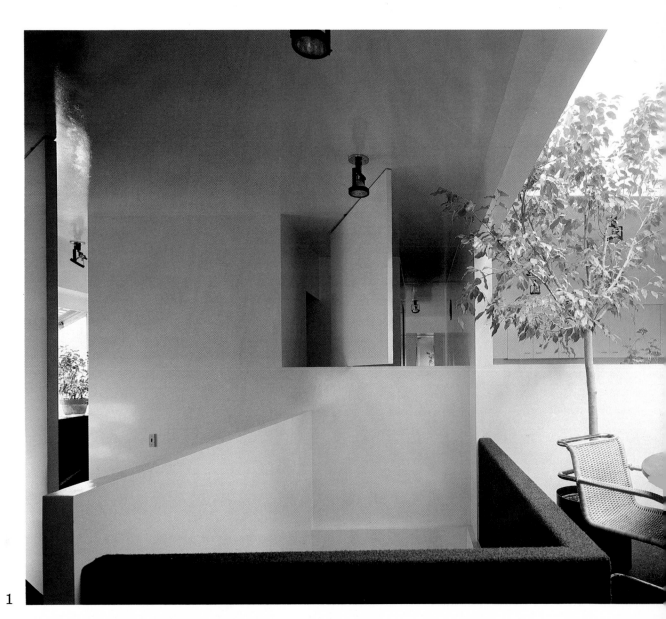

1

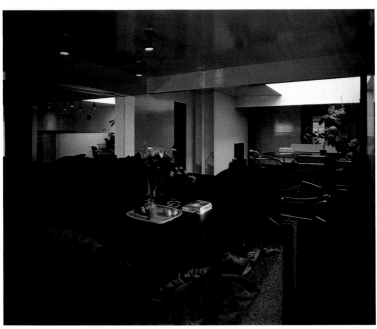

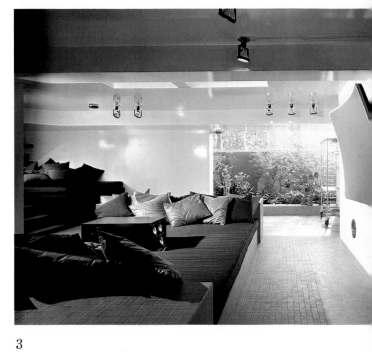

2　3

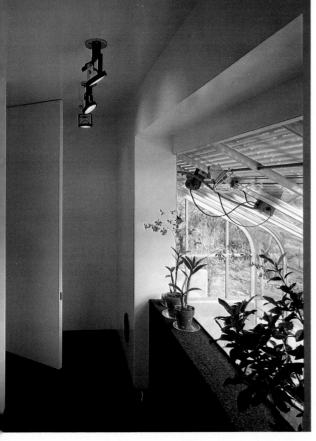

4

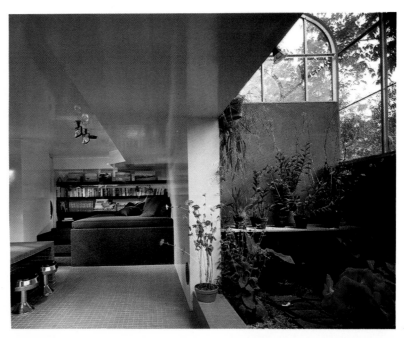

5

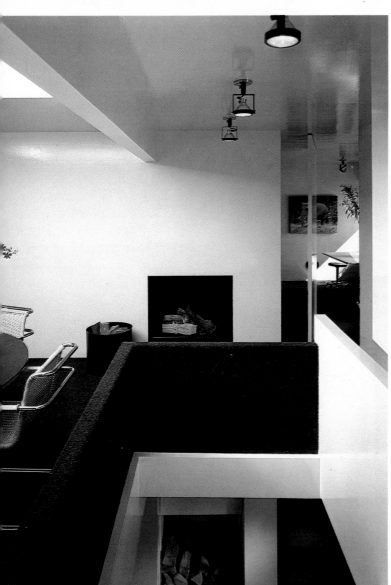

6

7

David Hicks

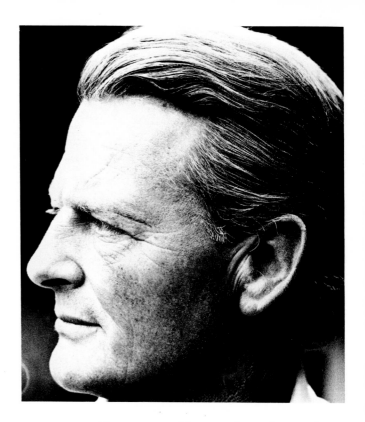

Wherever one goes in the world today, the name of the British designer David Hicks is known. Through houses, hotels, and offices that he has decorated; sheets, carpets, furniture, and accessories that he has designed; through his stores in Europe, the Far East, and Australia; through the books he has written; and through numerous protégés who are now designers in their own right, his name has become synonymous with interior design.

He, probably more than anyone else, has proved that periods and patterns can be mixed without sacrificing elegance and simplicity.

It's all done, he says, by exercising discipline and caution. "You must never use too many elements and you mustn't overuse any one. What you leave out is as important as what you put in. Almost none of my work looks dated, because it has been very carefully put together. It is restrained. I don't believe in gimmicks or trends. In fact, I think it's immoral to give anyone a fashionable interior: that's selling built-in obsolescence. Whenever you do a room, you should expect it to last ten or more years."

David Hicks' work covers the last twenty-five years from the day he decorated his first house—his own—and it was published in the British *House and Garden* magazine. Since then he has designed residences on every continent in a wide variety of styles but always with the Hicks hallmark of integrity—integrity to the house and to the client.

A well-known American designer says of him: "David has a scholarly interest in houses and their furnishings. He has a wonderful way of accurately translating period rooms and observing the contributions of the past while at the same time providing something bold and new and daring."

David Hicks is invariably very firm—even definite—with himself and with clients. "You've got to be very decisive in decoration," he states, "especially now when there are such a stupefying number of alternatives. If I have any reputation, it's because I am constantly editing out—accepting one alternative and rejecting another. One is aiming for good manners, good quality, and the avoidance of visual indigestion. A room should never be like an overrich meal. That's where the amateur often goes berserk—wanting a little bit of everything. You have to realize that there are things you can't do."

But the range of what you can do—at least if you are David Hicks—is wide. You can mix patterns: "The patterns must be connected by motif or color, and you must use motifs of differing scales." You can mix textures: "Glazed chintz contrasted with wool is exciting." And you can punch a period chair into the twentieth century by covering it in tweed, cotton, or suede.

But always, when David Hicks does it, one is aware of the discipline. There is never too much, or too many elements, at work. There is, however, always livability, casualness, restful comfort.

"Practical considerations are increasingly important," says Mr. Hicks. "Today, we all work, we don't have servants, and so everything must be more simple and workaday to live with. The first thing I ask a client is what he or she already owns. If they own nothing, what would they like to own? If they don't know that, I must provide alternatives. Would they like to collect French furniture, English architectural drawings, whatever?

"And I have to know how they are going to live. Will they give dinner parties for twelve or will they not? Is TV big in their lives? Do they watch it in bed? Which colors do they like? Which do they dislike? I'm like a doctor. I have to get them to describe their symptoms and then make a diagnosis."

After the client comes the room. "The internal architecture is very important. I am very concerned with rooms having good proportions—the fireplace, windows, and doors being in the right places. If a room lacks character, perhaps it can have cupboards built into each corner to give it an interesting contour. Or a narrow hall-

way with lots of visually confusing doors can be unified by simply wallpapering over doors and walls alike.

"I don't think you can fool the eye with color. A ceiling is the height it is whether it's painted black or white. (Anyway, I only like white ceilings.) But any house or apartment must have a neutral hallway or passage so that, visually, you can go easily from, say, a green study to a pale pink drawing room. You can't have something bright such as orange in between. I am always very conscious of what's happening in all areas of an interior.

"Then we start to decorate. The first thing to choose is the carpet. That's the major investment in any room, for, while the room scheme may be modified ten years later, the carpet should last for twenty.

"Lighting is very important. You should never see the source of light. Even when I use spotlights they are always angled close enough to the wall to illuminate only the picture or object they're aimed at. They never shine directly at anyone. I loathe candles on a dining-room table unless they're shaded. The flame is ugly and blinding. All lighting should be kept low to protect ladies with double chins."

When it comes to the actual furnishings of a room, David Hicks follows general precepts rather than specific rules. A room is done, he says, when it looks lived in and cozy and there are sufficient objects to please the eye. This is done through a feeling for what's right, which comes from an educated eye.

David Hicks has educated his eye all his life. Four years at art school studying theater and costume design, book illustration, and painting were followed by two years in the army ("a useful period when I realized that I was not a genius with costume design or paint"). Six months in the art department of an advertising agency convinced him that his future lay elsewhere, and it was then that his lifelong love of houses, furniture, and color led him to interior design. He learned—and still learns —by looking. Wherever he goes in the world, no notable building or exhibition escapes him.

Although his style is still definitely European, he credits its formulation to two visits to the United States in the mid-1950s. "I saw the Seagram building, my first downlight, Philip Johnson's glass house, and the whole West Coast school of decorating with its use of white and pale colors and rather casual attitude toward rooms. It was all a tremendous influence."

Today, he would like to reciprocate by influencing America via his furniture, fabric, and carpet designs. "Unfortunately, most Americans are aesthetically uneducated. There is an American liking for vulgarity— look at Las Vegas, Reno, and Miami. Americans are too ready to accept junk and gimmicks.

"Quality and taste do not depend, in the end, on money. They depend on the intellectual approach—the way you use things, not what you use. I'd like to come into America as a Puritan and sell simplicity and elegance. It will be expensive, but simplicity always is; there's no place to hide mistakes, so everything has to be perfect."

1. *As much as anyone, David Hicks has been responsible for popularizing the idea of the bathroom as a room, not just a necessary household adjunct. Here, the tub is center stage, surrounded by disciplined geometry in the latticed bookcase, gridded window and table, and the washbasin and chair covered with Hicks-designed fabrics.*

2. *More pattern-on-pattern—this time floral as well as geometric—is kept under strict control in this country-house bedroom with its half-tester bed.*

3. *A carpet designed by David Hicks sets the tone for his own library with its strong proportions. As he always prefers, the ceiling is white, and the blinds are kept low enough to prevent direct glare from the sun.*

4. *A curved gallery is hung with family portraits and furnished in a mix of styles and periods, but there is no "visual indigestion" here.*

5. *This entrance hall to an English country house dates from 1728. The floor is of stone and slate, and the walls have been repainted their original brown (a color found by Mr. Hicks beneath sixteen coats of paint). The sofa is of white horsehair, and the 1710 high-backed hall chair is one of a pair. The hall is deliberately underfurnished in the style of its period.*

6. *There is no pattern, just pure color, in this bedroom, except on the fourposter bed, which is hung with pale blue cotton lined in white with tiny blue polka dots. The tester top is tied at the corners with tailored bows. The same cotton covers eighteenth-century chairs; there is white cord matting on the floor. Eighteenth-century brass candlesticks were converted into lamps. Without a frill or flounce in sight, this is nevertheless a soft, pretty, and feminine room.*

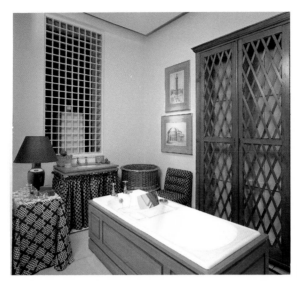

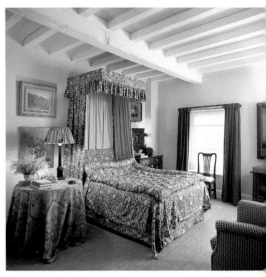

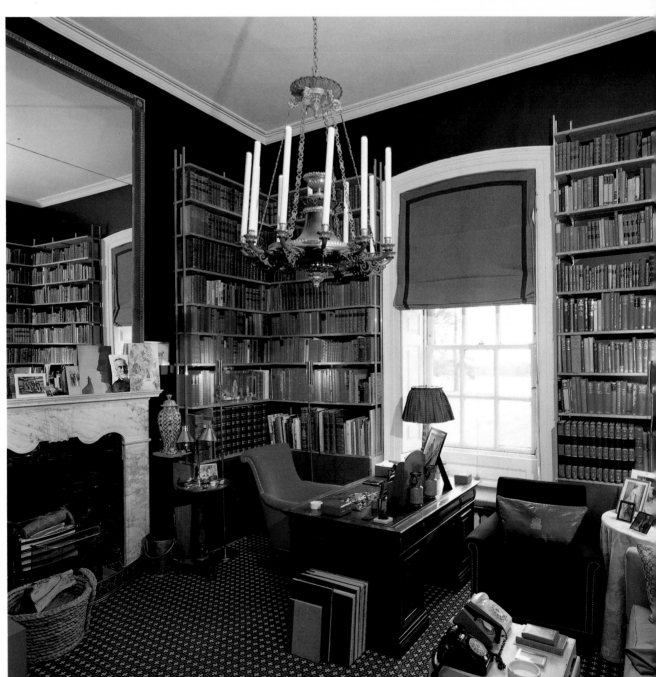

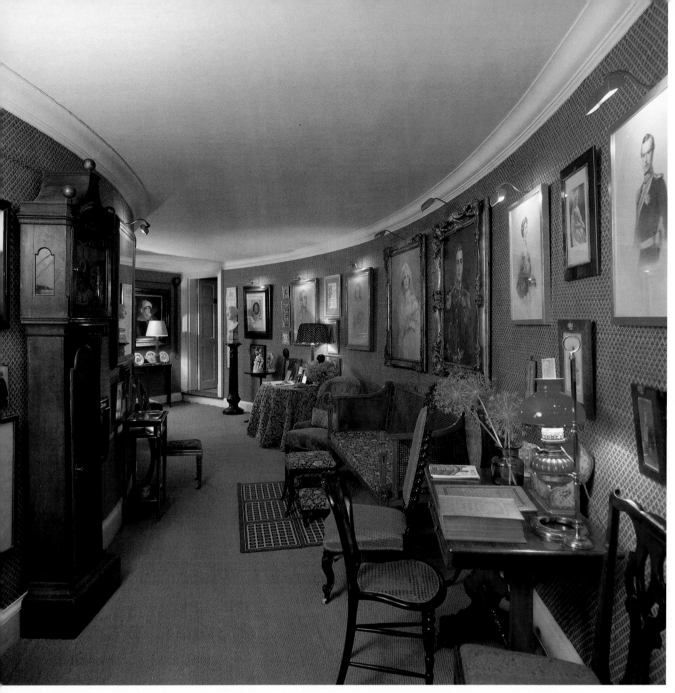

4

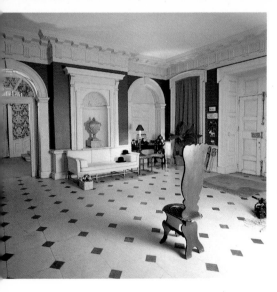

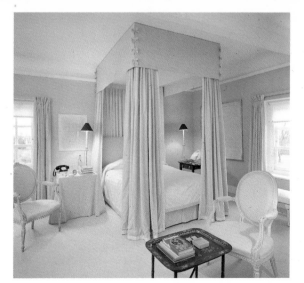

5 6

Juan Montoya

"When people tell me I am a minimalist, I agree with them," says Juan Montoya. "But not for their reasons." To Mr. Montoya, a young South American now based in New York, minimalism as a design philosophy is too often a dogmatic formula imposed on a space and a client. Mr. Montoya is against anything so doctrinaire. "I want to understand the space and the needs of the client and translate those into my design. I would never arbitrarily say, 'This is what you should have—live with it.'

"But I am a minimalist in the sense that I take what the client already has and simplify it so that each design element can be seen—a view, a wall, a space, an entrance, a door, a chair. I want people walking into rooms I design to be able to focus on one thing, not ten thousand at once.

"I am not a minimalist in the sense of believing that spaces should be left blank. I don't do that unless the space demands it, and that happens very rarely. I believe in *objets d'art* and in collecting things. There is tremendous beauty in objects. But I do ask my clients, 'Do you really like it? Why do you like it?' If they have a good reason, that's fine. If they don't, sometimes they will realize there is no need for that thing in their lives and we get rid of it. But at all times I must respect what is dear to the client. If they are awful things, I say so. But if they insist on keeping them, I include them in my scheme.

"I am a minimalist in that I like black and neutral colors. But I also like red and would not, in any case, impose my preferences. I will work with whatever colors the client likes.

"I am not a minimalist because though I have a great sense of order, I don't mind a little mess. But I am a minimalist when it comes to decoration. I don't like gilded, stuffy, ornate interiors. There is no honesty in them; they are trying to be something they're not."

The major influence on Mr. Montoya and his work, he says, was the architecture that surrounded him when he was growing up in Bogota, Colombia. Always interested in classical design—at the age of ten he was building model houses for friends, and he studied architecture for two years before giving in to his urge to travel—he was very much aware of his country's native adobe buildings. "I grew up among thick walls and in lots of corridors. All the houses I knew were a series of connecting links so that, as you walked through them, there was a rising sense of expectation. You never saw everything at once. That sense of changing perceptions, of areas that you walk into and go out of, is very much in my mind when I see a space today."

But that was not his only influence. His desire to travel brought him to New York, where he learned English at night classes and by watching television. "Johnny Carson was great." He went to Parsons School of Design for three years, lived in Paris for two years after he graduated, and spent some time in Italy.

Europe made its impression, but he decided he belonged in New York. He returned and found work with a firm that designed dental offices—and nothing else. "I did all their drawings—presentation, working and schematic. It was the best training I ever had and I hated every minute of it. I liked the design side, but I have no patience with details."

His start as an independent designer came in 1976 when he was fired—"The owner said we didn't communicate"—and several clients decided to stay with him rather than the company.

Dental offices have long since been left behind, and Juan Montoya now concentrates on residential work. His clientele are young and knowledgeable. "When they come to me they usually know what they are getting into. They are convinced before they arrive that they want my services. I start with the very practical side: what their space is like, what they need it to do for them, and how much they want to spend. I always try to pin them down to a budget so there can be no misunderstandings about money later on.

"Then I budget my time—six months for a job in New York, a year for one outside the city—and then we have to get to know each other. This business is one of psychology. It is not one of merely painting a pretty picture. I have to analyze the clients' personalities and preferences and how they want to live—otherwise I become a sculptor.

"So I like a client who is perceptive and who will suggest ideas and who I can work with closely. The idea of a client who gives you carte blanche and disappears until you've finished is an attractive one to many designers, but to me it's dangerous. The way I see things in my mind is often difficult to put into words. We are dealing with concepts, and even if you show drawing after drawing, few people seem to be able to translate them into three dimensions. If the clients are not around

as the work progresses, they are sometimes surprised—even shocked—when they see the result, because all my jobs involve structural changes; the transfiguration of spaces."

The apartment shown here was one such. A fifth-floor tenement walk-up, its sole attraction was its low rent. The rooms were tiny—both the living room and the bedroom measure a scant ten by twelve feet—and the budget was correspondingly small. The ceilings throughout were wooden slats supporting multicolored canvas—barriers erected by the previous tenant to catch plaster falling from the real ten-foot-high ceilings. Much of the budget went on restoring the ceilings and no new fixtures for the kitchen, but Mr. Montoya also changed walls in the living room and bedroom and built storage into the banquettes and the platform bed. Both the bathroom and the corridor leading to it are narrow in the extreme, so a sliding ship's door was installed for minimum interference. The transformation cost less than ten thousand dollars when it was done three years ago, and anything less like a tenement apartment is hard to imagine.

"I do get pleasure out of improving people's lives," says Juan Montoya. "I have seen clients who hated their spaces when they came to me. They were constantly eating out and spent as little time as possible at home. All I know now is that they eat in, they entertain, they spread a sense of satisfaction. It's not that I am a great humanitarian, but seeing someone enjoy what I have done for them is very rewarding to me."

Color photographs by Jaime Ardiles-Arce.

1. Because most of the budget for this apartment went on restoring walls and ceilings, Juan Montoya kept the furnishings practical and inexpensive. Banquettes running around the living room provide storage. The cushions are covered in natural canvas duck. Tables are rattan spools with Formica tops and an upended woven basket from the Philippines. Color is provided by abstract paintings.

2. An exceptionally narrow corridor leads to a tiny bathroom with a sliding ship's door. Mr. Montoya uses these doors often, but here practicality was the prime motivation for doing so, since there is barely room in either bathroom or corridor to allow for opening a hinged door.

3. In the small bedroom, Mr. Montoya used mirrors to expand the space. The platform bed conceals more storage and, like the floor, is covered in inexpensive and hard-wearing beige industrial carpeting. A small dressing table was built in between the windows.

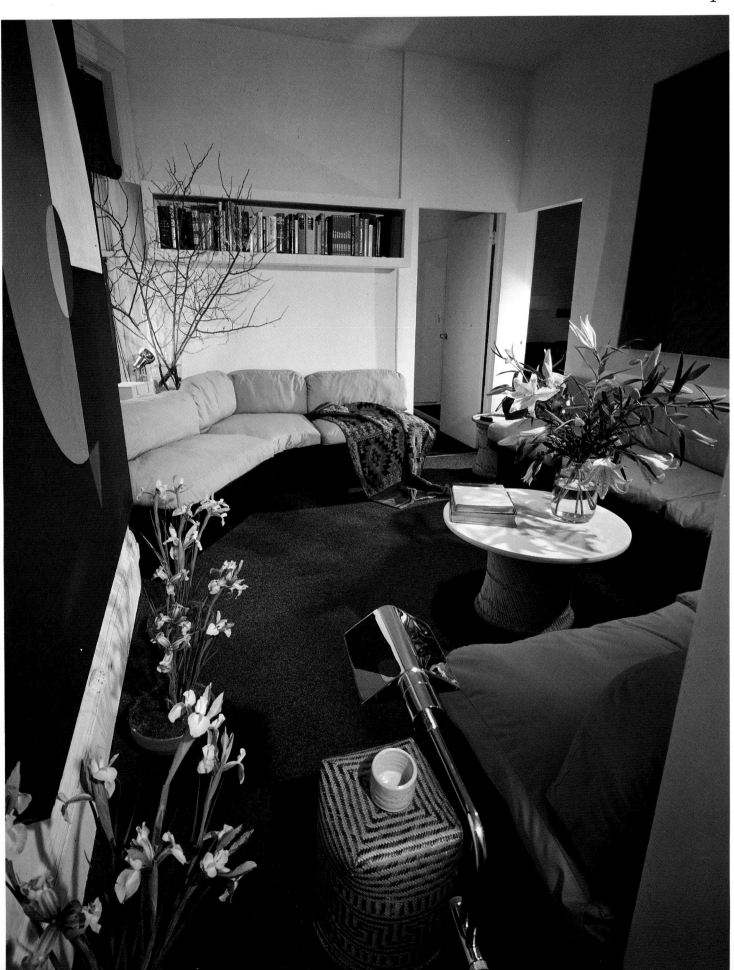

2

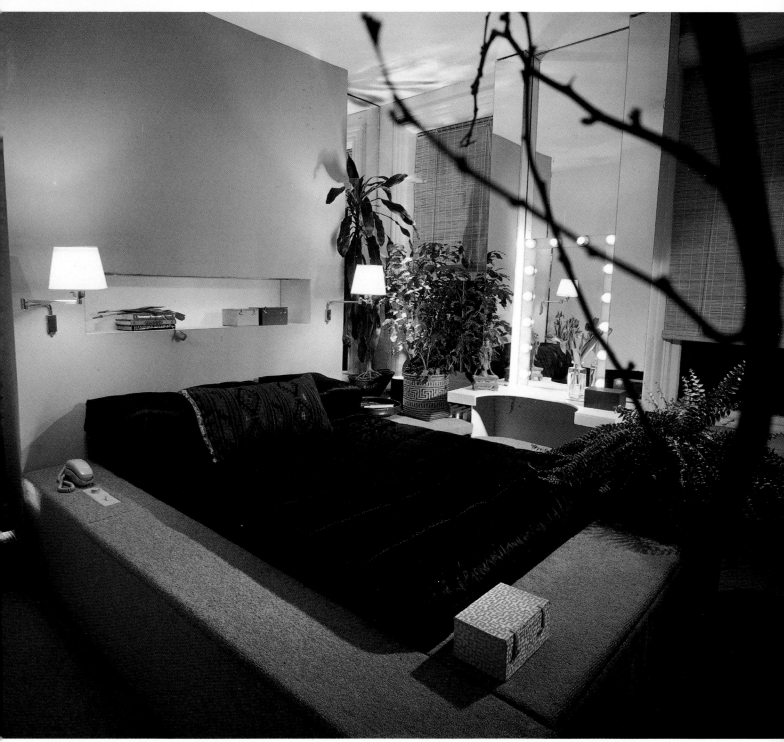

3

Mark Hampton

"Rooms can be a million things but they shouldn't be some quirky new catch phrase." To Mark Hampton, that is a basic tenet of interior design. "I have very few dislikes among approved schools of decoration and architecture, but the older I get, the less amused I am by being shocked and the less interested I am in new ideas just for the sake of their newness.

"I hated the way things were vandalized in the fifties—painting period French furniture bright yellow and pink; turning Mexican stools into coffee tables, and wrought-iron gates into headboards—and today my pet peeve is high-tech. I can't imagine being devoured by a house the way that kind of interior would devour me. There's no room for change or spontaneity."

Mr. Hampton lays a lot of the blame for design catch phrases at the door of the shelter magazines. "Editors, with their constant nagging for a story line, stimulate what I think is a false point of view about houses. They are not content with the simple story of the beautiful room, the way it is lived in, and the people who live in it."

Mark Hampton is more than content to have his work reflect such a simple story line. "If someone comes

to me with a consuming interest in any more-or-less pleasing style, I'll be happy to work with him on it. I do know a lot, and I'm lucky enough to be preoccupied with my work."

Mark Hampton always knew his career would have to do with houses. When he was a third-grader in Indiana, his school scrapbook was plastered with pictures of Williamsburg, and at the age of ten, "I was a Frank Lloyd Wright nut." He expected to become a famous architect until he discovered math. "I can not and will not deal with it." Instead, he studied history, spending a year at the London School of Economics in the process.

While there, he showed his scrapbook of drawings of houses real and imagined to David Hicks and found himself hired as an assistant. "Like David, I had a voracious interest in houses," he says. "But David's knowledge was scholarly. Because of David I skipped over things that he found ordinary and that I would have come to realize were ordinary. And he taught me rights and wrongs: that while you can cover a Louis Quinze chair in plain cotton, you can't use a squiggly ribbon chintz on a severe Directoire chair. It isn't right and it doesn't look right."

Returning to America, Mr. Hampton spent a year at law school, "to please my parents," and then four years in New York University's museum training program. Once again, he was hired for the summer at a top design house—this time by Parish-Hadley. "I was dumped into a completely new (to me) yet traditional point of view. Mrs. Parish knows every possible detail of decorating. She has an incredible regard for the way people live in their houses. In her rooms the people who occupy them look better than they would anywhere else."

Completing his master's degree in 1967, he represented David Hicks in New York for two-and-a-half years and then joined McMillen Inc. Once more, he learned. "I had my own office and worked autonomously, but one always took into consideration the McMillen canons of good taste. They combine professionalism and discipline with originality and skill. Whatever style they work in, everything is *right*. McMillen rooms are scholarly, and, like David Hicks and 'Sister' Parish, they have a great sense of how people want to live."

Mark Hampton branched out on his own in 1976, and, while the influences of his three excellent "finishing schools" show in his work, so too do his own forth-

rightness, catholic good taste, and concern for his client. "I would never say to a client, 'If you don't do it my way, I won't work for you,' although I will say, 'I can't do for you what I know you want. I am the wrong decorator for you.'

"Few people see themselves as others do. But if people want to promote a particular image of themselves, I can go along with that.

"People who have no taste should at least express a preference before they start and then put themselves in the hands of a professional. People who have taste, but it's unschooled, owe it to themselves to realize their potential and learn what they are doing. Part of my job is to educate the client so that he or she can follow through on his own."

But whatever the extent of the client's self-knowledge, Mr. Hampton insists that they be realistic about cost. "If you like something and can afford it, get it. Don't tease yourself by thinking you have to find the perfect thing that is also a bargain. The two rarely come together."

Another rare combination is a knowledgeable client and beautiful space. Beautiful space is a scarce commodity, especially in New York. "If I can make structural changes, I do. But sometimes I have to rely on superficial means—painting the walls a beautiful color or hanging material on them, or hiding ugly windows behind lovely curtains."

Mark Hampton's ideal clients have taste, a positive feeling for what they want, and some pieces of furniture and art that they really like. "They give me the clues I need to start from."

In the rooms shown here, the clues were varied. The floral chintz in one bedroom had been used by the client in a previous house. This time, she wanted to mix the colorways. To do so required great discipline, "almost to putting it on paper," says Mr. Hampton. "It looks loose but it's not interchangeable."

The other bedroom began with the striated wallpaper and a desire for a canopy bed. "The strange apricot-rust color of the paper limited the choice of fabric from the start." Once that was found, the carpet was designed to pick up its pattern.

The library/dining room had a specific point of departure. "The client had seen pictures of Coco Chanel's Paris apartment and wanted to evoke the same atmosphere of gold walls, brown suede, and Chinese lacquer. I gave her a calmer version."

The library came with its Georgian-style bookcases and Louis Seize fireplace. The clients already owned the collection of blue-and-white porcelain and the chairs, and both they and Mr. Hampton loved red in a small room.

The dining room, says Mr. Hampton, could have had the same atmosphere as the library. "But it revolved around two things: the clients' Welsh dresser and the huge painting that eats up one wall. The paneling was already painted yellow and I kept the color: it was right for the room."

Five rooms, each with a different reason for being but all sharing the design qualities Mr. Hampton believes in. Each is civilized, comfortable, and designed with the client in mind. "I don't consider myself a great original," says Mark Hampton. "And I have no desire to be one."

Color photographs by Tony Albarello/Tom Bernsten. Photograph of Mark Hampton by Priscilla Rattazzi.

1. *Using a huge canvas by André Brasilier and a Welsh dresser as his diverse starting points, Mark Hampton completed this dining room with new furniture. Mahogany Queen Anne–style chairs pull up to a dining table designed by Mr. Hampton. Its red-lacquered linen top is supported by two U-shaped pedestals of oxidized bronze.*
2. *"Red is always good in a small room," says Mr. Hampton, who used it in this library to set off a collection of blue-and-white porcelain. The open armchairs are Empire; the rug is straw.*
3. *In this Chanel-inspired library/dining room a mood was evoked, not copied. The walls are covered with gold Chinese paper; the Napoleon III chairs are in brown velvet. The mirror is French Régence; the commode is also French, with Japanese lacquered panels. The peach, blue, and sable carpet is eighteenth-century Chinese.*
4. *A lover of canopy beds "as long as they don't look thrifty," Mark Hampton installed this one using the classic sunburst pattern for the tester top. The table is Chinese in style; the George III chair is cane with a painted satinwood frame.*
5. *Another canopy bed, this one more tailored. The carpet was designed for the room. The country-French chair is old; the ottoman was made for it.*

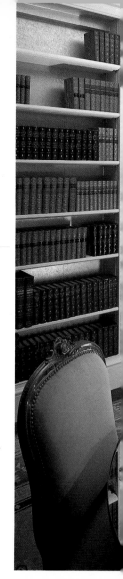

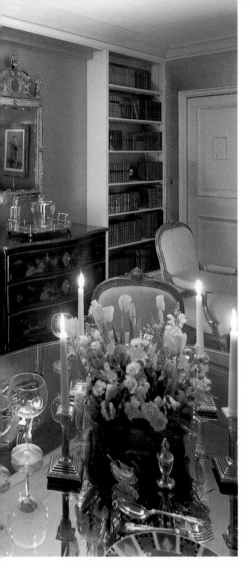

3

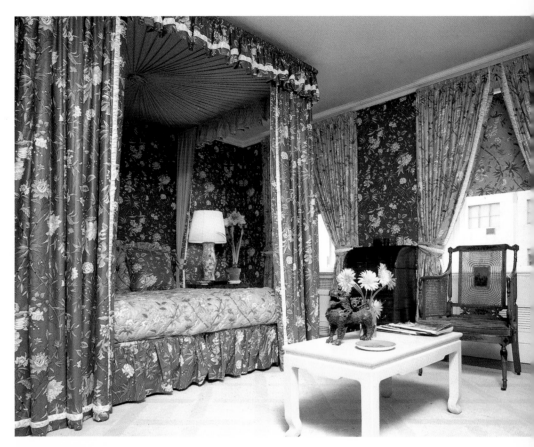

4

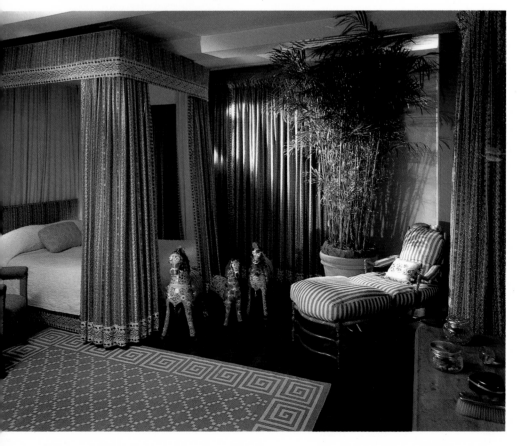

5

Bob Patino and Vincente Wolf

Bob Patino

"The layman tends to fall for complexity because it is impressive. But simplicity usually works better," says Bob Patino and Vincente Wolf. As the nine-year-old design team of Patino-Wolf Associates, they have become known for interiors based on strong, clean lines and symmetry.

These are both qualities associated with architects, but neither designer has had any architectural training. "I have nothing against a formal design education," says Bob Patino. "But unless the student has very strong ideas of his own, there tend to be too many 'don'ts' taught that channel him in a narrow direction and he loses his individuality. The technical side is important, but I think the best way to learn something is by doing it."

Both Mr. Patino, a New Yorker, and Mr. Wolf, a Cuban, learned this way. Bob Patino brings to the partnership the eye of an artist combined with ten years of working in textile and design showrooms. Vincente Wolf provides experience acquired at his father's construction sites in Cuba followed by a series of jobs when he came to America in 1963—"I tried everything from merchandising to fashion design to banking to advertising"—until finally he got into design through a sales job in a showroom.

While they object to many aspects of modern architecture—"Architects too often design with a mind to angles and structure and refuse to consider the function of a room"—they do approach their work in an architectural way.

"We treat space architecturally," says Vincente Wolf. "We don't try to design it with furniture. We deal with space and proportion and how to make a room satisfy all needs. Everything about a room has to function and have a reason for being. We don't do anything on whim, and we don't believe in embellishment for its own sake. We want to start creating a room's atmosphere by perhaps eliminating walls or by building platforms. The furniture is secondary—although it has to be beautifully designed and comfortable."

Bob Patino and Vincente Wolf speak about design with one voice to the extent that asking each the same question invariably elicits the same response. They regard themselves as contemporary designers with a timeless approach. "We love things that are sensual and soft. Leather, for example, is simple, easy to maintain, but romantic and belongs to no period."

Neither designer is pattern-oriented, both preferring to give their interiors visual variety by their use of lighting and textures. "The total environment is much more important than individual things. Nothing should jump out at you. There is always one plan for a room that is better than any other, but we are all subject to change, and so we always try to build in flexibility. That's easier to do if the background is simple and clean than if there is a strong pattern on the walls or floor."

Perhaps because neither man has been schooled in a set of rules, they try to approach each job without preconceived ideas. "We don't accept the idea that something can't be done. We challenge accepted opinions all the time, and a lot of interesting ideas have come out of that. There's nothing irresponsible about it. A good contractor can tell you whether what you plan will stand up, and a licensed architect has to approve and file the final blueprint."

But both Mr. Patino and Mr. Wolf have very strong ideas concerning the client-designer relationship. "Clients should have a realistic idea of how they live and how they want the space to function," says Bob

Vincente Wolf

Patino. "They should have a list of priorities, be objective, and should not be concerned about what other people might think. They are doing this for themselves.

"We can't do our best for them unless we know those things. But once they have given us that information, they must let us take over. We go to see the space with a completely open mind. Usually, we experience an emotional reaction of some kind, and we take that, together with the clients' ideas and the physical dimensions of the space, and try to make them mesh on paper. What we propose might be totally different from what they anticipated, and at this point they have to trust us and open their minds—after all, they've come to us because they can't do it themselves."

The room shown here is completely different physically from the way the clients originally planned it. Part of a house that holds two adults and five children, it was conceived as a family room that opens out onto a swimming pool. The clients came to Patino-Wolf with an architect's plan and asked them to do the interior. "They also asked us what we thought of the plan," says Vincente Wolf. "We told them, honestly, that it was awful.

The fireplace was in a corner and the powder room was in another corner opening directly into the room. It had multiple angles and pitches that had nothing to do with the existing house, and as a finished space we didn't see how it was going to work. The clients were obviously not very happy with it themselves, and we ended up doing the whole thing."

Patino-Wolf designed a very basic, balanced structure in keeping with the whole house. It also makes the most of volume (the pitch of the ceiling is eighteen-feet high) and light (from huge skylights as well as floor-to-ceiling windows). "When the whole family is together we wanted them all to have breathing space," says Bob Patino. The furniture is planned as an accessory to the room, and it also had to be hard-wearing. So the sofas are covered in dark green leather, the floor is carpeted in closely woven wool, and the center table is of slate. Ample storage space is built in around the slate fireplace which is a focal point at one end of the room. Flexibility, too, has been built in: all the furniture is on casters for easy mobility.

"We dealt with it very simply and symmetrically," says Bob Patino. "That's really the way we like to deal with everything—perhaps because we've never been properly schooled."

Color photographs by Norman McGrath.

1. Bob Patino and Vincente Wolf designed this room from the ground up. An extension to an existing house, it leads to a swimming pool and was designed to be comfortable and hard-wearing for a large family and their friends. Architecturally, it is clean and simple with strong visual impact coming from the lines of the slate fireplace at one end of the room and from twin skylights in the ceiling.

2 and 3. Furnishings were kept simple almost to the point of being accessories to the architecture. Everything was made of wear-resistant materials. Leather-covered sofas are grouped into two seating areas around a slate coffee table and cubes. Side chairs are chrome and wicker with leather cushions and armrests.

Carpeting is the tough industrial variety. Although there is a "right" place for everything, groupings had to be flexible, so sofas and tables are on casters. Ample storage space was built in on either side of the fireplace.

45

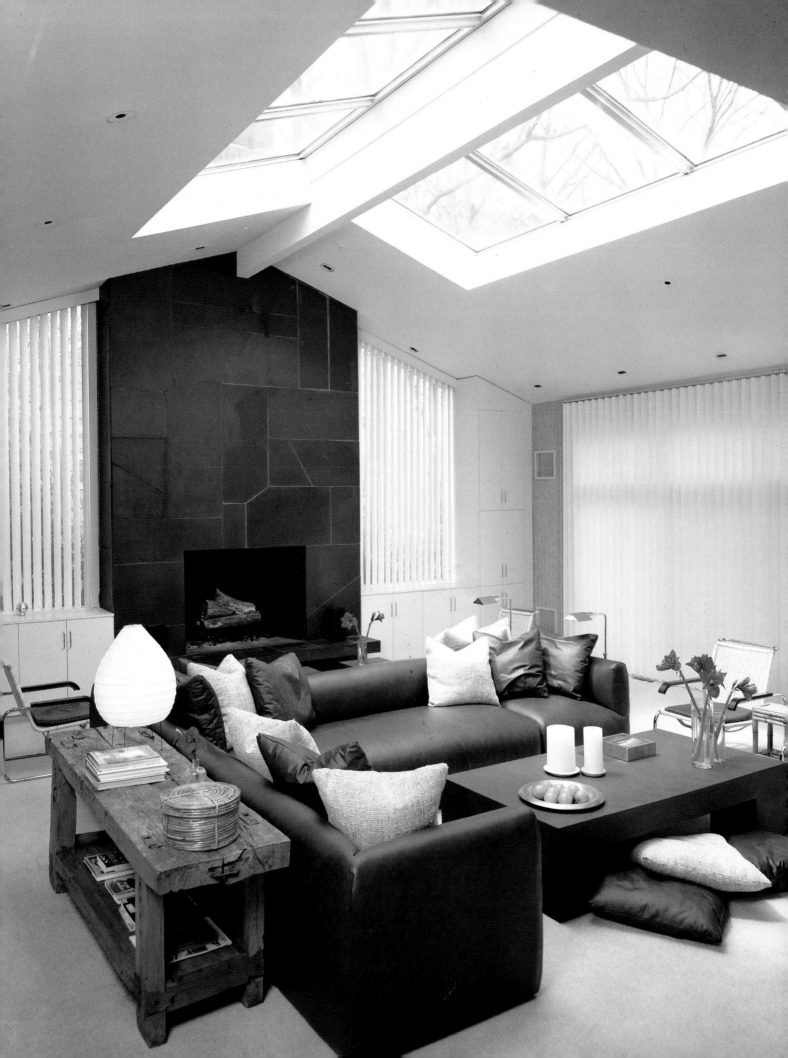

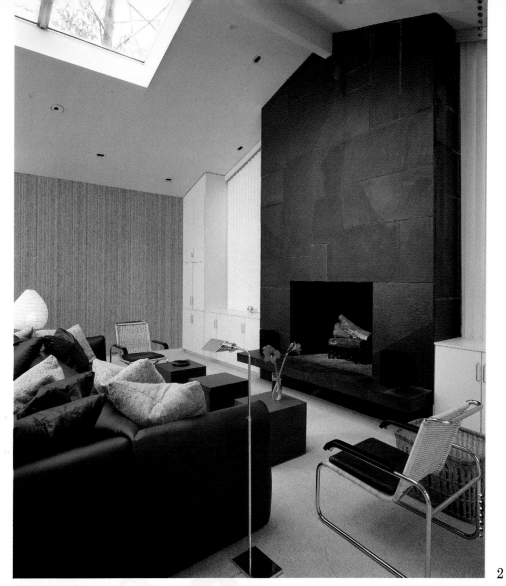

2

3

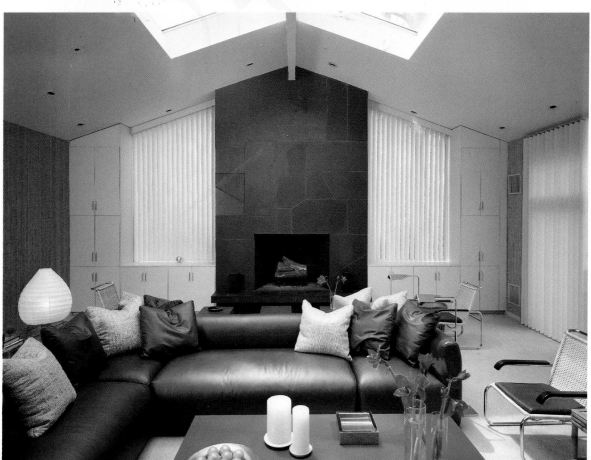

Tessa Kennedy and Michael Sumner

In London in 1965, three separate events took place. Tessa Kennedy's husband, Dominic Elwes, was putting together a book on interior design. Michael Sumner became appalled by the "boring and uninspired reality" of the beautiful drawings he saw in the architect's office where he worked. And David Mlinaric was just starting his own design studio.

Coincidence conspired to combine these three circumstances. At the same time that Mr. Sumner was upbraiding himself for "letting myself be seduced by the quality of drawings rather than that of the buildings they became," he saw an advertisement in *The Times* for a junior assistant in an office in Chelsea. The office was that of David Mlinaric, and Michael, who like David was a graduate of the interior design department of London University's Bartlett School of Architecture, became David's first employee, apart from a secretary.

Shortly thereafter, a visitor at the Elwes house saw some pictures of David Mlinaric's studio that were to be used in Mr. Elwes' book. The visitor wanted to hire Mr. Mlinaric to do his own house. "It would be David's first big job," says Tessa. "But he said he couldn't take it without an assistant, and he couldn't afford one. My husband volunteered me, and I started at five pounds (about $12.50) a week."

The three worked together. Michael Sumner handled all the planning and design functions; David Mlinaric was in charge of decoration, and Tessa, whose salary was doubled after six months, built up her own clientele and rose to become a partner. But in 1969, she and Mr. Sumner branched out on their own. It was simply a matter of economics. "David didn't want to expand, especially not into commercial work, and there just wasn't enough income to pay three salaries."

Kennedy Sumner started their business from Mrs. Kennedy's home with one secretary and one client. Today, they have a roster of clients throughout Europe and the Middle East and a staff of eighteen, including six designers. Though commercial work accounts for the bulk of their business, they still enjoy residential work, and they approach both with the same thorough professionalism. "We have extensive sessions with clients," says Tessa Kennedy. "We're like a computer. The client feeds in the information and we digest it, so that what we produce is what they would really have liked to have done themselves, with the addition of our flair and know-how."

The flair and know-how come from a productive interlocking of different talents. Michael Sumner is the planner and designer of functions. "I'm hopeless at color and texture," he says. "That's Tessa's great strength." The entire staff throw ideas around at the beginning of a project, and then responsibilities are defined. "I really don't think you can work today without tremendous organization," says Mr. Sumner. "Even in a private house, there are going to be times when many different contractors—heating engineers, electricians, carpenters, plasterers, and glaziers—are all going to be involved in the same room. They must all understand exactly what each is doing. The only way to coordinate all this is by doing detailed drawings that each trade can understand."

Ms. Kennedy agrees. "We automatically know what is going to work and what will save money. We draw up complete specifications so no contractor can give us less than we've asked for, and we attend site meetings. Half the time, the layman isn't capable of being at a site meeting and he wouldn't know what to ask if he was there.

"Nor do we change our minds. Laymen do, and builders love that. Even if it's just moving one radiator, the cost can soar, because you're immediately out of the original estimate. We tell a client before any such work starts that once we've gone through all the presentations, he must visualize how the room is going to look and stay with that. Once we start, there will be no changes. Otherwise, prices will escalate."

But the way Kennedy Sumner work, very few clients ask for changes. The "computer" digests its information and a basic plan is evolved. "We start with function," says Michael Sumner. "We could do a boring, cliché sort of decoration and it wouldn't be so bad if the room functioned well. But the most beautiful job of decoration couldn't save a room that functioned badly."

After function and traffic-flow, the design principle and mood is decided, often at a brainstorming session of the staff. Furniture—very often designed in-house—and lighting come next, then color, texture, and fabrics. "We think colorings are the least important thing," says Tessa Kennedy. "Those decisions, for sofas, carpets, and fabrics, come right at the end."

This close involvement with the client and thorough analysis of each design element and its function go a long way to explaining the designers' success. "You can't walk into a house we've done and identify us as

the designers. It's always tied in too closely with the client," says Tessa Kennedy.

And it is, in spite of the fact that many clients are less than perfect. According to Mr. Sumner, they generally fall into one of three categories.

"The first is the single man who is very busy and doesn't notice his surroundings. This kind comes to you for a machine for living that works. It's not that they don't have taste—some of them have excellent art collections—it's just that they don't have the expertise or the energy or the interest to do it themselves.

"The second kind is usually a woman who knows exactly what she wants but doesn't know how to get it. In effect, you are acting as a contractor, not a designer.

"The third kind comes because they've seen a picture of your work and they want to duplicate it as a kind of stage set that would set them up in society perfectly. It would fulfill their image of themselves and how they would like other people to see them. Film stars are the classic examples."

But the owner of the living room shown here did not fit into any of these categories. "He didn't know what he wanted," said Tessa Kennedy. "The only thing he told us was that his wife liked blue." But the house, in the center of London, is one Ms. Kennedy had known about for many years and always wanted to do. "He asked us to do it the way we would like to have it. When we first saw it, it was in terrible condition. The living room is huge, about thirty-five feet by twenty. It was very dark, and the floor above was very badly planned. You had to go through bathrooms to get to both the master bedroom and a guest room.

"The architecture of the living room is so beautiful we decided pale colors would embellish it, and we decided on a classical design in keeping with its architecture. It is very simple."

But its simplicity, like much of Kennedy Sumner's work, hides many intricacies. The moldings, the main architectural feature of the room, had to be restored, and there are in fact four different colors on the walls and ceilings. Banquettes are built to fit but are movable, and complex television and stereo equipment is hidden in two tables.

When in use, the television set rises from a square low table at one end of the room. Other sections conceal a video recorder and storage for tapes. A long table behind a sofa contains tape deck, amplifiers, and tuners. When closed, the doors become indistinguishable from the decorative brass inlays in the lacquered wood.

"We went very softly, not knowing their likes and dislikes," says Tessa Kennedy. "But when it was finished, the client sat in the room and said, 'I never dreamt I'd ever have anything as beautiful as this to live in.'"

Color photographs by Bill McLaughlan.
Photograph of Tessa Kennedy and Michael Sumner by James Mortimer.

1. *This spacious living room in a London house had to have much of its architectural details restored. Once that was accomplished, Tessa Kennedy and Michael Sumner delicately emphasized the elegance of the moldings by gilding details and using four shades of white on walls and ceiling.*
2. *Banquettes at one end of the room are built to fit but are movable. The television set recedes into the low table when not in use. The table also conceals video recording equipment and cassette storage.*
3. *The master bathroom is where the master bedroom used to be. It is fitted with an oversize marble tub and a shower room on one side and dressing room on the other. Two double-sided mirror panels hang from the ceiling over the twin marble washbasins.*
4. *The side of a table running along the back of a sofa in the center of the room opens to disclose stereo equipment—tuners, amplifiers, and tape deck. All the furniture was specially designed by Kennedy Sumner to be practical and classical.*
5. *In another bedroom, mirrors are used on ceiling and vertical wall panels to give a four-poster-bed effect.*

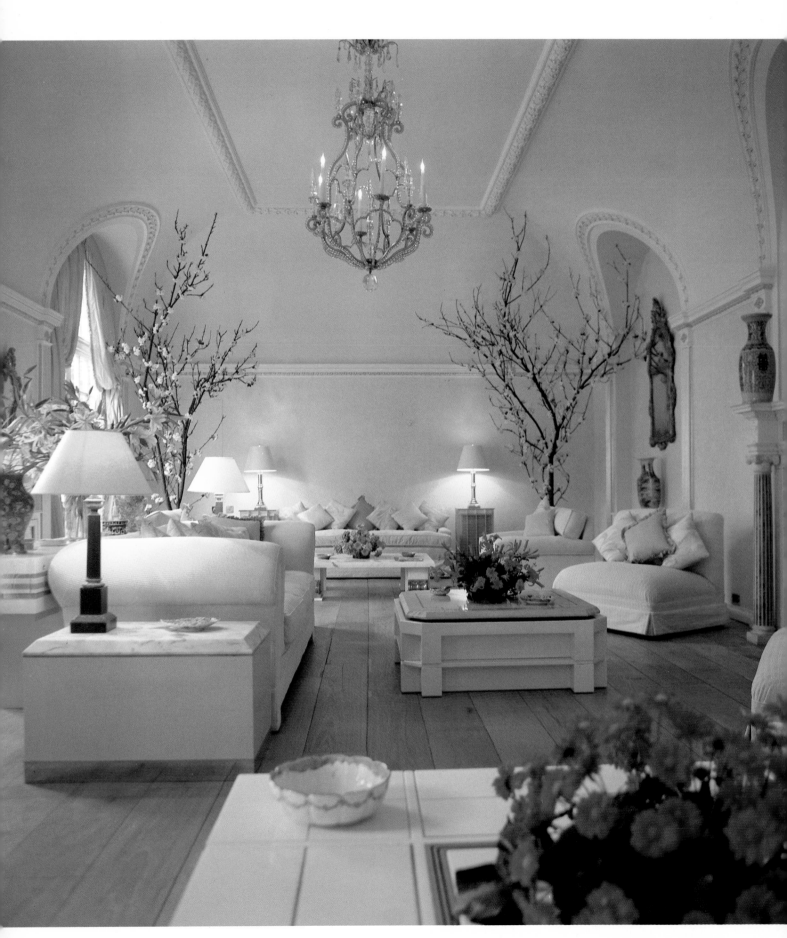

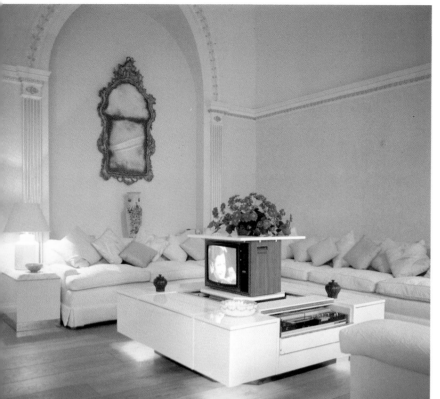

2

3

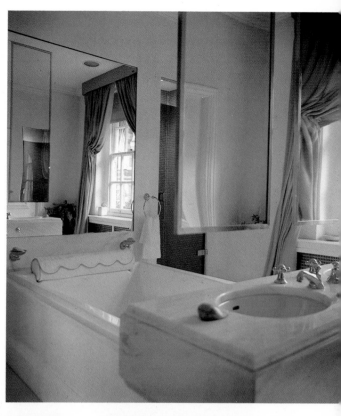

5

4

François Catroux

It has been twelve years since François Catroux, an Algerian-born self-styled playboy, was asked to become an interior designer. Not that the idea was phrased quite so specifically. "I had made quite a nice apartment for myself in Paris and one day a friend brought someone over for a drink. She looked around, said she'd just bought a palace in Milan, and asked me to do it for her." "She" was fashion designer Mila Schon; the palace was to be converted into her showroom. So began the career of the man who is now France's top interior designer.

Both his apartment and Ms. Schon's showroom illustrated the talent that François Catroux quickly became known for—his ability to use slick twentieth-century materials such as metal, plastic, chrome, mirror, and glass and put them together to create a soft, luxurious

elegance rather than a cacophony of hard-edged finishes. The showroom garnered a lot of publicity, and François Catroux was launched in a big way. As he says with a certain self-deprecating charm, "Without study, I was a success from the start. I never had to be flattered by the offer of doing two small rooms."

Not that Mr. Catroux is a dilettante or a snob. He is far from being either. "Doing 'nothing' in my twenties enabled me to travel and observe. I had a small apartment in New York, and most of my friends were artists or architects—Philip Johnson for one. I knew I had talent and a good eye."

Like most architects, François Catroux is preoccupied with space. "It is the most important factor in any interior design. In fact, I won't take a job if I can't control volume and proportions. I'm not interested in taking a badly proportioned space and simply adding furniture and choosing fabrics. Nor do I want to work with a client I don't like. The client-designer relationship is vitally important. We must trust each other. Every design must work for the people who will live in it. One has to find out whether they are married: Are there children? Of what age? Will there be a lot of entertaining? Of what kind? Most of my clients are 'old rich,' though there are some new rich, too."

But Mr. Catroux does not work through a litany of negatives. He is as positive about his likes as his dislikes. "I prefer neutrals set off by black or the gleam of metal. Neutral colors expand space, make it flow and yet unify it at the same time. I don't like primary colors. To me, they are unnecessary and jarring. I take space and make it work for me and my client. The ideal space is in an old building with good proportions and its own sense of charm. I love having that built-in ambience to work around.

"I do some work in the United States, mainly between New York and Palm Beach, but most of my work is still in Europe. There, there is a better chance of a house or apartment having that charm. In America, even the older buildings tend to be on a smaller and simpler scale.

"I like plants used and lit as works of art, and I like working with a client's art collection, though I will often edit it or add to it. Art should never be displayed en masse in a room. Unless you want to live in an art gallery, four or five important pieces are enough for any room.

"I like strong lines, but they must be delicately etched. Everything must have its own symmetry and correct scale, but nothing must overwhelm the eye. I do see Oriental—especially Japanese—undertones in my work, but I use stronger geometrics.

"Also, even though I am known as a modern designer, I love antiques used well. Of course, the old-fashioned styles of decorating are easier to do than the modern—one can go to museums, see what the styles are like, and copy them."

It goes without saying that anyone holding such strong views on what is right and what is wrong is a perfectionist. François Catroux is his own hardest taskmaster. His pursuit of the right scale, the right proportion, the right colorings, the right shape, the right object, has led him to the inescapable conclusion that only if he designs a piece of furniture himself will it be perfect. So he does just that—sketching everything from fireplaces, banquettes, and tables to bathroom cabinets. "When I design them, they work perfectly for their space."

The apartment shown here illustrates Mr. Catroux's dicta. And it even came ready-equipped with the charm of being in an old, elegant building in one of Paris's most fashionable sections. Its owner, a bachelor, handed François Catroux something else he loves— space—in a salon measuring fifteen meters by seven. It was almost too large. The owner loves to entertain—for which a large space is perfect—but there would also be times when he would be on his own—for which it wouldn't. François Catroux's answer was to divide the space into three parts using slatted ebony partitions inlaid with nickel. The screens are strong enough to break up the space into more intimate areas but are unconfining so that the overall proportions of the room are retained.

The color scheme is neutral played off black and the metallic tones of nickel. Geometry and symmetry are everything to the scheme but make their presence felt gently.

The space is unified by sand-colored carpeting used throughout—even in the bedroom where the same design elements are at work. Plants and art objects are carefully but not studiedly placed.

It is a design that has been worked out right down to the last detail, yet it is not over-structured. In short, it fulfills all the Catroux criteria of good design.

Color photographs © R. Guillemot. Connaissance des Arts.

1. *In this Paris apartment, François Catroux divided a huge living area—fifteen meters by seven—into three areas with three slatted ebony floor-to-ceiling screens inlaid with nickel. They give intimacy to the two seating areas at either end of the room without interfering with the overall flow of space. Their evocation of the Orient —in this case Japan—is an element often seen in Catroux's work. The four tables in the foreground can be grouped together or set apart according to need.*
2 and 3. *Another screen separates the master bedroom from its bathroom. The bed is covered in nubbly beige tweed and a fur throw; the ottomans at its foot are covered with brown suede.*
4. *Another screen spans the window wall of the master bathroom. A Catroux-designed free-hanging, four-sided medicine cabinet hangs between the washbasin and the bath beyond.*
5. *The central area of the living room is also its entrance and is occupied only by a black leather Mies van der Rohe chaise. It sets the tone for the entire apartment—neutral tones played off black and metal. The sand-colored carpet is used throughout.*
6. *Chairs and sofas of natural suede and black leather form the second seating area. The vertical lines of the screens are continued in the wide bands of nickel that edge the windows.*

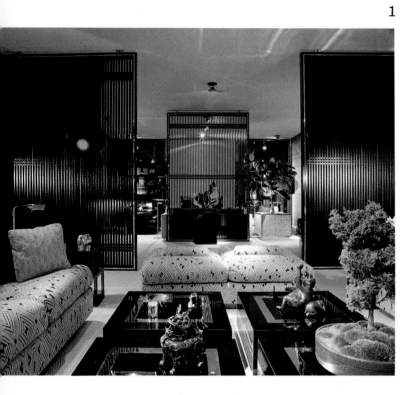

1

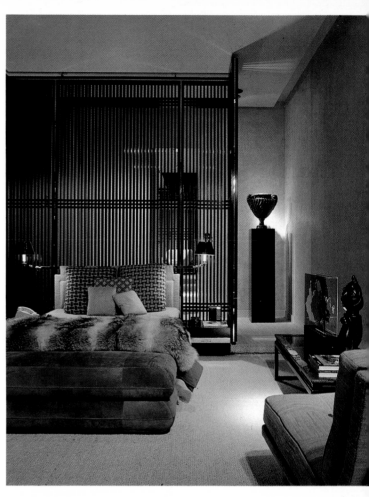

3

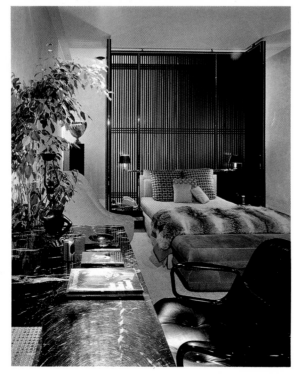

2

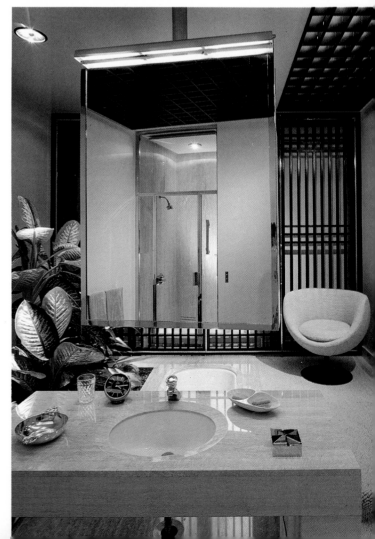

4

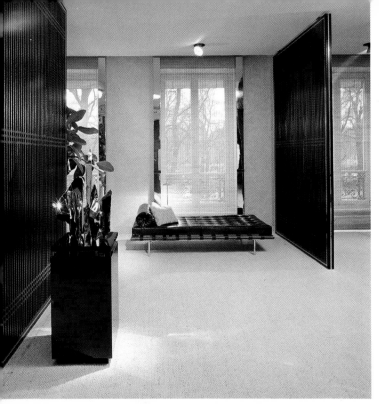

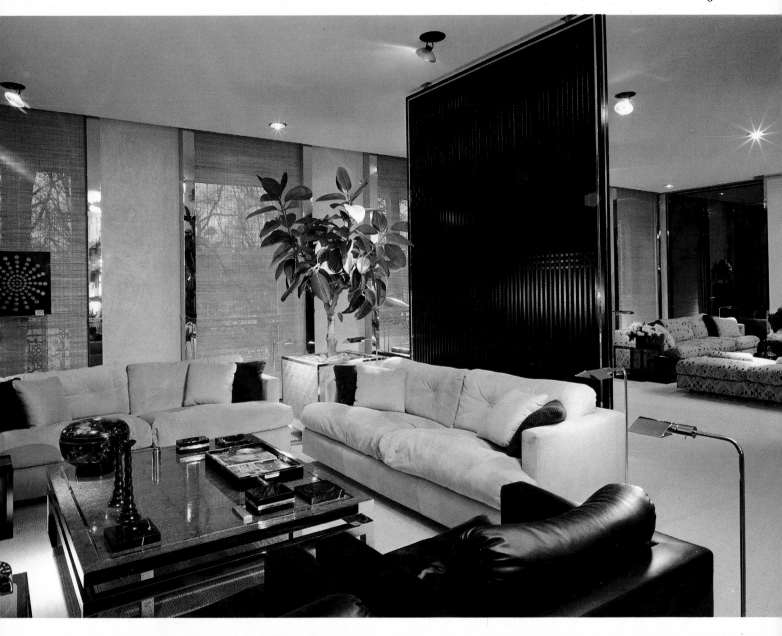

Robert Bray and Michael Schaible

Michael Schaible and Robert Bray

"Minimalism and high-tech are very dangerous labels. They mean very definite things to people," say the design team of Robert Bray and Michael Schaible, who have had both terms attached to their work and resent it. "We don't feel we ever put that tight a parameter on what we do," they protest.

And indeed, while one can see why the labels were applied, one can also see why they shouldn't be allowed to stick. They came to be used, believe Mr. Bray and Mr. Schaible, because when they formed their partnership ten years ago most of their clients were young people with very little money to spend.

Says Michael Schaible, "Bob and I are both interested in space, especially in New York, where it can be very dark, confining, and depressing. We feel that getting a space down to its bare essentials by doing whatever architectural changes may be necessary to make it work and be beautiful is the first and most important step in any interior design. The furniture and art can all come later as the client's budget allows.

"People didn't seem to realize that most of our early work was far from finished; that there had been just enough money to get it to the point where every-

thing offensive had been removed. We were creating only the very basic environment from which to build."

Not that Bray & Schaible designs would have been dramatically different had their clients had more money. Both firmly believe that a stripped-down environment is the one that gives the client the greatest freedom of choice. Says Bob Bray, "If a client falls in love with a painting, the type of environment we provide means that he or she can get it and there will be a place for it, no matter what its period or colorings. We haven't introduced, let's say, a sofa fabric that's so powerful you can't hang anything over it."

Though they came to interior design via very different routes—Bob Bray is an architectural engineer, Michael Schaible has a degree in fine art—they both studied at the Parsons School of Design, and their attitude toward design has always been identical. But it has not remained the same over the years. Their work has, as Mr. Bray puts it, "gradually evolved into a sudden change.

"For a long time it was very academic, and we were very conscious of our training. There was no frivolity at all in our early work. We wanted the academic creden-

tials and jargon standing right at our backs ready to use in our defense when we presented a design.

"People forget that when a designer first starts out, he's usually terrified. Talk to anyone in his first year in business about his daily problems. There's a great deal of pressure. And we are all egomaniacs in the sense that we want every job to be *the* job. But what happens, thank goodness, over a period of years is that you relax and stop worrying about what your peers are going to think. Then you start doing what you believe in—and your work gets better.

"We've now reached the stage where we have our own confidence and identity, and we're starting to break out from the rules we set for ourselves and have more fun. We're taking a few chances and getting more emotional in our work.

"Also, you're seeing more art and antiques in our interiors. We've never had anything against them, but they are starting to show up now mainly because we're starting to get clients who have more money to spend or who already have some beautiful things."

One of the things that hasn't changed about their work is their primary concern with space. "It would be nice to walk into a room and see the windows in the right place and a wonderful view," says Michael Schaible. "But usually that's not the case. You say, 'God, that end of the room is dark! And look at that window—it cuts up the view and could be bigger. And this space could be opened up.' I can't imagine us ever not insisting on getting the ugly, the offensive, out of a space before we put anything in."

As their clients become more affluent, what goes into the space becomes more important. The basic requirements, say Bray & Schaible, are the same for everyone. The "feeling" for what goes in comes from each client's individual quirks. Says Bob Bray, "You can learn a lot from walking through where the clients are living when they come to you—what's on the bookshelves; what's in the closets. You get a sense of how they see themselves. Obviously, we ask them directly what they like and dislike, but we take the dislikes with a grain of salt. I've had people say they hate something but fall in love with it if it's presented to them in a different context."

Just as Bray & Schaible are working with more objects in their interiors now, so they are starting to deal with color for the first time. "Color is a funny word," says Mr. Bray. "I see a lot of color in white. At one point we handled 'colored' color in a completely transient way—just by introducing flowers. Now we are starting to use it less transiently in art and objects, but it hasn't got to the heavyweight architecture yet. It's very difficult for us to put it into a room and call it permanent."

The apartment shown here, a tiny studio belonging to Mr. Bray, was designed to be a starting point, but it has not had other elements introduced. "When I started living in it," says Bob Bray, "I came to feel that there shouldn't be anything more in the room. It's not that I don't like art, I just don't think it's necessary in this case. I think the walls are beautiful—more beautiful than any paintings I might put on them. But if I wanted to, anything I chose would work."

As it is, the apartment makes the point Bray & Schaible want to stress: "We are not saying people should live without things all the time. We *are* saying, 'We have given you what you need to start with.' "

Color photographs by Jaime Ardiles-Arce.
Photograph of Michael Schaible and Robert Bray by Steve Shadley.

1. *The living, sleeping, working, and dining areas of this tiny studio apartment are defined by platforms at different levels, all covered with industrial carpeting. The highest level is flush with the bottom of the windows so that the view expands the space. The beach chairs are of tubular steel and woven plastic.*
2. *In a space as small as this, everything has to be dual-purpose. The bed, with its black channel-quilted canvas cover, doubles as extra seating. The black Colorlith laboratory counter top is for working and dining. The kitchen is behind the rear partition.*
3. *With their preoccupation with "making space beautiful," Bob Bray and Michael Schaible painted walls and ceiling high-gloss white and framed the windows as if the views were works of art. Paintings could be introduced if wanted, but Bob Bray, who lives here, thinks the walls are beautiful in themselves. The only "formal" seat is a gray suede Le Corbusier chair.*

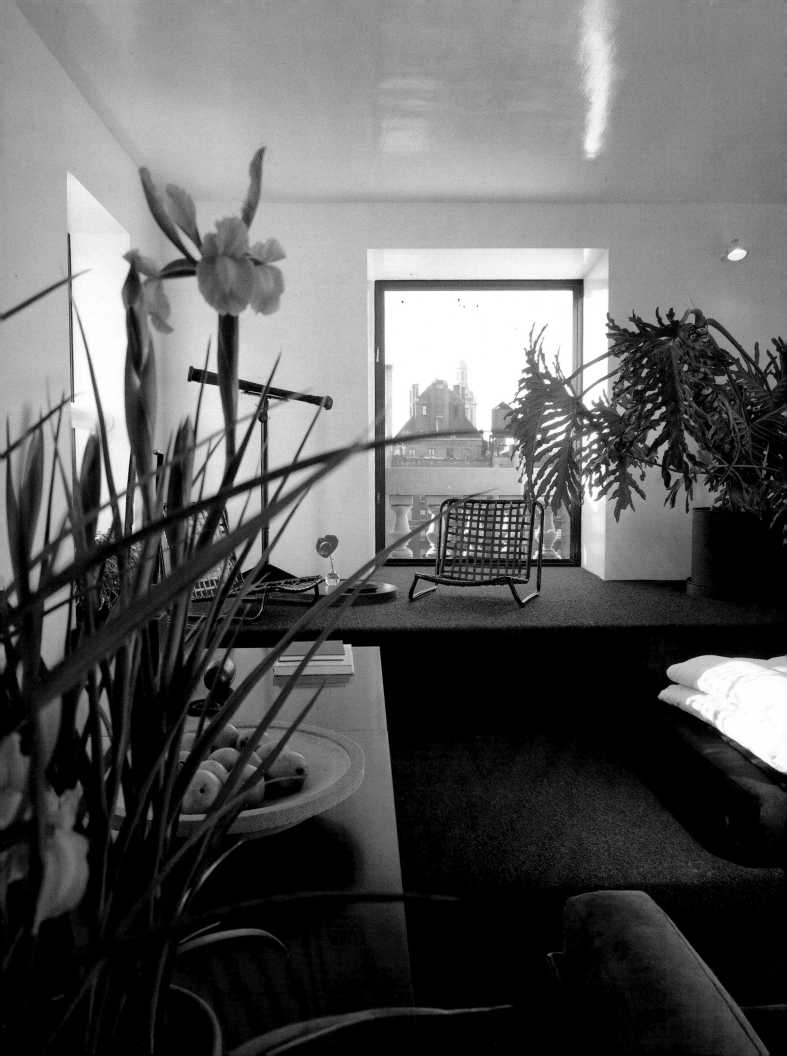

2 3

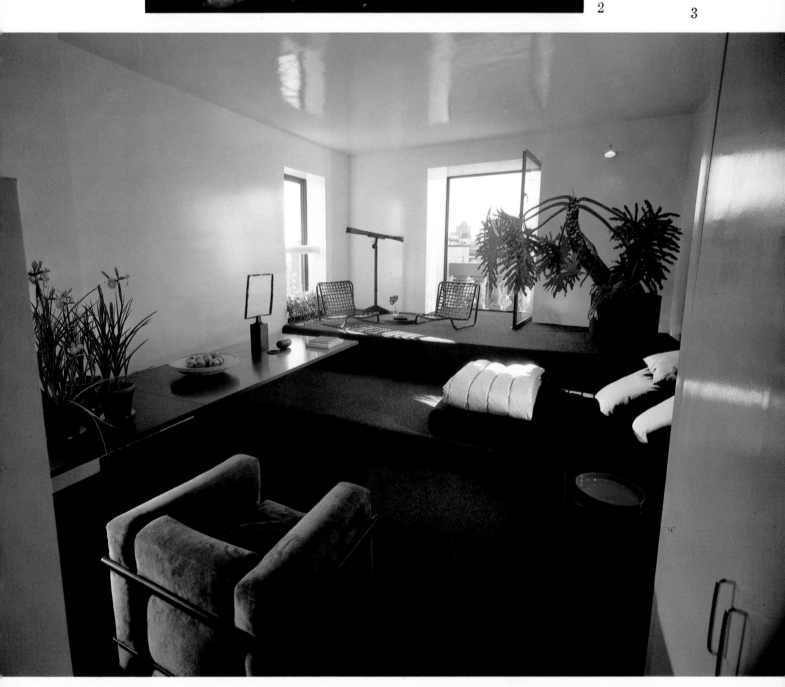

Mario Buatta

Mario Buatta is an unabashed romantic. For as long as he can remember, he has had a passion for beauty and a love of nature. "Our world is harsh, and tough and ugly at times," he says. "Coming into your home should be like walking into a magic garden discovered in the middle of a cold, gray forest." The fact that no one creates these magic gardens better than Mr. Buatta has made him one of the most successful interior designers in America.

The garden analogy extends beyond the soft colors and floral chintzes Mr. Buatta loves to use. He thinks of a room and its furnishings as a living, breathing entity, always changing. "You should never say a room is finished. Once you do that, there's no chance for it to go beyond that point. It dies. A room should grow and change as the person who lives in it grows and changes.

I have to stop, of course, and I can do that at any point after the basics, the bones of a room are in place."

When Mario Buatta says he stops, it usually means just for the time being. Many of his clients are still with him seventeen years after he started his own business, and each year they ask him to do a little more. These clients he loves. "They are like me. They recognize that decorating is a lifetime experience. They realize that the right painting or the right table might not be found for years, and they will wait. Or, when we're talking about art or antiques, they are people who want to improve their collections. They'll have something that they're happy with now, but they'll say, 'If you find something better next year and it's in the budget, get it.'"

Budgets. A Mario Buatta interior looks expensive and it is. But there is a strongly practical side to Mr. Buatta. He makes no bones about the fact that a living room can easily cost $35,000, but he insists that that is reasonable and suggests that people who doubt it should do an honest costing of their present furnishings—including the ones that proved to be mistakes. "That's not $35,000 overnight," he stresses. "It includes furniture the client may already have and some antiques and art—all investments that can be converted back into cash.

"If a client has no furniture and $10,000 to spend on that same room, I suggest we buy the best we can with that amount. Let's do the best paint job because that will last ten years. Let's buy the best upholstery because that will last too. Both those items are investments in quality. Investing the client's money, not just spending it, is my prime concern. What's left of the budget would go on inexpensive but well-designed and attractive tables and lamps. Then, over the following years, as money allowed, we'd better these surroundings."

Actually, Mario Buatta works this way whatever the budget. "Even if they have the money, most people don't want an accessorized living room overnight. They want to ease their way into a room or house and see how they like living in it with the major pieces. Then, when they've worked out the arrangement that suits them best, that's the time to add occasional tables, chests, mirrors—the pure decoration—always remembering that what you're looking for is lasting quality."

Mario Buatta's natural preference is obviously for the antique, for that comes with the guarantee that his standards will be met. And he prefers a nineteenth-century reproduction of an eighteenth-century piece to a

modern one: "The older reproduction has more patina and charm than the one made today." He will use contemporary pieces: "No one today has the budget to furnish a room entirely with antiques." But he will not use modern glass and brass and plastic furniture: "It doesn't age well; it just gets tired."

His natural bent has always been toward the eighteenth century. It was set when he went to study in Europe after learning (during a year as an architecture student) that he didn't really care how houses stood up as long as they did and were beautiful.

"I grew up on Staten Island, and Europe was an eye-opener and an education. When I got to Italy and saw the villas, especially the Palladian ones, and the vastness of their interior spaces and then went to England and saw what the English could do with the same kind of architecture, I really found myself.

"But I don't like being labeled a traditional decorator. I think in terms of decorating in the traditional way for people who are living in the 1980s. My work is contemporary—not modern, that's something else—in that it is practical and realistic for the way we live today. It is not a study of the past."

Rather, it is a study of the client, coupled with instinct. "Usually, I can tell exactly where things should go the minute I walk into a room. And I've learned to trust my instinct. My first idea is usually the best. But I also have to know what the client has in mind and we must see eye to eye. We are going to be practically living together over a period of years and I'm going to be like the family doctor. I'm going to get to know everything about you—and a bit more.

"I get along with most people, but I can't stand working with people who can't make up their minds. The most damaging thing to any client-decorator relationship is indecision. It kills everything."

But Mr. Buatta is always open to suggestion. He is, as he says himself, adaptable. Floor plans are drawn up, discussed, and decided on according to focal points, traffic patterns, and what's good for the room architecturally.

Color plans—"the most personal part of any scheme" —are put on paper so that the client can visualize what it will be like to walk into the house and progress from one room to the next. "All the colors should be pleasing. When you look from one room to another you should get the sense of being pulled steadily onward. The colors should not all look alike, but there should never be a jarring transition."

As so many interior designers do, Mario Buatta credits his eye for color (like every aspect of design, this is a trained, not a natural talent, he believes) to John Fowler. "Getting to know him in England was certainly the greatest single influence on my work." Like Fowler's, Mario Buatta's style is understated. In his interiors everything looks comfortable, relaxed, and, however new it may be, as though it has been there forever.

"Making a room look undecorated may seem the most natural thing in the world," Mr. Buatta says. "But achieving that effect happens to be very difficult. Elegance and simplicity are not easy things to create. They must be striven for."

Color photographs by Ralph Bogertman, Charles Weisehahn, and Richard Champion.
Photograph of Mario Buatta by Chris Barounis.

When he finds something he loves, Mario Buatta stays with it. He used the same blue-and-white floral chintz in the living room of his present apartment (1) as he did in his previous one. (2). He is an incurable collector of, among other things, paintings of dogs and blue-and-white porcelain.

3. In a sitting room, a mélange of patterns and shapes are brought under control by deep-green crisscross lacquered walls. The floor was bleached, and the tulip-patterned carpet is French. The black painted and lacquered English Penwork cabinet dates to about 1820. The mirror above the fireplace is eighteenth-century Italian, and the red lacquered bureau/bookcase is Queen Anne.

4. Mr. Buatta uses a more delicate combination of colors in a bedroom. The Swiss tambour curtains of the canopy bed are lined with a small red-and-white print chintz. Walls are apple green. All the colors are brought together in a botanical chintz used for curtains and headboard.

5. When Mr. Buatta first saw this oval living room it was painted blue. "The owner already had the collection of blue-and-white porcelain, but the room looked cold." Soft apricot warmed and softened the appearance of the room. Blue and white was chosen for the upholstered furniture so that the porcelain collection became an integral part of the room.

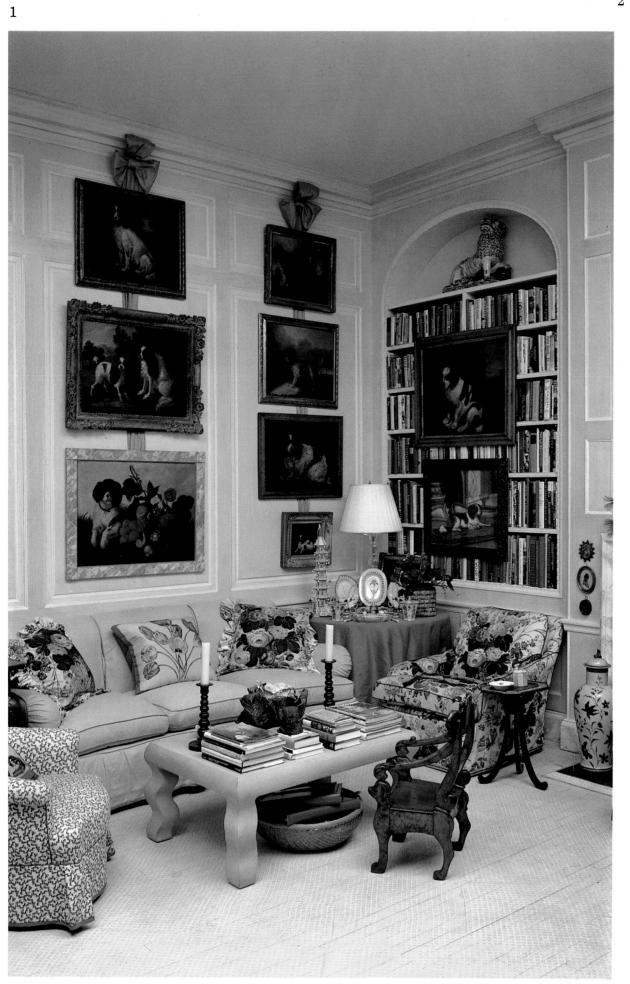

3

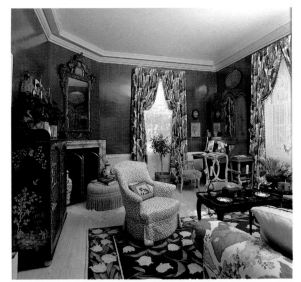

4

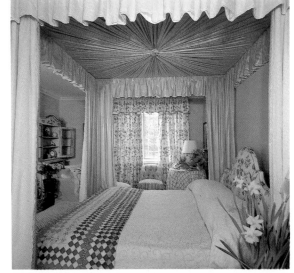

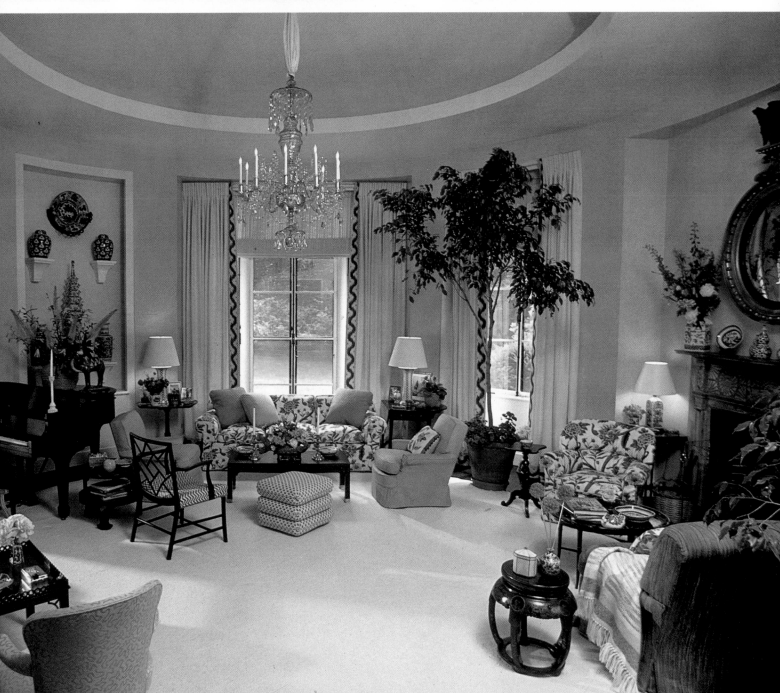

5

Earl Burns Combs

Earl Burns Combs is one of a new but increasing breed of American architects who do not scorn interior design. Perhaps that's because he became an architect almost by accident. As a liberal arts student at Cornell University he drew cartoons and illustrations for the college newspaper. The art director was an architecture student, and when Mr. Combs delivered his drawings to him in the architecture department, he was impressed by the way everyone there "seemed to live a relaxed, bohemian life style. It looked like a lot more fun than what I was doing."

So he transferred, and it was fun, even when he made the discovery that "the flash of intuition and creativity is generally the smallest part of a design. Ninety percent of it is hard work, checking details and products to make an idea work. But it's worth it for that ten percent at the beginning."

Now he has his own architectural practice in New York, and though he often does interiors in buildings designed by someone else, he concentrates on designing both the space and what goes in it. "When I do a house I always want to do the furnishings—they are part of the whole. It can be heartbreaking to see the wrong furnishings put in by someone else. Interiors are a very intense and personal kind of architecture. You must have a strong rapport with the people you're working for, and they must contribute. I must understand them, and what I do should suit their life style. But I also hope that the client's life style will evolve and change because of new ideas I contribute.

"I like a client to give me the limitation of setting down what they want. I then work out what is consistent with that, but for it to be stimulating and exhilarating, the final design should also gently push the client in a new direction. I don't mean that arrogantly, but we should both grow."

The desires of the client form the strongest limitations when Mr. Combs designs a house from the ground up. When he works within an existing space, however, that structure imposes its own limitations. He believes in organization to overcome these. "I measure everything and draw plans so I can see the whole space as it is, warts and all. Then I take a few rolls of film of the client and how he is living now. I absorb both those facets before I make any proposals. Then I try to correct the space as much as possible and bring it into balance. I believe in balance and logic. There's always a point," continues Mr.

Combs, "when spaces begin to mold themselves and require certain solutions of their own. I only make one floor plan to show the client. I think in every blank space there is a scheme that is right for the existing conditions, not several alternatives. Of course, modifications do occur, but they're refinements of details."

Mr. Combs is one designer who admits to both architectural purity and a sense of fun in his work. His architectural training shows in his love of axial relationships and balance, but he acknowledges that "while there ought to be a place where each thing intrinsically belongs, you're not looking only to solve problems. Any scheme should be stimulating and have a playful quality of some sort somewhere.

"While we're working on space, I think in black and white. I never think of color in a surface way; it has to spring from what's going on spatially. So do the right textures and the materials to use. They come from the basic plan but then exert their own influence."

This coming together of many elements is the most difficult design process to describe. Indeed, it almost defies description. Earl Burns Combs' definition is among the best: "It's like sculpture—you start with a blob that you gradually bring into focus until finally you see every surface and every texture. But the surfaces and textures come after you've done all the thinking and the work on the masses and spaces." In applying these thought processes to a fairly standard, box-like, two-bedroom apartment, Mr. Combs illustrates what he means.

Originally, a long, narrow living area was flanked by an enclosed kitchen and tiny breakfast area. Two bedrooms were small, and no room related to any other. There were good views but no vistas. The first thing Mr. Combs did was take down some walls so that rooms flowed into each other. "The owner is a bachelor, and when he entertains he doesn't want to be shut away in the kitchen. So I took down the wall between it and the living room. Immediately it opened up the width of the living area.

"Then I knocked a hole between the kitchen and the study/bedroom. This means that from the living room you now get the benefit of the view from the study windows as well as from the kitchen window and the living room's own windows. The effect is to virtually triple the size of the living room. One end of the living area became a dining room, and it was given its own importance by elevating it on a platform.

Color photographs by Michael Dunne.
Photograph of Earl Burns Combs by Delilah McKavish.

1. *In a long, narrow living-dining room typical of many modern high-rise apartments, Earl Burns Combs built a platform to set off the dining area. The platform not only defines the space, it also widens it visually. The mirrored back wall reflects the view from windows at the end of the living area.*
2. *Because the owner is a bachelor and wanted to be able to talk to his guests as he cooked, the wall between kitchen and living room was removed. It also made two previously narrow rooms into one spacious area.*
3. *The kitchen, with its sleek black cabinets and stainless-steel fixtures, is functional but elegant. A Parsons table and two stools make a breakfast area next to the window.*
4. *So that the client's collection of paintings would have additional impact, the color scheme throughout the apartment was kept deliberately monochromatic.*
5. *The bed was originally meant to float in the center of the room. On the floor plan this worked. In practice, it gave its occupant a view of other people's terraces, so it was moved back against a wall.*

Efficiently placed storage consists of built-in fixtures all of which can be taken apart and moved to different surroundings. "Too many people think this kind of design is limiting," says Mr. Combs. "But it needn't be if it is thought about ahead of time and if you don't let your ideas become rigid."

Mr. Combs is acutely aware of the pitfalls of dogma in design. "When I was at Cornell, symmetry and Beaux-Arts were dirty words. Everything was asymmetric and 'dynamic' and we were all under the influence of that. But I was never completely happy with it. Luckily, I won a Fulbright and spent a year in Italy. I just drank it all in. There is a richness in the history of architecture and design that should not be ignored."

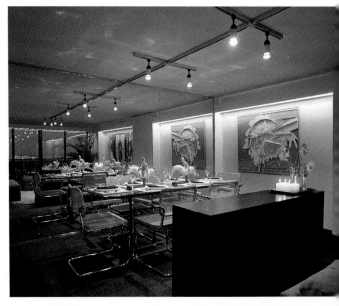

1

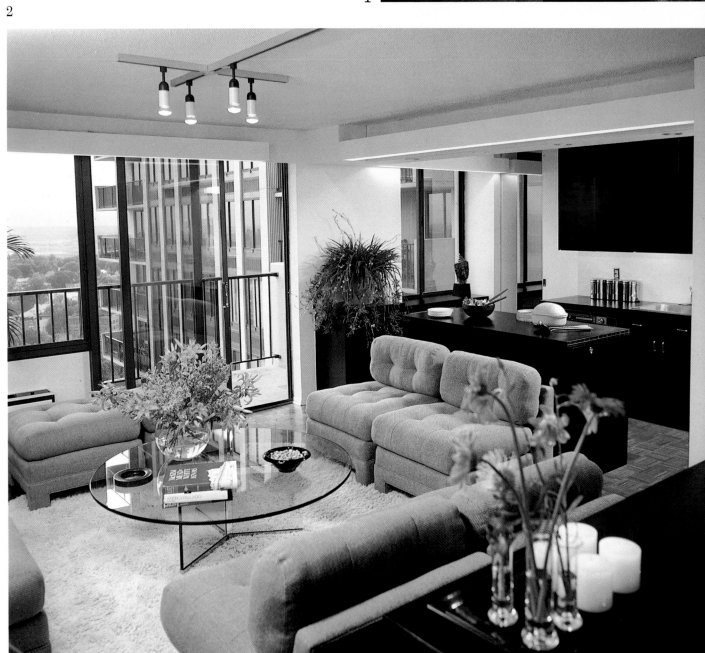

2

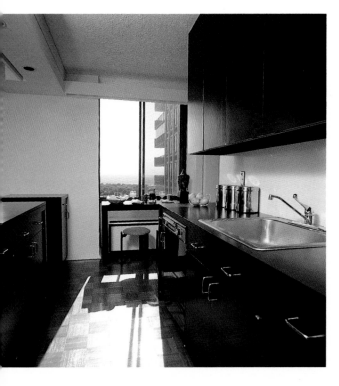

3

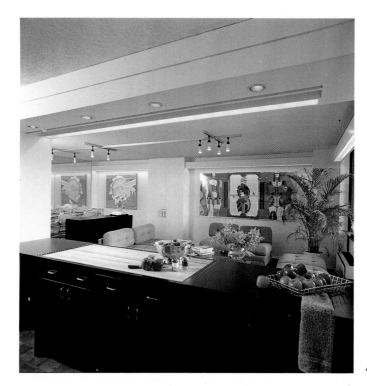

4

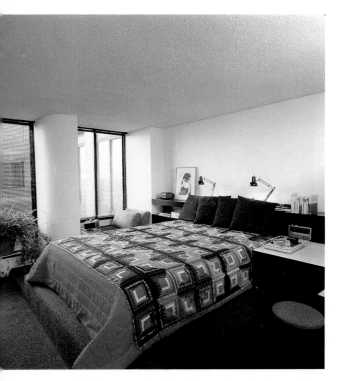

5

Georgina Fairholme

It is perhaps inevitable that the name of the English decorator John Fowler crops up throughout this book. For more than fifty years, until his death in 1977, he was the leading exponent of the English-country-house style. But he was more. His eye for color was legendary and his capacity for teaching enormous. Almost every designer in this book, working in whatever idiom, admits a debt to John Fowler, and none more than Georgina Fairholme, who worked closely with him for seven years.

If anyone can be said to be continuing the Fowler tradition—but in her own way—it is Ms. Fairholme, who has worked and lived in the United States for the last nine years. Like John Fowler, she has a scholar's knowledge of period furniture and houses and how people lived in them historically. Also like Fowler, she works as much by instinct as by training and attaches great importance to the use of color.

"If there's any art to this job," she says, "it's finding the colors that a client really likes, which are good for them and will make them happy. Many people never really think about color, and it's very interesting to see how they react when you show them what you think will suit them. I have a client who is very pale, and I've colored a lot of her house a soft coral. It works wonders for her. Somehow it brings her out."

But it's not just a question of finding the color that suits the client—it also has to suit the room. "Light affects color so much. In New York, even on a gray day, the light is so much clearer than it is in London, so you can use stronger colors—but not as strong as in California, where the light is brighter still."

Georgina Fairholme uses color delicately but definitely, as it was used in the eighteenth century. "You've got to remember," she says, "that the colors we see in old houses have been there for years and years and have faded. Most people evoking the old use too-smudgy colors. What people call Adam green—a saggy, rather dreary green—originally was quite a punchy color, and the yellow they used was enormously strong."

Ms. Fairholme feels that her color sense is something she was born with—"There are a lot of painters on my mother's side of the family"—but her sure eye for furniture placement and her insight into her clients minds have come from training. She worked in an antique shop before going to Colefax & Fowler, John Fowler's design firm in London. "They weren't just jobs. I really wanted to learn everything about houses and

what goes into them. I don't think I did it for any 'good' reason. I just knew it was what I wanted to do. In the first interview I had with John Fowler he asked me why on earth I wanted to do this kind of thing. I said I loved houses and fabrics, and he said he supposed that was a good enough reason.

"It's a very difficult job because there are so many aspects to it—knowledge of architecture, cabinetry, how sofas and curtains are made, the whole business side, and the psychological aspect of understanding the client.

"The client is the most important element in interior design. A successful job does not impose the designer's opinions. I shape my concept around the client and then around the house. Even if the clients think they don't know what they want, somewhere at the back of their minds they all really do have some ideas, and you have to pull those out of them—even if it's just to the extent of discovering that they hate blue. I always take clients into the marketplace and make them pick out things and colors they like—not necessarily to buy but just to get the idea of which direction I should go in."

Any room Ms. Fairholme does evolves from color—

"That's what I always think of first"; from what the client already has—"Even a young couple will have a rug or something that a mother-in-law has given them"; and from the client's needs—"How many people do they want to seat in a room? Will it be a family room or formal?"

Then comes the drawing board where the floor plan and basic architectural changes are mapped out. "So many rooms today lack architectural details, and I like to put them in where I can. Cornices and chair rails can make so much difference to an undistinguished room that even if you then just painted it white from top to bottom it would look much better. Moldings and so on are expensive, but a ribbon or wallpaper border can be substituted for very little money."

The plan serves only as the most basic of guidelines. "The right proportions in furnishings are very important. But there are no rules of thumb. Something can be over-scaled technically but still work when you put it in a room. So I experiment with things.

"I don't like the 'instant decorating' kind of look—moving everything in one one day, hanging the pictures, and having everything suddenly there. It should be a much slower process. The right pictures and the right mirrors are the final touches."

The project shown here was a designer's dream when Ms. Fairholme (then in partnership with Harrison Cultra) started work on it. The house is one of the most important town houses on the Eastern seaboard both in terms of its architecture and its siting. Also, the client had excellent taste and a good collection of English and American furniture. The brief was to make the house comfortable to live and entertain in.

"Since the furniture already existed, it was really a question of providing a background for his collections and putting everything together," says Ms. Fairholme. That meant color. The whole house had been painted in a sad mushroom-beige. "I was very aware of the 'period' of the house, which is pseudo-Georgian, and colored it accordingly. I used to see the client come to see the work as it progressed, and his whole face would light up as the colors brought each room to life."

Most jobs do not come complete with exciting architecture and a knowledgeable client. But Ms. Fairholme feels that more and more people are becoming aware of what's good and what's bad—and that part of her job is to encourage that awareness.

"I always hope that what I do will guide people. It's very exciting for me when I've started a young couple off and they come back with a picture they've bought and say, 'We thought this would go there' and they're right. That's wonderful."

Color photographs by Norman McGrath.
Photograph of Georgina Fairholme by Bill Stone Photography.

1. *The fireplace in the dining room of this town house was "hideous." A black marble one with bolection moldings replaces it. The severity of the tiled floor is relieved by the deep melon color of the walls.*
2. *Georgina Fairholme made a canopy bed that once belonged to fashion designer Norman Norell into the focal point of this small bedroom. The bed is hung with painted silk curtains that pick up the color of the carpet—a sharper than usual celery. A small French dressing table stands between the windows.*
3. *A French trumeau mirror dominates a small upstairs sitting room. The Charleston Chippendale sofa is covered in red damask. The curtains are silk taffeta, elaborately styled.*
4. *No attempt was made to prevent the English paneling in the library from being the main point of interest. Comfortable armchairs and a sofa are covered in beige silk.*
5. *The entrance hall has the same tiled floor as the dining room. The mirror is English in the Adam style; the green tole hanging lantern is also English.*
6. *The drawing room lacked sufficient architectural details for its size, so curtains in the grand English manner were used to "give the room more body." Soft blue striéed walls set off a magnificent late-eighteenth-century English needlepoint rug.*

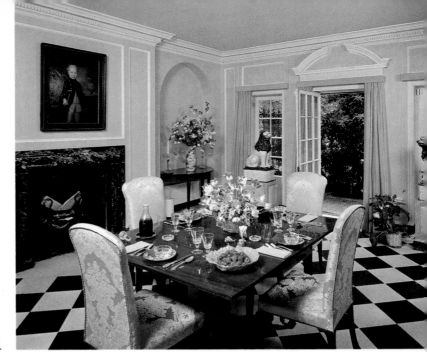

1

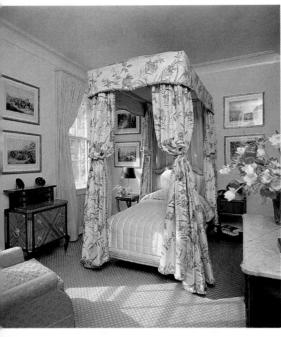

2

3

Angelo Donghia

At the age of forty-five, Angelo Donghia is unique in the world of American interior design. While most designers find their work with private clients all-consuming, he has successfully embraced almost every aspect of the design business and even achieved the impossible: he has moved into the mass market without lowering his reputation in the eyes of his private clients.

Today, in addition to his interior design company, Angelo Donghia has four other distinct corporate entities: a fabric company, a furniture company, a licensing company, and an ever-growing collection of showrooms throughout the country. In all, he employs eighty people.

At the age of ten, Angelo Donghia was growing up in the small mining town of Vandergrift, Pennsylvania, aware that he didn't want to follow in his tailor-father's footsteps and that he liked making things more attractive. According to Mr. Donghia, nothing has changed. "I'm really doing the same as I was then," he says. "Except now I'm doing it in the big wide world. I've always wanted to do things. In high school I was the president of five different organizations at once. I was always very busy, and I love getting lots of people involved. Strangely enough, I didn't do any of that at college; I was very quiet."

College was three semesters at the University of Miami followed by three years at Parsons School of Design. From the day he graduated, his life has followed a logical progression of one success after another. "At the end of 1959, I decided to apply for jobs. I had three designers on my list: Michael Greer, Yale Burge, and Billy Baldwin. For no particular reason, Yale's name was first so I called him first and he hired me. I asked for one hundred dollars a week. He said, 'You'll take seventy-five,' and I said, 'You're right.'" It was an association that ended only with Mr. Burge's death in 1971.

Angelo Donghia became an associate of the company in 1962, a vice president in 1964, and in 1966, when he was made a partner, the company became Burge-Donghia. "By 1968," says Mr. Donghia, "I was running the decorating business and designing rugs and fabrics and some furniture for specific jobs. Yale had a furniture business separate from our partnership, and he decided I should have one too. So we created & Vice Versa, a fabric company, for me.

"I needed furniture on which to display my fabrics, so I used the pieces I had designed for customers. The fabric company became successful, but I felt I could do more. So I started selling the furniture through the same outlets.

"Then Yale died. I continued the decorating business as well as the fabric and furniture companies, but I noticed I was being 'knocked off' by the large furniture and fabric companies. I decided it might be a good idea to do my own 'knock-offs' of my own designs, and that's when I entered the mass market." To work with the manufacturers involved, the licensing department was formed in 1973.

Mr. Donghia's network of showrooms grew from his dissatisfaction with the way his custom fabrics and furniture were being represented on the West Coast. "They were pushing me off into a corner and not supporting me. So, to protect my designs, I looked around for my own small showroom space." In doing that, he discovered that he wasn't the only designer who was unhappy with his representation. This persuaded him to buy a large Los Angeles showroom, where he now represents twenty-seven companies. Its success led him to open others in Troy, Michigan; Chicago, and Miami.

The story of Angelo Donghia's career may sound too cool, calm, and collected to be true. But for those who know Angelo Donghia, it's hard to imagine it otherwise. A man of calm assurance, he also has a creative, versatile, quick mind, and he realized early on the im-

portance of having a cool, hard business head as well.

"It's very easy to be creative in the design business," he says, "but it's very difficult to make money. As a designer, your expertise is in pretty colorings and gracious living, not in dealing with other people's money. But you have to do that too. So you might as well make them work together.

"I was brought up by a father who was a terrific businessman. I was exposed to the constant effort needed to make any business grow. Then Yale Burge gave me the best possible training in our particular business.

"But I think the main reason I succeeded has been that I was never afraid to fail. If I fail, I know one thing: I am very talented with my hands. If all this goes out the window, I'll never starve. If you reduce everything to the necessities of life—being able to feed and protect yourself—I'll always be able to do that.

"I never take success for granted, and I don't do things for success. At the same time, I'm not going to do things that cause failure. I'm going to work hard and follow all the rules that make one successful—establish a good credit rating, make choices that appeal to people, gather a staff that supports me, not suppresses me. And I believe very much in integrity and in keeping agreements."

These are not the kind of words one hears often from an interior designer—or from any creative person—as the reason for his success. And Angelo Donghia is creative. He, more than anyone, has given us soft, sensuous luxury in a modern setting. While his designs are light, airy, simple, and meticulously tailored ("I learned from my father how to cut pants and vests, but I never got to the big time—coats"), they are also romantic in their softness, their colorings, and their interplay of pattern and shape.

Mr. Donghia doesn't think there are many secrets to interior design. Furniture should be comfortable and suit its purpose—"A reading chair is not a reclining chair, and vice versa"—and versatile—"Dining tables should have other purposes, and you can dine in rooms other than the dining room. Remember that windows exist to let in light and air, not as an excuse for fancy treatments. Use less but bigger pieces of furniture and only a few important accessories. Get rid of the unnecessary.

"There is no magic to color combinations. Look at the colors you enjoy wearing most, and look at the way nature combines color; you never see anything ugly there. By all means, play safe with neutrals. They are always good backgrounds for people."

The house shown here exhibits all of Mr. Donghia's design principles and also points up his sure hand with color and pattern. In lesser hands, mixing strong colors with equally strong plaids and geometrics is a certain recipe for visual disaster. When it is done by Angelo Donghia, however, one senses the cool control of the man along with the romanticism. Nothing is extraneous, but the rooms are soft, not stark.

Obviously, Mr. Donghia no longer plots the details of every interior his company designs. But he does control them. "I'm now half designer and half businessman," he says. "I deal only in concepts. But I have the ability to project what I want to the people who work for me so that they produce what I have asked them for."

As he crisscrosses the country keeping his designer's eye on the myriad spokes of his business life, Angelo Donghia has time to reflect. "I always resisted the way my father constantly drove himself. I always thought he worked too hard and was too successful. I have become exactly what he was—and I'm not sorry."

Photograph of Angelo Donghia by Armen Kachaturian.

1. Light pouring through multifaceted skylights makes its own geometric play in a living room where checks and plaids are counterpointed against white. White separates—and at the same time holds together—the strong blues and reds used on sofas and chairs and in the rug. The bar stools came from the S. S. Caronia.

2. At the other end of the living room, pattern plays on texture. A Victorian wire birdcage stands in front of a window shaded by vertical blinds. The floor is covered with terra-cotta tiles. The rectangular table is rattan-covered; the round table with animal-like legs is by John Dickinson.

3. More counterpoint of color and pattern in a bedroom. The small geometric design of the carpet is picked up and enlarged upon in the quilting pattern of the bed cover. The effect of these hard edges is softened by the curved headboard with its broad rim of gathered white cotton.

4. The bedroom opens onto a small sitting area. The carved-wood sofa was spray-painted white and covered in white cotton. The room divider holds objects but also encloses ugly, but necessary, water pipes.

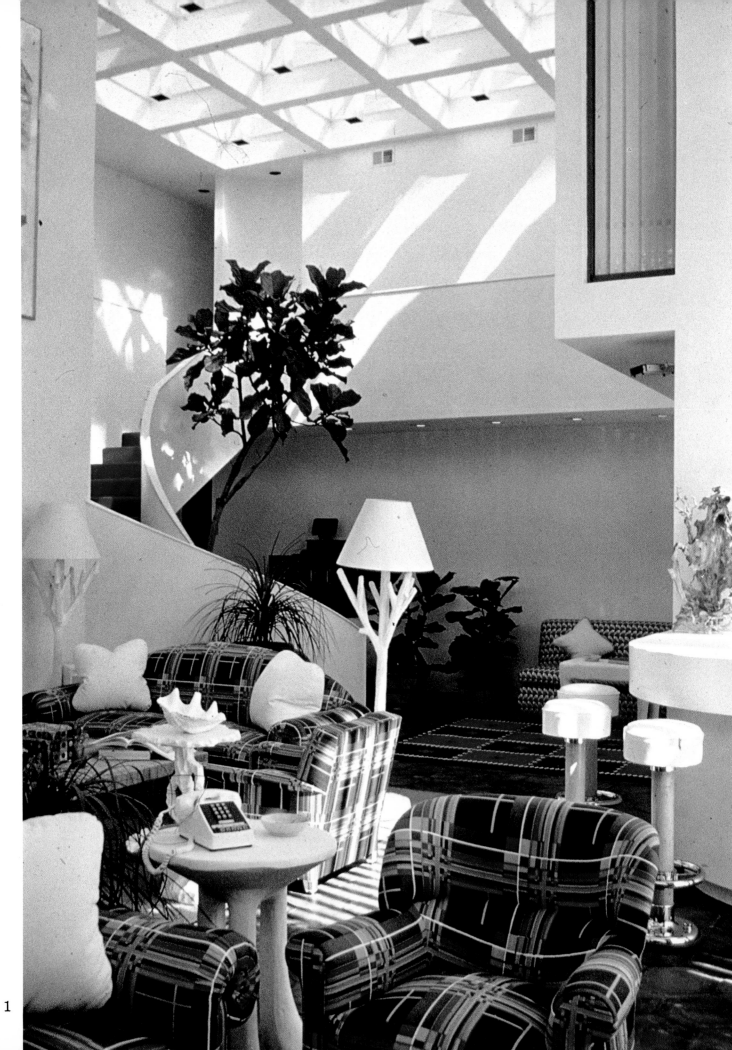

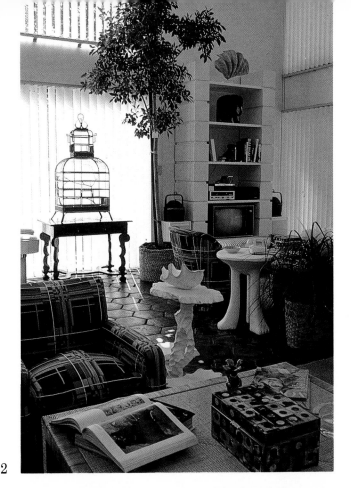

2

3

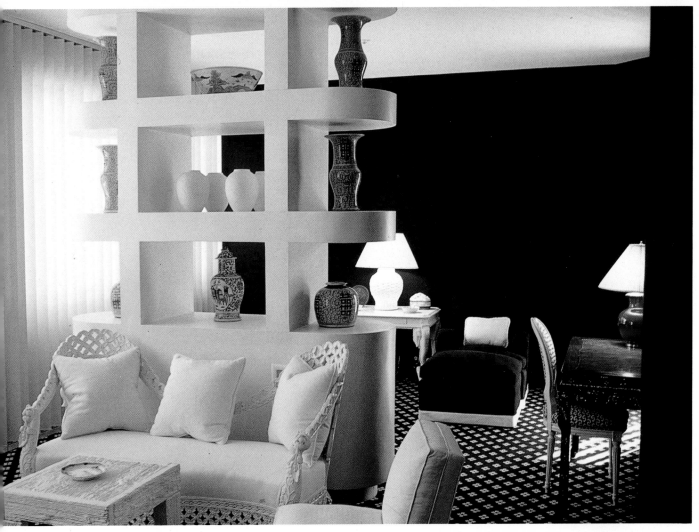

4

Tom Parr of Colefax & Fowler

Tom Parr is a senior partner in what is Britain's—and perhaps the world's—most famous interior decorating firm, Colefax & Fowler, founded in the 1930s by Lady Sybil Colefax and John Fowler. The firm's work has always personified the quiet charm of lived-in comfort. Following in the great John Fowler's footsteps would be impossible, and, says Tom Parr, he and his other four partners wouldn't try. "Obviously, one of the reasons we worked with him was because we agreed with his opinions on decorating, but we don't copy him. He achieved a plateau of excellence based on eighteenth- and nineteenth-century English country homes. I think we can do a very modern room and ask ourselves, 'Would this be good enough for John?' It's a question of quality and a high level of taste rather than one particular style."

Tom Parr joined Colefax & Fowler in the early 1960s after two years of selling antiques and six in partnership with David Hicks in a shop that was an important force in the design world of the late 1950s. "I sold the antique furniture," says Mr. Parr, "and David did the decorating."

So Tom Parr learned decorating "by osmosis" from two of the best possible teachers: David Hicks and John Fowler. One would therefore expect Mr. Parr's interiors to be classic—and they are. But one can't typecast them. "I think," he says, it's a mistake to be too stylized. Yes, I love doing English country houses, but if that's all I had to show for myself I would be working in too narrow a frame of reference. I think it's fun, for instance, to do an essay in Billy Baldwin, and the biggest job I've ever done is pared down to the point where it's almost minimal: the emphasis is on the marvelous shapes of the rooms and the textures of the materials—wood and marble.

"The most important attribute that I bring to any job is that I am good at living. Not telling people how they *should* live, but knowing how they would really like to live if they knew how. That may sound conceited, but a lot of people really don't know how to live luxuriously. By that I don't mean pampered. It's not sitting on a chaise longue all day with a Pekingese and eating boxes of chocolates.

"Living luxuriously is getting the mechanics of living right. It's having lights in the right places so you can see to read both at day and night; grouping furniture so you can chat or watch TV; having a big enough bedside table; even where the drinks tray should go in a room. Those are all important things to get right."

When he talks about getting things right, Tom Parr means right for the client. "Decorating a house is the combination of two people. It mustn't be my house, it must be the client's. The skill is to get the truth out of them so I can give them what they want that, at the same time, lives up to my standards.

"The best clients are those that will go into a room you've done for them and change things so sympathetically that if you go back a year later you think, 'My word, we did do well with this.' Then you discover that the client has added some things and changed others."

The clients least satisfying to Mr. Parr fall into two categories: those who don't understand what the designer has done and add "awful objects," and those who leave everything alone. "I find that rather dreary. A colleague of mine had a client who called to ask which side of a table a vase of flowers should be placed."

Getting the mechanics of living right starts with the architecture of a room. "If I feel an architectural change is absolutely necessary, I won't continue with a job unless the client agrees to it. Then, when you have the plan right, you can start blocking it in—deciding which walls will be patterned, which plain; will there be wall-to-wall carpeting or wood floors and rugs. Color and pattern follow. One doesn't start with a wonderful chintz or piece of furniture. They can be totally ravishing in themselves but totally unsuitable for the particular house, person, or function of the room."

The way Tom Parr's mind works comes through strongly in the apartment shown here. It is in the Albany, one of London's most famous addresses and most beautiful buildings. "The brief was very simple. The owner is a bachelor who travels a lot. He wanted a pied-à-terre that was suitable for him and for the Albany.

"So the headlines that came into my mind were: nineteenth century, masculine, cozy, mahogany, dark colors, chintz used rather grandly, luxury without chichi. Unfortunately, the flat had been brutally vandalized by previous owners. Walls had been built, cupboards put in the wrong places, and the original fireplaces removed.

"We moved the kitchen and reshaped the entrance hall. Originally, double doors separated the two big rooms, but they had been walled up. We put them back and replaced the fireplaces.

"Once that was done, the rest came together easily. One realized that the two rooms had to be the same;

one couldn't be red and the other blue. One room had to be a bedroom but not look too much like one, and it also had to have room for a desk, a television set, and space for clothes.

"I've never had a more trusting client. He wanted to be led, but he also put up enough of a fight to put me on my mettle professionally."

The result is an interior that is true to its owner and its surroundings—and is classic and timeless. "Decorating," says Tom Parr, "shouldn't be fashionable. It's too disruptive and expensive. And who wants people to be able to say, 'I see you had your house done up in 1973'?"

Color photographs by Michael Dunne.

1. *The entrance hall in this set of chambers in London's Albany looks as it might have when the building was erected in 1805. In fact, Tom Parr had to completely redesign the hall because "it had been brutally modernized over the previous fifty years." The hall was reshaped to accommodate a new kitchen seen beyond the mahogany doors—also installed by Mr. Parr—but all detailing was done with strict attention to the building's period.*

2 *and* 3. *The two public rooms, the living room and bedroom/study, also had to be completely restored. They had been made into two separate rooms. Mr. Parr returned them to their original relationship—that of adjoining rooms—by installing double doors between them. A fitted carpet runs through both rooms to unify them, and walls are covered in a red-on-red small geometric pattern. Mr. Parr's mastery of pattern is evident in the way he has combined the strong Rocksavage-pattern carpet with the equally important pink Bailey Rose chintz on chairs and at windows.*

4. *The bathroom, like the rest of the apartment, is nineteenth century and masculine. Bath and washbasin are framed in mahogany. The wallcovering is a red passionflower chintz.*

5. *Bookcases were specially made for the living room, as was the fireplace—a copy of one Mr. Parr found for another client ten years previously. The painting,* The Turkish Janissary at the British Factory at Aleppo, *is the last known work of the eighteenth-century English painter Tilly Kettle.*

1

2

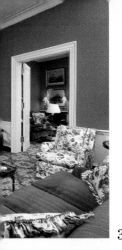

3

4

5

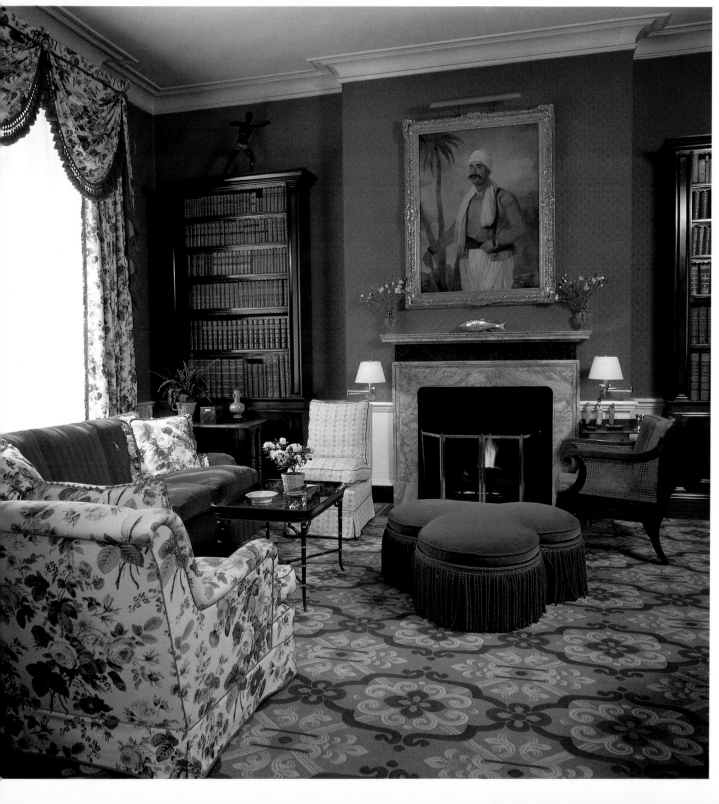

John Dickinson

John Dickinson is a design intellectual. Both he and his work are spare, cerebral, uncompromising, and original. "Design," he says, "is like vocabulary. There are so many ways to say the same familiar things, so originality is paramount. But one should never design with the idea of being extraordinary: after all, somehow, somewhere, it's all been done before, and furniture must conform to the shape of the body.

"Logic and function must always be the prime motivations. Having satisfied them, you can then—at the end—look for originality, taking as many liberties as your own good sense allows. If you can bring a little of the time you live in and a sense of freshness to a design, without sacrificing proportion and good sense, you're on the right track."

Few people are better qualified than San Francisco–based John Dickinson to make such pronouncements—he has forty years of experience from which to draw. "For the first twenty years I was a decorator," he says. "For the last twenty I've been a designer."

Of his time as a decorator he says now, "I worked in display departments and furniture stores in California. I thought nothing of doing the most conventional rooms for the most conventional people. I never resented it or thought there was another way to do things.

"Then, in the late fifties, I started to design, and a vast change occurred in the way I thought and looked at things. I honestly can't account for it. I slowly became aware that I was getting far more pleasure out of my work—and also that I was making less money. The way my designs evolved seemed to frighten a lot of people."

What evolved certainly will never appeal to the mass market. John Dickinson designs furniture with animal-like and skeletal legs, carpets that dictate the placement of furniture arrangements, and interiors that are precise and geometric yet filled with fanciful touches.

"What I do is always mine. I want my work to be instantly recognizable. I think this idea that everyone pays lip service to, that a room should reflect the client more than the decorator, is utter nonsense. Clients come to you for a look. It can be tempered and diluted or softened, but my rooms always end up looking like me. There's no way I can avoid that, and I don't want to.

"What's more, there's always a best arrangement for a room, and then there's a second-best. Why settle for second-best just for the sake of change?"

Precise as his work is, there's nothing rigid about a John Dickinson interior. The size of the space is not very important to him, "unless it's too small ever to function well at what it's trying to be—you often see dining rooms like that. I say, forget it, make it into something else so its size accommodates its function. Dine elsewhere.

"But you do all these changes very subtly. You never do outrageous things. There's a very fine line between fantasy and humor and out-and-out eccentricity. I rely on scale and proportion to create drama in a room, and then the deft placement of a few amusing or witty things to take care of any pomposity it might have.

"A room should appear comfortable. Having seated people comfortably, it should then please and amuse the eye. A room is shelter, and it should be convenient—for example, a chair should have a table near it. I don't like the conventional, however—the expected fabric in the expected place.

"I always use natural materials where I can, and I enjoy taking ordinary materials and treating them as if they were precious. I like tin worked as gold and silver would be, and muslin draped as artfully as silk. They are unostentatious, dressed-down, and simple. But in that simplicity, there's always humor. I'm very conscious of

that, and I always provide for it, though it shouldn't occur very often.

"I use very little color in the conventional sense. I think color is a big cop-out; in so many cases, it is used to cover up mistakes. In a muted or monochromatic scheme all flaws are noticeable. But if you have a red table and a green chair you're not going to notice that the table is the wrong size—all the eye picks up is red and green.

"I usually see the way a room should be very quickly. A room is finished when you cannot remove something without it being missed. Everything must earn its keep. Ideally, it would be nice to have furniture that would work in every room of the house. There's a great deal to be said for repetition and standardization. It's very disturbing to see eight different kinds of table in a room when one design in different sizes would look better. That's the sensible solution."

John Dickinson's sensible solutions are well illustrated in the interiors shown here. They are logical, even deceptively precise, yet full of fanciful touches. All the furnishings are Dickinson-designed, and nothing is left to chance. The carpet that covers the living-room, dining-room, and entrance-hall floors has a vaguely Mondrian-like design that purposely dictates where each piece of furniture should be placed. For example, the placement of the L-shaped sofa is dictated by an L-shaped, chamois-colored area of the carpet.

Mr. Dickinson's strong sense of the past, especially the classical past, counterpoints the modern geometry of every room. Sometimes the influence is obvious, as in the "ruined" column in the bathroom. Elsewhere, the influence is more difficult to detect. Classical symmetry in the living room is achieved by "false" stainless-steel window frames that raise the height of the windows at one end of the room to conform to the height of another which is taller. The discrepancy is hidden by Roman blinds always kept just a shade lower than the actual tops of the windows.

The tub which dominates the bathroom is a superb example of the way Mr. Dickinson combines spareness and precision with subtle luxury. Oversize—about three feet by seven—it is made of stainless steel and gives the impression of utmost simplicity. But, he says, "it took years off my life. We were working with a very rigid material that we wanted to look gentle, with curved edges. Every piece had to be welded immaculately and then polished. Stainless steel also has a definite grain that has to be taken into account."

Plumbing was also carefully arranged so that hot water runs through pipes under the tub, through a towel rack, and then into the tub itself. "I didn't want anyone ever to get into a cold tub," explains Mr. Dickinson. Since there is no spout, only a hole set into the side of the tub, pressure was also carefully controlled. "It had to have some authority. If water just dribbled out it would look as though we had a plumbing problem." Taps had to be decorative but not fancy, so they were made to look like gold nuggets.

The furniture has the Dickinsonian animal-like legs. John Dickinson has now further refined these and pared the designs literally down to the bone. His new lamps, chairs, and benches are skeletal. "I see nothing macabre about them," he says. "I simply felt there was a need for a new motif in design. It's just a way of making a leg look different. It was also logical, after I had done the animal legs, to realize that the inner structure was even more attractive. You could say it's my form of minimalism."

Color photographs by Jaime Ardiles-Arce.
Photograph of John Dickinson by Grace Warnecke.

1. *The master bedroom is designed with all the precision and spareness that John Dickinson is noted for. The bed, end tables, and lamps were designed by him, carved of wood, and painted to look like stone. The carpet is stone-colored, with a garnet border. The windows have blinds and "tent-flap" curtains held back by grommets. The walls are mottled for a "distressed plaster" effect.*
2. *The hard-edged geometry of the dining room is softened by pale neutral colors. Blinds ("curtains are tiresome") hang at the French windows. The chairs are Dickinson-designed and covered in goatskin.*
3. *The skylit study area of the bedroom looks out to the garden beyond. The chair is Greek-inspired. To the right is the bathroom with its oversize stainless-steel tub.*
4. *The tub is precisely aligned with a stainless-steel washbasin. The tent-flap curtains are white wool on one side, white chintz on the other. The center sections of the "ruined" column are revolving storage units.*
5. *In the living room, furniture placement is decreed by the pattern of the specially designed carpet. The furniture was also designed by Dickinson.*

81

1

2

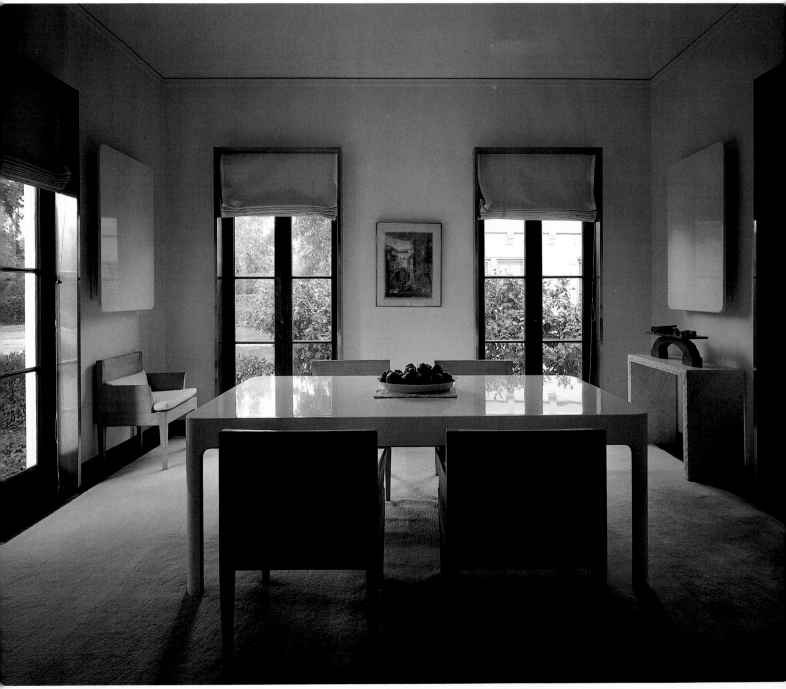

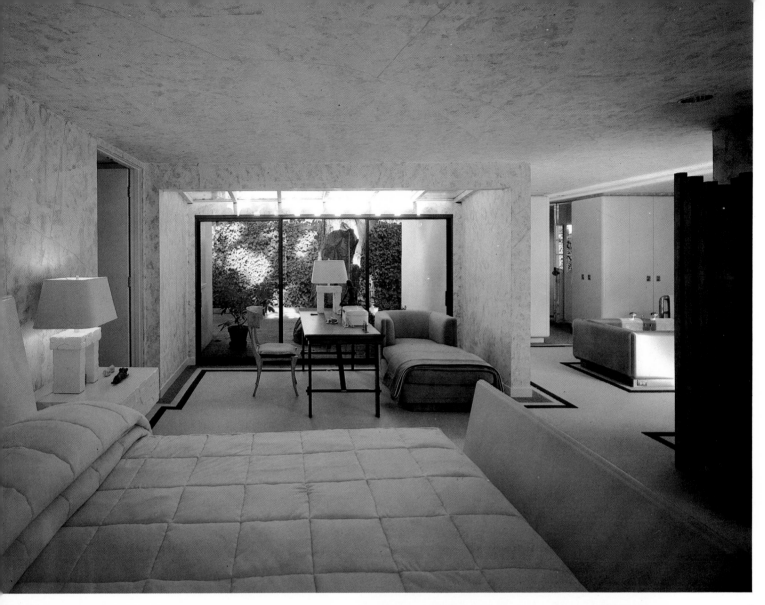

3

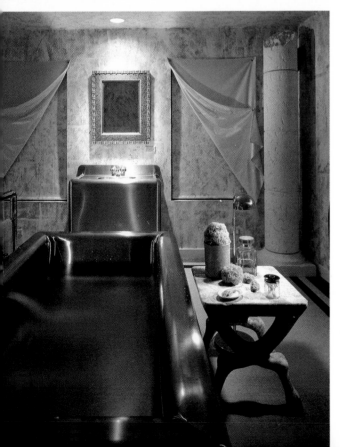

4

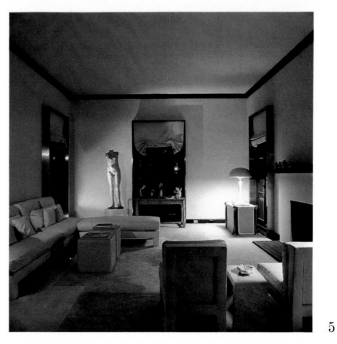

5

Ian Lieber

"You can't sit down and learn how to be an interior designer from a book," says Ian Lieber. "You pick up knowledge by looking and doing." And Mr. Lieber did just that, working in a fabric house and antique shops and doing restaurant and display design before opening his own London-based company in 1969.

Like most English designers, he denies having any particular style, but he does have strong likes and dislikes. "I hate set pieces. However high the budget, you don't want a room to tell you it's expensive. Nor, even though there are design rules, can a room be planned entirely according to them. It might work technically but it never works in real life. It's like three actors playing the same role. Each might have equally good technique, but if they are really good, each will bring his own interpretation and shadings to the part. That's what a good designer does."

If Mr. Lieber likes to be associated with any particular look, it is what he calls the "slightly sloppy room. As it gets older," he says, "it should get better, because the

more lived-in it looks, the more charm it will have. Of course, this untidiness is in fact deliberate and disciplined. I'm not talking about mess and tattiness. The whole difference between planning and accident is what makes the designer what he is. In many ways, luxury is simplicity."

Mr. Lieber is also a strong proponent of the idea that a designer is a necessity rather than a luxury. "People think of us as fey creatures with our heads in the clouds. But we have to be very practical people to deal with the wiring, plumbing, and construction work that are an important part of good design today. Things have to work, not just look attractive."

Mr. Lieber also feels that most of us need the help of a professional to make a room look its best. "People are spending more and more time at home for both social and economic reasons, and their surroundings are becoming more and more important to them. But with the bewildering array of furnishings available today, how many people know what to choose for which room, what colors work together, and how to make an ugly element beautiful? Also, how many people really know what they want around them? A room should be a background for the person living in it, but most of us can benefit from a knowledgeable and objective outsider's opinion when it comes to deciding what will really suit us.

"One's home is an extension of one's self, and I've noticed time after time that a client will have much more confidence and feel much happier in a room that's been well designed with his personality in mind. It's the same as when you tell a woman how pretty or well-dressed she is. Her whole personality blooms. But," he adds on a note of caution, "you can't take a room off and on the way you can clothes."

Because an interior will be with its owner for a long time, Ian Lieber leans heavily on classical design principles as the backbone of his work. Proportion and balance are everything to him, and he always prefers to make architectural changes if they are necessary to achieve those twin goals. "Once the shell is good, everything else falls into place easily."

The house shown here proves to what lengths Mr. Lieber will go in his search for proper proportions. It is a small Regency house tucked away in the center of London, and when he first saw it with his client he advised her against buying it. "It was really a cottage and all the rooms were tiny. That was fine for her when she

was on her own and wanted to be cozy and comfortable. But she is an eminent businesswoman with a strong personality, and in many ways she needed something quite grand. The house as it was couldn't have taken the kind of entertaining she has to do. However, she loved its atmosphere and was prepared to let me do the major architectural changes I knew were going to be necessary to make the house more versatile."

The house was semidetached, and the layout focused the rooms toward the road rather than toward the much more attractive rear garden. The first thing Ian Lieber did was move the entrance from its inconspicuous place at the front of the building around to the side, where a much more imposing impression could be made. Then he turned everything in the house around to make the garden the focal point.

This meant that the function of all the rooms changed. The old entrance hall is now the kitchen; the former drawing room is the dining room; the new oval entrance hall is where the dining room was; and the original kitchen and maid's room at the rear of the house became a small drawing room. The new drawing room was still too small for entertaining, so a larger drawing room was built on behind it. This room opens onto the garden and is so in keeping with the original house that it looks as though it has always been there.

But there was nothing Lieber could do with the low (eight and a half feet) ceilings. He has produced the illusion of height, however, by making all the rooms open into each other through eight-foot-high double doors. This also helps give the French feeling the client wanted.

Upstairs, the changes were less comprehensive. A dressing room and bathroom were added to the master bedroom, and there are one guest bedroom, a study, and another bathroom. As furnishings, Mr. Lieber used the client's French provincial antiques to their best advantage, but his colorings and patterns give the rooms an unmistakably English touch.

What he has created satisfies both sides of his client's life. The public rooms literally open up for entertaining via the double doors. Close the doors and the result is a series of rooms small enough for one person to feel at home in. Says Mr. Lieber with justifiable pride, "The house works as an architectural entity now, but, what's more important, it works for the client. I've given her both her personalities."

Color photographs by Michael Dunne.
Photograph of Ian Lieber by Richard Goddard.

1. *Ian Leiber built this drawing room onto a Regency house in London so skillfully that it is indistinguishable from the older part of the house. Though the ceilings are low, floor-to-ceiling double French windows give the illusion of height. The French country feeling the owner wanted is here in abundance. The walnut mantelpiece is Louis XV, as are the two fauteuils. The rug is Kashmiri, in the French style, and lamps are made from Chinese vases.*

2. *The anteroom that leads to the drawing room is part of the original house, but it used to be the kitchen and maid's room. The pink and green of the curtains and the Aubusson-style Kashmiri rug set the color scheme.*

3. *This drawing room is a harmonious mix of furniture from various periods. The sofa is Louis XVI, as are the fauteuils. The late-eighteenth-century silk carpet was originally pink but has faded to gold over the years. The coffee table is made from one panel of a coromandel screen. On a draped table there is a collection of Staffordshire pottery birds.*

4. *Mr. Lieber used brown wrapping paper for the walls and a comfortable mix of furnishings for an upstairs study.*

5. *In the master bedroom, a chinoiserie-patterned chintz covers walls, ceiling, and half-tester bed. The furnishings are French provincial antiques.*

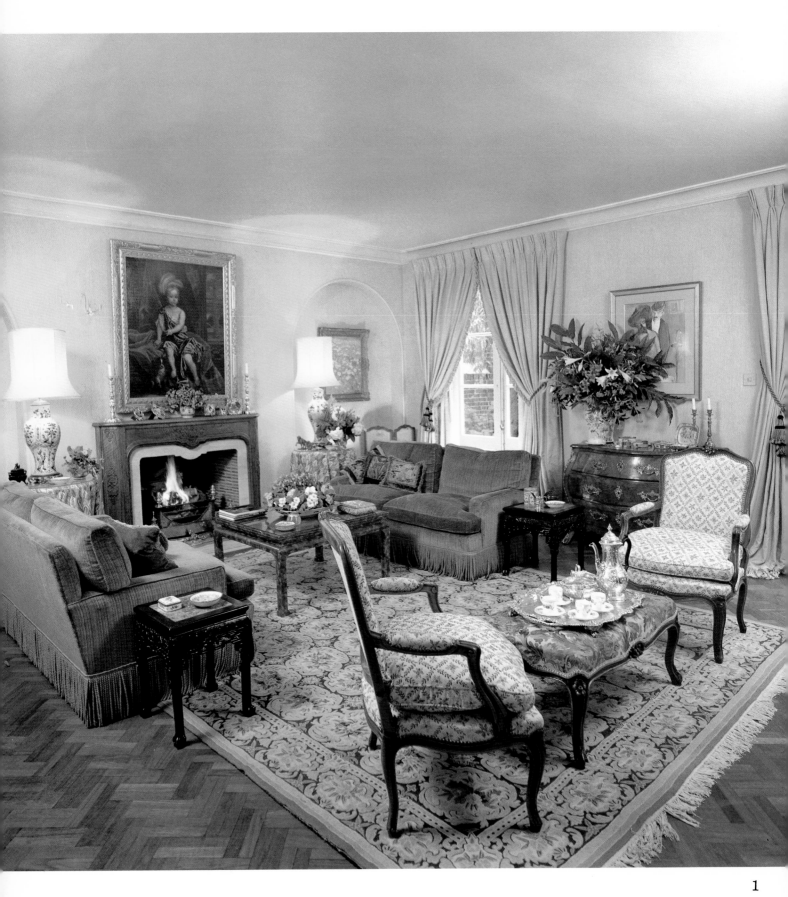

2

3

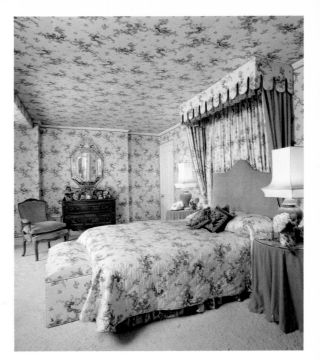

5

4

John Saladino

"I create gardens that have to be looked after and weeded every day," John Saladino says of his sensuous interiors. More than any other designer working today, Mr. Saladino approaches his work with the eye of an artist, shaping interior landscapes that combine the practicality of hard-edged, classical architecture with soft, romantic colorings. Rooms are regarded as three-dimensional still lifes and John Saladino thinks of them as he would a canvas. Considering his background, this is hardly surprising.

At the age of seven he drew a Palladian doorway as the entrance to heaven ("though I didn't know it was Palladian at the time," he says). Born and brought up in Kansas City, Mr. Saladino took a B.A. in Fine Arts at Notre Dame, followed it with an M.A. from Yale, and did in fact work as a painter for a year in New York.

"I'm a good painter," he says, "but the problem is not talent, it's what kind of person you are. Painting is a very lonely existence. Everyone else gets up in the morning and goes to work, and you are left confronting the canvas. It was a dialogue that grew tedious after about three months." So he turned to interior design, worked for several firms in New York, spent a year in Italy in the late 1960s, and opened his own design company in 1972.

The combination of the soft and sensuous with the geometry of strong architectural elements in John Saladino's work comes from an inner dichotomy. "By nature I'm a romantic, but by choice I'm a classicist. It's yin and yang, male and female—a beautiful environment always has to be hermaphroditic. Any work of art must be in constant tension. With me, it's the romantic and emotional side that comes out first when I start a project. Then I bring that under control with classical architecture. I establish a strong module for the work. Then, usually when I'm about three-quarters through, it becomes too orderly, so I break it and let the human side come out again. That's where many architects go wrong. They become so preoccupied with their plan, they let it take over. Designers are more preoccupied with the human, intimate scale.

"Too many people see a room as a passive filing cabinet to be filled with things and people. A room is a walk-in work of art, and what you leave out is as important as what you put in. There is no such thing as negative space in my work. Everything has a purpose." This feeling for space and for sequence ("In order to appreciate large rooms, you must first pass through small ones") is one key to John Saladino's philosophy of the interior as fine art. The other is color. Today, he is perhaps best known for his use of nuanced, faded, floating colors to soften the crisp lines of his architecture.

"The greatest compliment ever paid me was by a musician who said, 'You have perfect pitch in color.' There has to be a balance, and it really is like music; there's a time to pull back and a time to hit the cymbals. In many interiors, it's not just a question of which colors you use, it's their interaction, what lighting is used, the amount of color and its weight—you use a small amount of a heavy color and more of a paler color. Funnily enough, in the sixties, when I first started, people thought I was afraid of color—color then meant the primaries—but now, my use of the muted, nuanced palette has established a movement that I see in architects' work."

Just as a painter's every canvas is different but always bears his imprint, so John Saladino's basic precepts are crafted to every client. With a client, he says, "you have to be a psychic and a psychoanalyst. Always you're dealing with personalities, and it's a very emotional tightrope walk. You have to find out if they have their own ideas or if they are coming as a blackboard for you to write on. I find that total freedom from a client is total paralysis. I need some input—for example, you can learn something about your clients' sensibilities from the furniture they already own."

The apartment shown here is in Manhattan. Its owners had had two previous apartments decorated pro-

fessionally, so that, says Mr. Saladino, "by the time they came to me they had gone through what I like to think of as an education. Their first apartment was very obvious, very decorated; the second was more restrained, and then they got to me. The couple are very interesting. He's sweet; she's what I'd call hyperactive. So, for her, the environment had to be very serene and calming. The problem with the apartment was, once again, that it was a filing cabinet for the living. I had to make some kind of architectural distinction out of pedestrian space. The only things it had going for it were great views and lots of glass.

"When I first saw the space, I did what I always do. I walked through it a few times to get the sense of procession—how one goes from the entrance on through ultimately to the major room—and how that can be improved. Then I take into consideration which way one faces in a room, what the clients have to say, and how the room will be used. In this case, they like to entertain, so there had to be a fluidity to the downstairs space and, at the same time, a way to close part off for guest accommodation. So we restructured it into planes and curves and angles to make the space exciting, but at the same time we made it serene with soft colors, lights, and quietly reflective surfaces."

"I didn't see the staircase just as a staircase," Mr. Saladino says; "I saw it as a forty-five-degree piece of sculpture. And I saw the existing convectors not as weights to be ignored but as part of the furnishings I would be putting in."

Such decisions come quickly to John Saladino. He usually sees the completed scheme, down to the last ash tray, in his mind's eye after his second visit. "I take my knowledge of the clients and the space and a sheet of paper. I do drawings in total privacy—that part is very personal—and then the client can play around with them a little.

"I think your first thoughts are so often your best ones. They are unencumbered and spontaneous. I see no correlation between how long you spend on something and its quality." But he doesn't share every detail with his client in advance. "People must trust me and my vision—that's why they come to me. It's like going to a good restaurant, you don't have to know the chef to know you will eat well."

What John Saladino creates is a quiet, refined, luxurious expression of security. "Insecure people don't come to me, because I won't use design as a vehicle for showing how much money they have. A tweezered, mirrored, gilt, flocked, overstuffed, overcarpeted environment offends me. It has nothing to do with the twentieth century. There is such a thing as vulgar scale. I lost the biggest job I ever had when the lady told me she needed a closet large enough for three thousand dresses and I told her no one needed three thousand dresses."

Not that he dictates the way people should live. "I'm flexible, and my work is constantly changing. I like to think I keep pushing myself toward new solutions. Anyone who deals with the visual acquires a kind of warehouse of 'tricks' that you know will work. But you mustn't start to rely on them—that's when you start to get slick, atrophied results.

"I don't ever want my work to have the completeness of a painting. I want it to have the life and spontaneity of a drawing and to have an emotional quality. When you walk into a room I have done, I hope you will be moved."

Color photographs by Jaime Ardiles-Arce.
Photograph of John Saladino by Donald Grey.

1. *In the master bedroom, John Saladino placed the bed on the diagonal as much to make the room's nondescript architecture exciting as to make the most of its stunning view of New York. The curved wall makes a visual break between bedroom and dressing room. Its other side is a walk-in closet.*
2. *The dining room is separated from the living room by a stainless-steel-sheathed chimney breast. The strong vertical and horizontal surfaces of doors, alcoves, and beams were each painted their own distinct but delicate color to make them sculptural elements in the design.*
3. *Looking across the master bedroom from the dressing room, one becomes aware of Mr. Saladino's positive use of space. Furnishings are kept to the minimum, but the room is far from bare.*
4 and 5. *Curves and subtle colors—biscuit, soft pinks and greens—picked up from the antique Ushak rug soften the strong, hard-edged geometry of windows and fireplace to give the living room an abiding serenity.*
6. *The interplay of color and light on planes and angles gives the stairway and hall their own importance as focal points.*

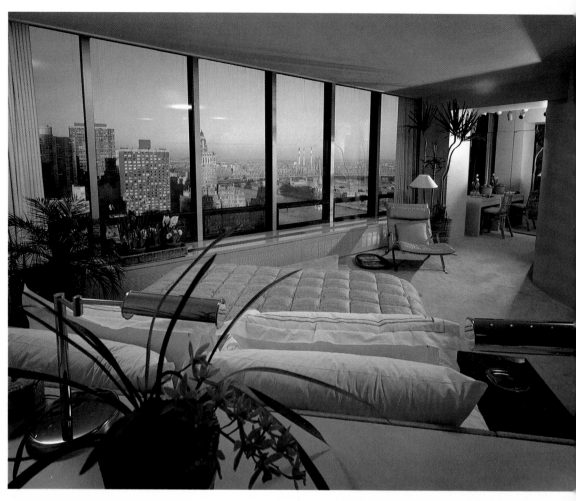

1

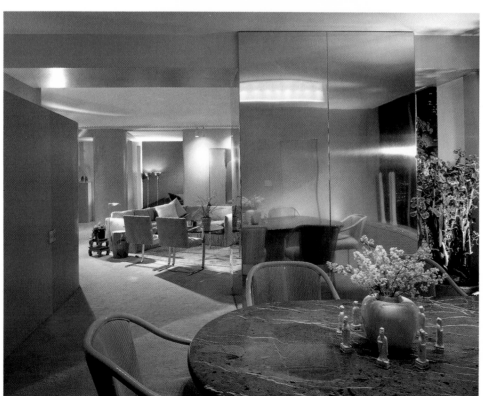

2

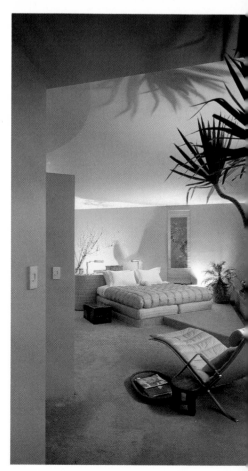

3

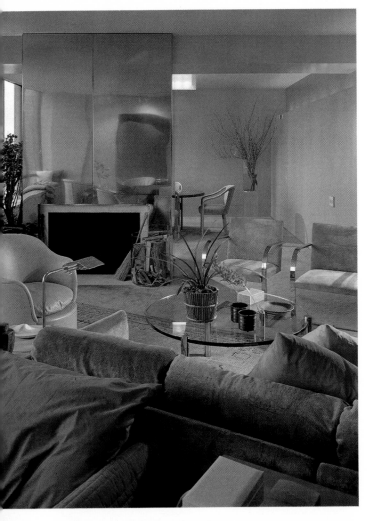

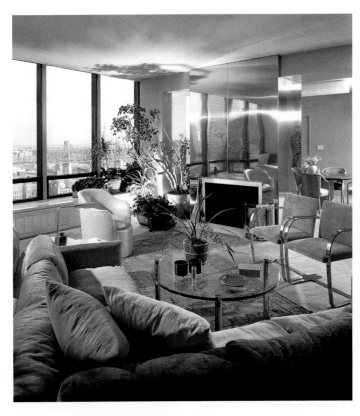

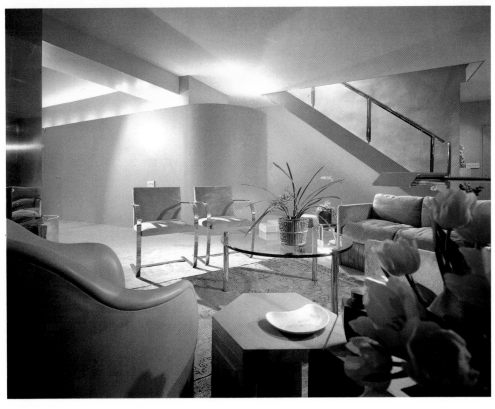

Carla Venosta

Carla Venosta is typical in many ways of Italian designers. She does not confine herself to one realm of the design field, and she has solid architectural training. Ms. Venosta designs machinery and industrial plants, furniture and equipment for schools and hospitals, as well as houses and their interiors. Her work ranks her as one of the top exponents of modern Italian design—pared down and elegant to the last detail.

Like that of many women, her career was delayed by marriage. "I had studied architecture in Milan for three years when I married and moved with my husband to England. I never graduated, which now I think was a pity, and I didn't start to work until we returned to live in Milan in 1965," she says.

"However, I have never been able to separate what is now my work from my life. Even in England, leading a completely different life, I was always noticing things and storing them away in my mind. So when I started, I was ready."

Carla Venosta started working in 1965 as an interior designer "because it was the easiest way to get into the whole design business. But I am not interested at all in decoration. I worked with two architects at first and then in 1971 opened my own office." Nine years later, she is at the top of her profession with an international reputation.

A Venosta interior always emphasizes structure. "I want to create something that will not date—and that means structure, not decoration. I never use color on walls. I use stone and stucco, which have their own noncolor, or even, when it's right, brick, because they are structural elements. If the material does not have its own interest—for example, sheetrock—I always paint it white—shiny or matte, but always white.

"To me, white is not decoration. White walls are strong and the nearest way of saying that when I design a space I would like it to last forever. White lets you see the structure of the space. If you do a room green or yellow, for instance, it is too much. The color takes over from the architecture."

Monochromatic, noncolor schemes also serve to unify space—another important factor in Carla Venosta's designs. "If you use different colors in different rooms, you visually determine the shape of each room and confine each separately. There is no sense of the overall space, which is very important to me."

However, since she is acutely aware of surround-

ings, she sometimes breaks her own rules. In a flat overlooking a harbor, for example, she allowed a slight blue tone in the white of the walls, "because it captured the reflection of the water outside and brought the natural features of the view into the apartment."

Casual is not a word in Carla Venosta's vocabulary. Furnishings, almost always designed by her, follow the structure of a room and what it opens out to—daylight, a garden, the sea. But, she says, the function of a room first tells you where to put things. So, very often, does the ceiling and floor treatment. Carla Venosta often illuminates a room via cuts in the floor or ceiling into which lights are recessed. Then, furniture will follow the lighting pattern. A ceiling or floor can be stepped up or down so that the change in level creates a "frontier" at which to stop or start a seating arrangement. Chairs, sofas, and tables must be placed so they are in harmony with the lines of the floor and ceiling. "I want a unity, a serenity, in everything I do," she says. "Bad design is too much color; too many things."

If these seem a very rigid set of design rules, their translation into reality never looks that way. Carla Venosta can compromise when necessary, yet still achieve her goals of unity and serenity.

The villa shown here is in the hills above Florence and posed several problems for the designer. First of all, she couldn't alter spaces. "The house is half villa, half farmhouse," she explains, and it is the secondary house on its estate. The main house, four hundred meters below, is called Villa Palmieri because of the many palm trees on its grounds. Tradition has it that Boccaccio, fleeing an outbreak of plague in Florence, stayed here while he wrote the *Decameron*. Built originally for the children of the owners of the main house, this house still fulfills that function.

Since she could not change the existing interior spaces, Carla Venosta unified them by using the same kind of stone flooring throughout. Called *pietra serena*, it is a very pale gray, almost white, stone much used by Michelangelo in his buildings. She also used the age-old Florentine stucco, which again is almost white but contains just enough gray to encourage shadows, giving added depth to the walls.

While Ms. Venosta may be the very model of a modern Italian designer, she is also at all times aware of her surroundings and their heritage. "I have done," she admits, "a very classical treatment. But for me those walls and floors don't exist. I have eliminated them and at the same time unified them so that they become only background—but the right background for this house."

Perhaps the most stunning room in the house and the one that shows Carla Venosta both at her purest and her most adaptable is the loggia that runs along one side of the villa. This she enclosed behind panes of glass, carefully putting the seams behind pillars, "so that it is as though the glass is not there." To continue the sense of unity with the outside world, the steps of the conversation area were made circular "to capture, in an abstract way, the form of the hills outside." The lamps are abstractions of palm trees, "because there are so many in the gardens. Also, I asked my clients to use papyrus plants, which look like small palm trees. The whole area is carpeted in white, and objects are kept to the minimum." ("I have done spaces which were beautiful when I left," mourns Ms. Venosta, "but which were later spoiled with too many objects.")

But she had to compromise when it came to the wood ceiling. "It, too, should be white," she says. "It would be more beautiful. But I wasn't allowed to do it."

Color photographs by Carla de Benedetti.
Photograph of Carla Venosta by Carla de Benedetti.

1 and 2. *The loggia of this Florentine villa was originally open. Carla Venosta made it a living room enclosed by large sheets of glass. The uninterrupted expanses of glass insure that none of the outdoor feeling is lost, while the stepped seating imitates the terraced hillside. The original columns ease the transition from a modern environment indoors to the age-old landscape.*
3. *The courtyard's stucco walls, iron gates, and terracotta floor span centuries. The track lighting is a twentieth-century touch.*
4. *Because it is white on white, the loggia changes in mood according to the quality of the natural light and the time of day. Carla Venosta likes to use as few decorative objects in her interiors as possible. Here they are kept to the minimum. The papyrus plant is an indoor reflection of the many palm trees in the garden—trees from which the villa takes its name.*
5. *A bathroom is sleek with mirror, stainless steel, and gray* serena *stone used for the floor and to frame the bath. The focus of the room is a view of the garden framed by the window.*

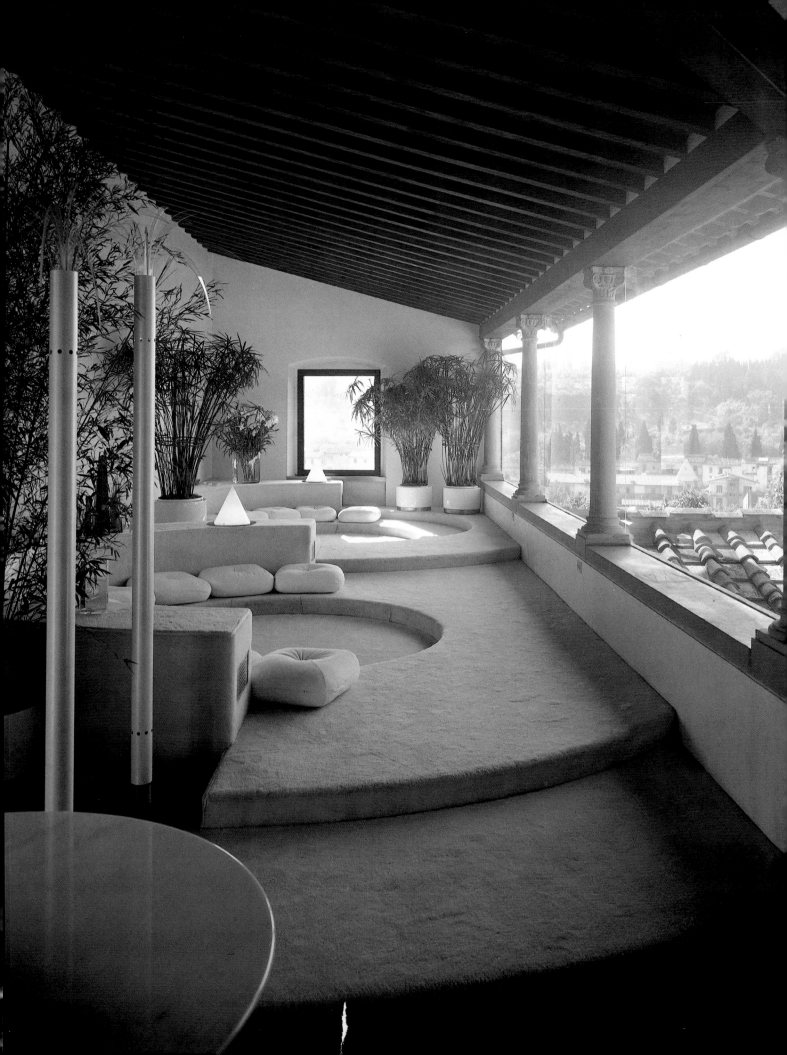

1

2

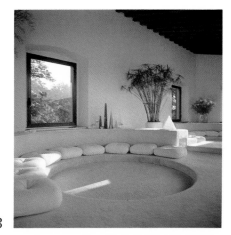

3

4

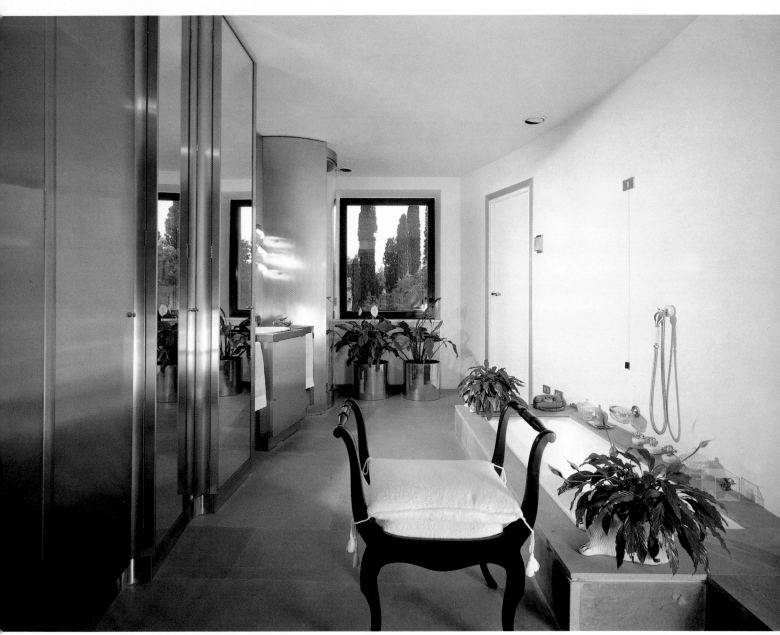

5

Chuck Winslow

"I don't think my designs are very different from anyone else's," says Chuck Winslow, a young American designer now living in San Francisco. "If I have had any success, it's been because I have an insight into people that lets me create an environment for them that is *theirs*. Clients trust me, and, basically, trust is what we are selling. I'm not the only person who has this ability, but I wouldn't be a good designer without it. It's important that you give the client the right background to live in. That's what interior design is all about."

Chuck Winslow never thought about being an interior designer until he became one. "I was spending the summer on Cape Cod before going to Georgetown University in Washington, D.C. I had a job bartending, but when that finished I had to make some more money. I answered an ad in a Boston newspaper for an assistant to a designer and got it." He was only a go-fer but he was hooked. "In between running errands I'd put things together in the shop. I realized I had talent when they worked—and for no apparent reason."

The summer passed and Mr. Winslow stayed in Boston. He never did go to Georgetown. After two years with the firm, he joined a new one, then went on his own. "Several clients had followed me to the new company, and it occurred to me that if they had done it once, they would do it again. And I thought I would lead a less regimented life and all the profits would be mine. It wasn't that easy and it was very premature. I made a lot of mistakes from the business point of view."

He moved to New York six years ago and then, two years ago, to the West Coast, learning along the way "from my peers and by keeping my eyes wide open. I'd feel a lot more secure if I had had formal training, but I've taken enough architecture courses to be able to do mechanical and architectural drawings, and to argue intelligently with a contractor. I still work very much by instinct, but I think architecturally in that I consider space before furnishings. Interior design and architecture really can't be disassociated."

Mr. Winslow also has class. "That's a bad word today, but I do know which knife and fork to use and how to set a table and dance and play polo and write a proper thank-you note. Many clients want to acquire those social graces along with an attractive and comfortable home in which to practice them."

An attractive and comfortable home designed by Chuck Winslow stems essentially from his insight into the individual who will live in it. "I know how to make rooms work in terms of scale and traffic patterns; I am very aware of lighting; I know what is pretty, but really my forte is in getting into someone's head and expressing his views."

Of course, more than insight is involved. "There are always only two or three good solutions to any room. In most, there are only one or two furniture layouts that will work. Most people will have a preference as to the style of furniture they want to use. Its shape and size will depend on the client—a big person needs a bigger chair—and, as far as I'm concerned, no more than two people are going to sit on a sofa whatever its size: any more and it's like birds sitting on a wire.

"Color depends on the client, though I love naturals. Not the boring earth tones, but the naturals you see in Greece where all the changing colors of the sky are reflected in—and change the color of—the white stucco walls. By the time you've considered these factors and eliminated all the things—shapes, colors, patterns—that the client doesn't like, there's really not much choice left."

Mr. Winslow feels he has been lucky not to have worked with many insular, high-rise boxes. "Most of the interiors I have done have had their own charm or cranky, humorous point of view that can be taken advantage of. I don't mind if a room has a minus in the design sense. I like the challenge of turning it into a plus.

"But I can't perform magic. Some people have incredible delusions about what their rooms should be. If you live in a modern apartment building and want to live in Versailles, you'd better move. I do believe in juxtaposition, but it has to be within the realm of reason, and that comes from understanding the space you're in."

There are other delusions. "People who think they have good taste and don't are terrible to deal with, and people who have so little taste that they think a room is finished forever when I leave are very frustrating. I'll never forget returning to a house two months after the installation and finding a book I had left on a cocktail table still in the same position. I was even more appalled when I picked it up and found that the client had marked its spot with masking tape. She thought that because I had put it there, it should always be there. I never complete a room. That's a contradiction in terms. People will ask why I haven't filled a corner or niche. That's for them to deal with. I can lead them in the right direction, but they have to continue on their own. I don't do stagnant rooms."

In the rooms shown here, flexibility was all-important. They had to function as living and working spaces and be comfortable for entertaining anywhere from two to forty people. Mr. Winslow chose to work on the diagonal. "It wasn't done to be reactionary. It just made the traffic flow better, and it also gives interest to ordinary rectangles." He wanted all the color to come from the art, so he stayed with his comfortable neutral palette. "If you keep things open and simple, they lend themselves to change; the paintings can be moved around and so can the furniture. When you live and work in the same place, it bores you very quickly if everything has to stay in the same place."

Mr. Winslow does not believe in drama in design. "I think you get into trouble every time you try to re-create the wheel. Everything is derivative of something. The trick is to be sure that whatever you choose to be derivative of, it's good."

Having fallen into the profession by accident, Chuck Winslow can't imagine himself doing anything else. "I love it," he says. "You have all the problems—fabrics arrive flawed; items get lost in shipping; upholstery isn't done on time; dye lots are wrong—but when you've been through all that and then see the room taken over by the clients and it becomes theirs, all those frustrations are worthwhile. When I was growing up, riding was my whole life, and the two are very similar. It's you and the horse who perform. It's just the same in design. If you're good, there's an empathy between you and the client that creates harmony."

Color photographs by Michael Dunne.
Photograph of Chuck Winslow by Grace Warnecke.

1. *Chuck Winslow covered the walls of this New York study with gray flannel, a perfect foil, he believes, for art. A platform reading area and a desk were built on the diagonal to give the room more than ordinary interest. The floor and seating platform are covered with sisal matting. The chair is a junk-shop find. Color comes from the paintings and the durrie rug. Track lighting follows the diagonal line of the platform.*
2. *In the bedroom, walls were covered with a Winslow-designed paper. Canvas duck, quilted in the same pattern, covers the bed. The wicker chair was found in London, the 1905 rustic table on Long Island. Again, a durrie rug tops sisal carpeting.*
3. *In the living room, the move to the diagonal continues in the placement of a camelhair-covered daybed. There is a kilim rug; the chairs are Dutch, and the table is a Mexican shipping crate topped with marble.*
4. *In the corner of the living room, a drafting table is used as a desk with a Louis XV fauteuil covered in Swiss cotton check. The painting is by Stephen Mueller; the rug is a kilim.*

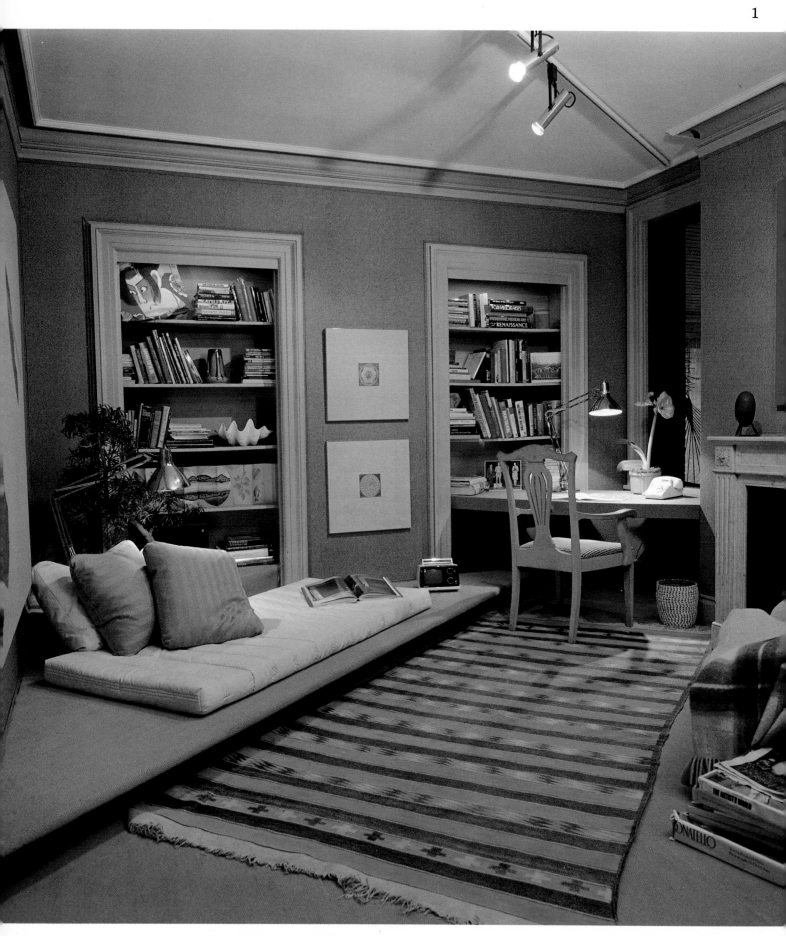

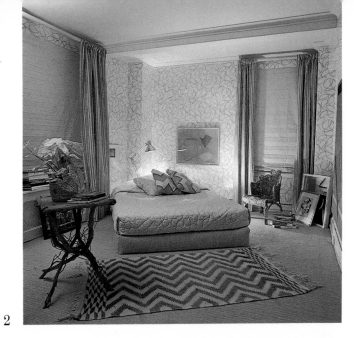

2

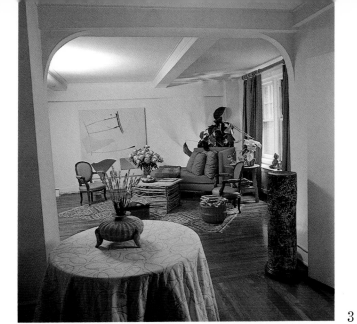

3

4

Diana Phipps

"I'm still not sure that I'm a professional," says Diana Phipps about her work. "I've always wanted to have a business and be businesslike, but I still haven't got round to having my unlisted phone number listed. However, people still find me."

It's only in the last four years that Mrs. Phipps has designed interiors for clients. ("Most of them seem to be literary," she says. "As they're the most famously unvisual of people, I'm getting a little nervous.") Before that, she worked for friends and gleaned all the experience she needed from decorating her own homes. Born in Czechoslovakia, she was brought up in Jamaica and lived in America and France before settling in England.

Her mother, she says, was a great influence. "She painted well and was always doing up houses. It was rather like *Gone With the Wind* in reverse—she was constantly making curtains and covering chairs with dress fabric and making pillows out of old clothes." A lot of this sleight of hand has, indeed, rubbed off on her daughter. She is a talented trompe-l'oeil artist without any training at all. "I think my talent comes from having grander aspirations than my pocket could ever satisfy. So I just watched how things were done and then did them myself—or faked a lot."

Fabric (especially sheeting), paint, a staple gun, curved needle, and paintbrush are her favorite tools. "I use fabric a lot on walls. It's the quickest and cheapest way of covering them. And I do all the special effects in houses myself. I'm quicker than anyone I could hire."

The furniture Diana Phipps chooses for a room is always eclectic—again because of her own experiences. "I started out with nineteenth-century furniture because it hadn't been discovered and didn't cost too much. Now, of course, that's changed. Perhaps I do still try to evoke that period. I love the *faux bois* they did and the oddly shaped pieces of furniture.

"I suppose some of the things I've used will be an investment in the future, but they've all been bought from wholesale or bric-a-brac shops. But even investment furniture is going to get banged and kicked, perhaps even broken, and it takes so much care. What I like best of all are really junk things that you can paint or add something to and make look wonderful. It breaks my heart to pay an enormous sum for something that can look almost as good faked.

"I never try to evoke a particular kind of mood or period, but I definitely like strong colors. I always think I am doing pastel colors—delicate and charming—but they always end up getting stronger and stronger. I think if you live in a place that's as cold and dark and dreary as England, you've got to use strong colors.

"I like comfortable things with a lot of cushions. That's laziness more than anything else—it's easier to make a pretty cushion than to cover a huge sofa."

Diana Phipps doesn't regret her lack of formal training. "I'm convinced that things like balance and proportion are not something you can learn. I think that's all in the eye. Also, I don't think it's any good making those little plans that decide where every chair and table is going to go. I think you have to try everything out, because so much is dependent on light and space."

But Mrs. Phipps' eclectic interiors with their elements of fantasy don't happen entirely by chance. The client and his life are the most important part of her work. "It's the way they live and what they have that they want to live with. Everyone has some possession that gives a starting point to a room."

Mrs. Phipps prefers to work for men. "I always give clients a choice between one thing or the other. But then I want them to know enough about their lives

to make a decision. Women quite often find that difficult. Perhaps they don't know what they want because they still quite often change their circumstances because of a man. Also, men don't need as many things around them. Perhaps that's because they don't have a nesting instinct or because, in many ways, their office is their home."

As more and more women join the business world, Diana Phipps can see design changing. "Maybe," she muses, "by the end of the 1980s we'll all have an office or a conference room cluttered with things that we visit. Then we'll come home to absolutely nothing except space and white and very little furniture with only a view or a few green plants to remind us we're alive." She would like, she says, to be able to live that way, but she admits it is unlikely. "I'd go mad with nothing to distract me."

In the interiors she is designing now, such as the house shown here, there is no shortage of things to distract—and hold—the eye. It was decorated with Mrs. Phipps' usual aim of looking grand while costing very little. Originally it was a tenement divided into flats, but she made it into a one-family home again.

In the "Indian" room, the sitting alcove was originally a windowless kitchen. Windows were put in, their frames following the shape of the twelve-dollar junk-shop mirror above the fireplace. The walls have light-blue denim stapled to them; the window frames are covered by Indian cotton bedspreads (also stapled on) like those used for the upholstered furniture. When the bench was found in a junk shop, it was dark brown with torn leather upholstery and a high back. Diana Phipps gave it a second life by chopping off the back, painting it white, and reupholstering it, "stuffing bits of foam rubber into the seat where padding was missing."

She had an aluminum balustrade made for the stairwell. A Boussac cotton was stapled onto the walls, and the horse's head is a cheap fiberglass reproduction gilded by Mrs. Phipps.

The study walls are covered with brown velvet, with embroidery pictures stuck into trays flanking the fireplace. The columns were another junk-shop find, restenciled with India ink and gold paint.

The tented alcove is at one end of the study and doubles as a guest bedroom. It is piled with three mattresses and separated from the rest of the room by an old altar rail cut in half. The chairs are "the only good

things in the house. They came from my grandmother and were on one of Nelson's flagships."

But it is in the paneled kitchen that Mrs. Phipps' flair is given full rein. The paneling was found in the street after it had been thrown out of a house that was being torn down. The columns come from yet another junk shop, and the pediment was the mantel from the fireplace in another room of the house. Of course, none of this fitted together neatly. Paint and new moldings were used to fool the eye where necessary.

The ceiling moldings were already in the room, but many of the rosettes were missing. "There's a wonderful product like plasticine only it dries hard," says Diana Phipps. "I just copied what was missing and stuck it up."

Her ingenuity seems boundless—except in one area. "I'm so used to 'making do' that if I suddenly had unlimited funds, I really wouldn't know what to do."

Color photographs by Michael Dunne.
Photograph of Diana Phipps by Eva Sereny for Harper's *and* Queen.

1. *An altar rail cut in two divides a tented guest bed from the rest of the study in this London house designed by Diana Phipps. The striped fabric is cotton, the brown curtains velvet. The mirror and accessories are junk-shop finds spruced up by Mrs. Phipps. The chair in the foreground is rare—it is one of a pair of Italian cherrywood chairs made for one of Admiral Nelson's flagships.*
2. *Paneling, real and false, lines the kitchen walls. All were installed and painted by Mrs. Phipps. The pediment above the fireplace is itself a mantel from another room.*
3. *Brown velvet covers the walls of the study. Baseboards and radiator covers are* faux bois *painted by Mrs. Phipps. She also restenciled the pattern on the two decorative columns.*
4. *The window alcove of the "Indian" room was once a windowless kitchen. Windows were installed, borrowing the shape of a cheap mirror that hangs at one end of the room. Indian cotton bedspreads line the alcove and cover the bench. A circular iron staircase leads to the floor below.*
5. *Mrs. Phipps had this staircase balustrade made from aluminum to look like bamboo and then painted it. The banister is covered with red velvet, the walls with fabric. The horse's head is gilded fiberglass.*

2

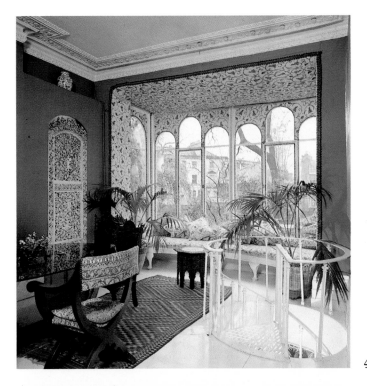

4

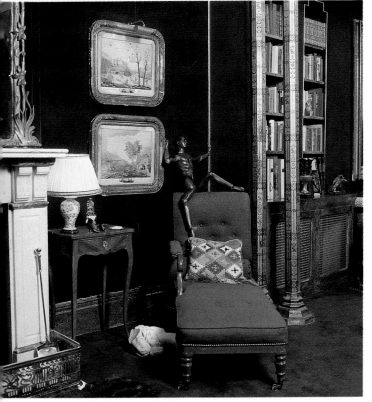

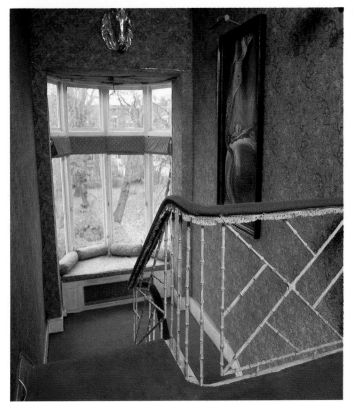

5

Nicholas Haslam

In many respects, Nicholas Haslam resembles the talented amateur, the well-bred man of fashion so influential in eighteenth- and nineteenth-century England. Educated at Eton and very social (he gave English society's party of the year in 1979), he brings no formal training to his work—which he says he got into accidentally after a couple of years working in the art departments of magazines in New York and several years breeding horses in Arizona. He does what he does, he says, "unconsciously."

"What I decide to do comes in flashes. I've had projects that I've been really stuck with—to the extent of not being able to think of them at all—but I know that somewhere I'll see something that will trigger me in the right direction, and I work from there."

This seemingly casual, if not cavalier, approach to interior design sounds more like the intuitive professionalism of a painter—which in fact Mr. Haslam grew up wanting to be. Disliking art school, he came to New York in 1963 "to look around" and stayed in the United States for almost ten years. By the time he returned to England in 1972, he had "helped decorate the houses of friends in America who liked what I had done with my own places" and had decided to make his hobby his business. His first client was a friend: the young Lord Hesketh, a leading light in English society. Mr. Haslam was off and running.

Today, half his clients are English, the other half foreigners—especially Americans—living in England. "By English standards," he says, "my work has a very American look. The taste is English but there's an American style to it. My English clients are people who want to keep the comfortable look they've grown up with but modernize it—get rid of the scruffiness we English are so proud of—and my American clients are people who want to keep all the modern conveniences they are used to but acquire the understatement of the English. Because of my upbringing in England and my years in America, I understand both."

But what influences his designs most is his talent as a painter. "I approach a room as I would a very large canvas. While another designer may do a floor plan, I do a layout. I do drawings because a client requires them, but I don't stick rigidly to the original design. I see a room building up as I go along—like a painting does—though I see the general outline and the overall effect I want right from the beginning. But one needs to see a room growing."

To Nicholas Haslam, decoration is the most personal of the arts. "Everything is done with one specific individual—the client—in mind. And it's sexual, because what you are doing is, in effect, drawing the *real* personality out of a person.

"You can tell a lot about what a woman will want in her home by the clothes she wears—whether she's formal and structured or casual and country. You can tell a lot about a man by his bathroom—how organized he is and how much he cares for his appearance." Medicine cabinets also hold clues: "If you see tranquilizers, you don't give the owner a screaming red room."

Mr. Haslam doesn't work just from such minutiae. "In England, there's a certain order of architecture that the eye is attuned to and that one must be aware of and stick to. Because buildings here tend to be old and already have a sense of identity, there's an inbuilt sense of what they should look like both inside and out.

"But I do play around with scale within limits. I often underscale a man's room so he looks bigger, and overscale a woman's room so she will look more vulnerable." Once scale has been determined, Mr. Haslam concentrates on lighting, which he regards as all-important. "If that's wrong, everything else is wrong. Furniture placement and especially color work according to the lighting.

"Most people have terrible color sense and use it too brightly, especially in England. Our muted light demands underplayed color. Bright color does not cheer up a gloomy room or a gray day. Neither will a small room necessarily look larger if you paint it a light color. It can look bigger painted a dark color and lit properly."

Nicholas Haslam has done, and will do, very modern interiors for those who demand them. But, he says, "however lovely they may be, they're not very cozy or sympathetic. They are more for show than day-to-day living." Since he inflicted such an interior on himself three years ago, he knows whereof he speaks. "It was like living in a dress shop. If I put one piece of paper down, everything looked out of place. And it's very expensive, not just to install but to get rid of. You can't change a highly designed space gradually. You have to rip it all out and start again."

Today, his work is much more classical and relaxed. This is partly the result of living in the country house that once belonged to John Fowler. Because the

house is owned by the National Trust, Mr. Haslam can change very little. "I've got the bones of what John left, and I have to make my way of thinking fit with his," he says.

His experience with this house has led him to use more and more antiques, "though I'm very spare about what I put into a room and especially cagey about using lots of little things. But, while I used to design a lot of furniture for a room—because it's easier to get a total look that way—now I feel I can handle individual pieces better and work with their different shapes and patterns.

"To me now, the ideal combination, if you can get it right, is the modern use of plain colors and shapes with the English-country-house look."

In the London house shown here, Mr. Haslam has imposed this view on the client. "The house is very European and the client's not. But he gave me carte blanche. I did a lot of structural changes to bring the house back to its period, about 1800. The previous owner, who was supposed to be an architect, had taken out a lot of the moldings, lowered the ceilings, replaced the original staircase with a lift, and built a new staircase at the back of the house that was the narrowest I've ever seen. Both it and the lift were too narrow to take even a chair. Every piece of furniture had to go in through the windows.

"I made the drawing room out of two rooms, restored the ceilings to their original height with moldings, and made a master bedroom and bathroom out of three rooms." Once the structural changes had been completed, the decoration of the rooms evolved from Mr. Haslam's usual mixture of planning, luck, and intuition.

"I planned to panel the dining room with modern reproduction wood. But the impossible happened. I was in an old junk shop one day looking for a fireplace when I saw what turned out to be the French paneling originally installed in 1760 in the small dining room of

Londonderry House. What's more, it fit this dining room perfectly."

But some things didn't work. "I had planned to use lots of California driftwood tables in the drawing room because I thought they'd look good with soft colors. But when I put them in they were too raw—not pretty or smooth enough."

The bedroom and bathroom have a very tailored look keyed to the owner's taste in clothes—gray-flannel suits.

The house was done for Mr. Haslam's favorite kind of client: a rich single man. "They know very strongly what they want, they get it across to you very quickly, and then they leave you alone."

But the house also epitomizes Mr. Haslam's description of his work. "My designs," he says, "are like very stylish women. They are smart, couture, and polished."

Color photographs by James Mortimer.
Photograph of Nicholas Haslam by David Bailey.

1. *"More relaxed about using antiques now," Nicholas Haslam makes an eighteenth-century gilded console table with marble top the focal point of one end of this drawing room. The rest of the furnishings—a brass coffee table, cotton-covered slipper chairs, and black television cabinet—are modern. The festooned shades at the windows are cream chintz.*
2. *Mr. Haslam's love of "cosmetic" colors shows in this living room broken into two seating areas by back-to-back sofas separated by a Parsons table. The glazed-chintz ruched shades provide a touch of tradition.*
3. *A very traditional small sitting room uses fabric on the walls as a backdrop for the owner's collection of early-eighteenth-century cartoons for tapestries. The eighteenth-century French provincial side chairs still have their original needlework covers. The gilt bench is Louis XVI.*
4. *This dining room was "built from scratch" with 1760 paneling found in a junk shop. The Viennese china dates from the same period; the fireplace and the chandelier are French. The Louis Philippe dining chairs were painted and covered in a red-and-white stripped cotton.*
5. *Mr. Haslam likes to design bathrooms around their users' taste in clothes—in this case, a man who likes gray-flannel suits. With that in mind, walls and ceilings were paneled in aluminum Formica and all fixtures are gray.*

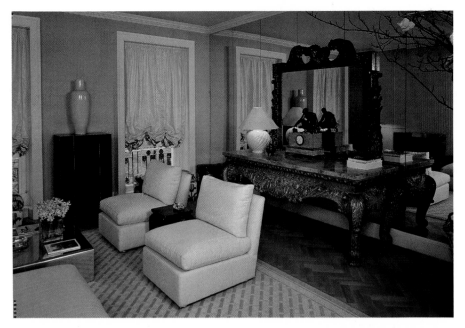

1

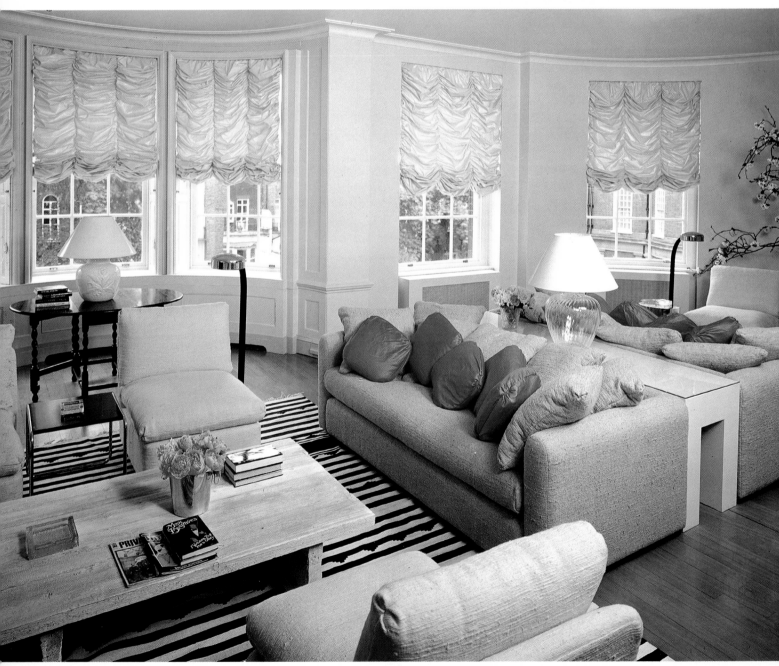

3

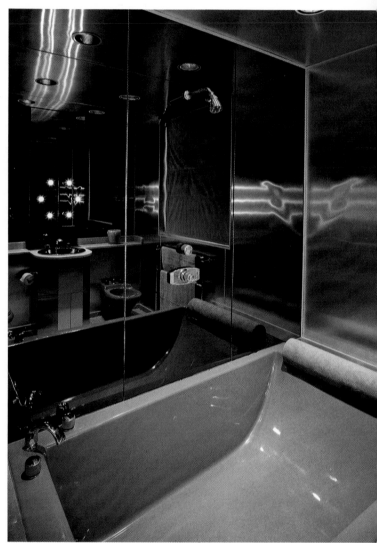

5

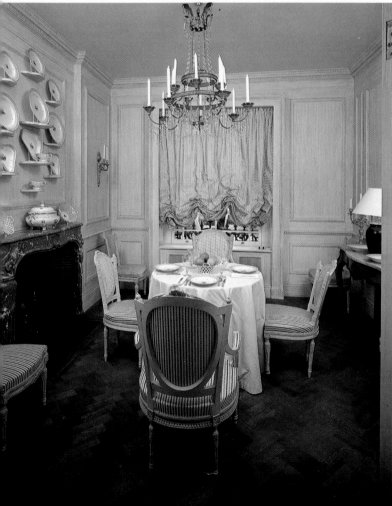

4

John Siddeley

According to John Siddeley, who has been both, there is a world of difference between a decorator and a designer. "A decorator is a talented amateur. A designer is a professional who has to know all the dull things: how to cut curtains and valances; how to construct furniture; the difference between tufted and looped pile carpeting; the possibilities and impossibilities in design.

"You must," he continues, "know all the nuts and bolts before you can create the skeleton of a room. And you must have that skeleton before you can put on the flesh and the clothes. If the skeleton is wrong, they won't work. But once you've created your own particular Frankenstein, it's terribly easy to put the clothes on."

Even though he has had his own design shop in London for twenty-eight years and had worked for another firm for three years before that, John Siddeley says

he became a designer only eighteen years ago, "when I had learned enough to design my own furniture."

His clientele is international, and this is reflected in his work. It belongs to no particular school and is not easily identifiable, and that's exactly the way he likes it. "The best compliment anyone could pay me would be to walk into one of my rooms and have to ask who did it because it didn't have a trademark. Then, when he was told, he'd be amazed because he'd just walked out of another of my rooms which was completely different."

His overriding concern is for the individuality of the client. "I will do a classical design, a modern design—though I find those rather sterile—or, which I prefer, what I call 'ancient and modern'—a mixture of old and new."

Whatever the mode, everything in a Siddeley interior is chosen for its good proportions. If the proportions are good in relationship to the human being, comfort is automatically built in, he believes. "The Barcelona chair is the most ravishing piece of sculpture, but it's incredibly uncomfortable to sit in, whereas the Eames lounge chair is extremely comfortable because it was designed with the body in mind.

"Also, there's something wrong with a room if you find yourself constantly moving the furniture around and if there isn't a place for everything. A lot of people, including designers, don't take into account the things that actually go into other things. You have a hi-fi and it has to go somewhere. You have drinks and the bottles have to stand up somewhere. You have shirts, and drawers must be deep enough to hold them folded properly. A lot of the important elements of design are never seen or noticed. One is simply aware that things work.

"Comfort brings with it relaxation, and that's what home is all about—though you wouldn't think it to walk into a lot of them. Too many people are afraid to relax; afraid that someone may 'catch them out.' We spend all day in our offices, and when we come home we should be able to wind down. In actual fact, one's mind is much brighter if it's not under stress."

Mr. Siddeley corrects this situation by "wrapping my knowledge, training, and something magic around the client like a cocoon. When people employ a designer, they're like children entering a fantasy world. They want something, but they don't know what it is; yet they know it must be what they want and not what

the designer wants. You try to teach them and lead them to good taste—whatever that is. Then, eventually, the cocoon turns into a butterfly and you have clients who have confidence and feel safe, because they belong in their home. Then I want them to have enough judgment to change things and buy others on their own."

Even after thirty years, John Siddeley is not certain how he does this, only that it works. Perhaps it emanates from his own quiet assurance, a characteristic which seems inbred in members of the English aristocracy. (He is also Lord Kenilworth.)

In his own life, he sees no virtue in display or ostentation. "How often," he asks, "do you walk into a house with stunning pictures twinkling away at you from the walls but the overall effect is 'so what,' because they are being shown off, not used in the design of the room? Remember, most pictures were originally painted to be a decorative part of life, not with the idea that they were going to be hung in a museum. Nothing should hit the eye immediately. A good room should be a constant voyage of discovery."

His own London flat, shown here, obeys these precepts. "It was a very ordinary flat," he says. "My wife and I had just separated, and I didn't have the slightest idea what I was going to do with it. I just wanted to create something that wouldn't make me feel miserable and dejected when I came home.

"The floor plan was sketched very quickly. The flat had a built-in flow pattern that works. I built in bookcases and cupboards and picked up pieces of furniture here and there. I had very little family furniture."

In many ways, what he has done in this flat is a good illustration of the advice he gives to people furnishing their first home. "Make sure you get the lighting right, and remember that natural light changes according to the time of day and with the seasons. Quality is paramount, and the first thing to buy is a good bed. Apart from that, you can buy junk and play around with it until you have saved enough for the best.

"It's always better to paint a wall white than to play around with color and pattern and expensive wallpaper. If everything is white, you can always add slowly. Stay away from gimmicks. Interior design is a major financial investment, so it has to last. Making mistakes will be expensive.

"There's a very apt quote that should always be kept in mind: 'Only the very rich can afford not to employ a designer. Only they can afford to change things if they make a mistake.'"

Color photographs by Michael Dunne.

1. *John Siddeley started from scratch with his own London apartment. The carpeting—used throughout to unify the space—is a simple grid pattern. Bookcases were built in, and the reveals of the windows were mirrored to visually minimize a wall slope dictated by a mansard roof. The mirrored panels beneath the windows hide radiators. Modern classics—Mies van der Rohe chairs—are mixed with antiques and inherited pieces. The reclining chair is an old dentist's chair upholstered in tweed.*
2. *A brown and cream small-print paper on walls and ceiling makes the small bathroom appear larger.*
3. *The dining area is visually separated from the kitchen by the use of wallpaper and the presence of a beam, both of which stop the eye.*
4. *Believing that bedrooms are for sleeping, Mr. Siddeley planned this one around an ivory-veneered four-poster bed of his own design. Closets were built in on either side. The mirrored dressing table once belonged to Syrie Maugham.*
5. *The walls and ceiling of the entrance hall are covered in gray men's suiting. The only decorative element is a collection of prints and engravings spotlighted from above.*

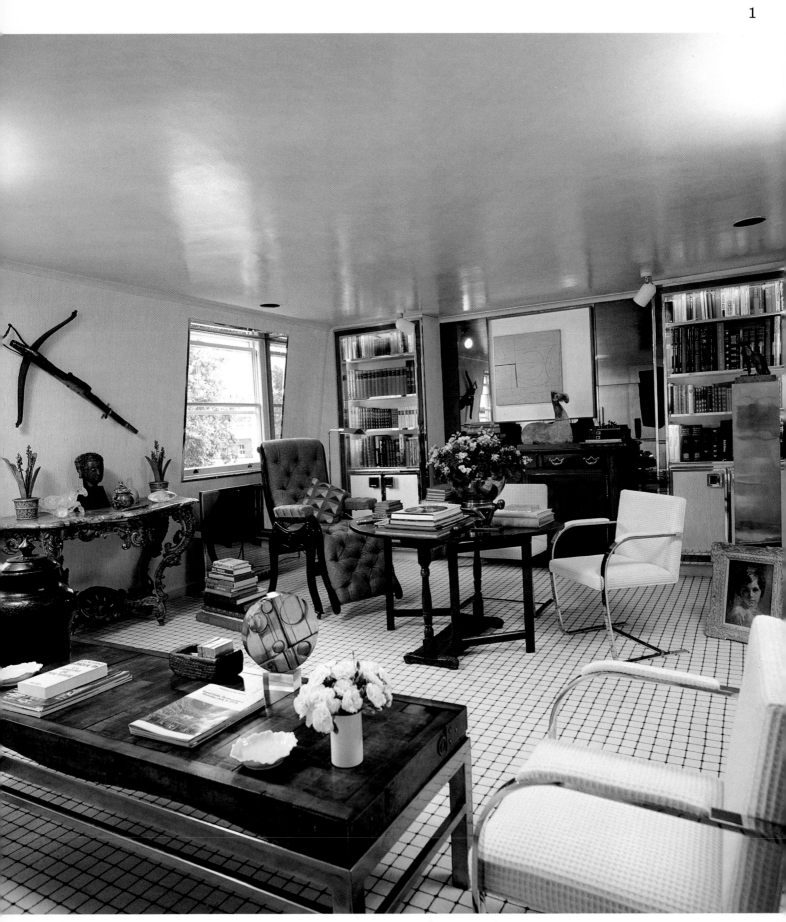

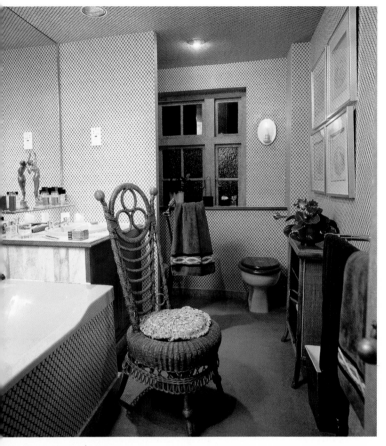

Jay Steffy

Jay Steffy describes himself as spoiled, but not in the petulant sense. He is referring to the fact that he grew up in the reality of America's fantasy—Hollywood and its film studios. With a father involved in film-making, he had the back lots, with their multitude of sets imitating all parts of the world, as his playground.

The people—the star system and its trappings of glamour—had their effect on him too. "Things I took for granted as a child are now the yardsticks of achievement for the rest of the world," he says. "I could never have created my style, or its range, if I'd grown up in London or New York."

More than most of us, Jay Steffy absorbs and is sensitive to his surroundings. Brought up among wealth, he learned early how to live well and with style, and he mourns the passing of gracious living in large houses—and the large staffs necessary to their upkeep. He sees most of today's world as a very mediocre place and feels his work has hit a plateau from which it will not rise again until there are exciting people and stirring events for him to react to and create from.

He is very much a child of the twentieth century. "Every town retains the foundations of the period of its creation," he says. "Los Angeles has the parameters and focus and power of the twentieth century. I absorbed that and I am part of it," he states. Ironically, though, as people in other places and other countries strive for the California way of life, either by bringing its designs home or by moving to it, old Angelenos, like fourth-generation Steffy, see it slipping from their grasp. "As people come in who are not part of the culture, that culture—which they are seeking—is diluted," he says.

His awareness of the world and what goes on in it dictates, to a large extent, Jay Steffy's designs. "The mid-sixties, when I started, were an exciting, creative time, and I responded to that. But now I have nothing to play against." That's one reason he has kept a low profile for the last four years. Another reason was his realization, in collecting pictures of his work, that, "whatever style I used, all the interiors had the same posture, the same scale, the same environment. Laid out all together, they looked monochromatic.

"So I moved myself, both mentally and physically, from a large space into a small space, and I've been trying to reorganize my thinking as far as the environment and its prerequisites, prerogatives, and efficiency are concerned—consolidating energy and looking for a new mental and physical spatial correlation. I've spent the last four years studying myself. When I do something new again, and I will, it will be based on that. What I've been doing during this period, as far as my work was concerned, has been to reiterate what I've already done."

What Jay Steffy had already done was considerable. When he graduated from high school he went to Paris, where he registered at the Sorbonne. "Registered," he emphasizes, "not studied." He visited relatives in England and returned to Los Angeles, where he spent three semesters at the Art Center College of Design. There he learned technique: "color, perspective, and photography. I'm very good at transposing three-dimensional things into two dimensions, as if through a camera lens." He is, indeed, an extremely talented photographer, but he is just as good at taking a one-dimensional idea and turning it into three-dimensional reality, as he discovered "when a friend inherited a lot of money and asked me to do his house. That's how I became an interior designer."

In the next ten years, Jay Steffy designed interiors traditional and modern with stops at most points in between. "I do a design the way I feel. I'm the star—the producer, director, and set designer. In a way, the clients rehearse *my* act that I've created for them. Interior design is really egotistical. It's the ultimate ego trip. If people ask you what color to paint their walls or which sheets to buy, they are asking for *your* value judgments. You are the arbiter and you are imposing your values on them.

"But you must be prepared to take the consequences and accept the responsibility of doing that. They have the money; I have spent the time learning how to live. They want a transference of my ideas to them."

The apartment shown here is special in many ways. While Jay Steffy considers it one of the finest things he's done, he also says—and it is not a contradiction—"it is too good." The apartment is in a modern suburb of Madrid, is used by the owners only a few months a year, and was done at the end of the Franco era "when labor was very cheap. You couldn't do it now. It would be far too expensive to construct anywhere in the world, and even if you could, you couldn't live in it all the time.

"Also, the environments I create are my history, and I'm too old to do it now. The concept was to be entertaining, and we took an ordinary modern apartment and reshaped the interior with bricks and cement. I

wanted to create a fluid space; a graceful posture. It was in intentional contrast to the Cubist epoch and a direct reflection of the art of the time—it was 1972—Stella, Frankenthaler, and that kind of abstract painting.

"I wanted it to have more than first met the eye. I wanted everything to lead somewhere in a clean sweep —like skiing. It's a place to go where there's so much happening that you don't have to think of anything else. Because it was in Spain, I let myself be influenced by Gaudi. If I had had the same basic ideas in Italy or in France, the result would have been different."

With new ideas in the embryo stage, Jay Steffy may not yet know what direction he will take in the future. But he knows which one he won't. "Today, there is so little to feed on creatively that it is dangerous to do modern design; it could look very silly in a historical perspective. And modern, whether it's minimalism or high-tech, is so restrictive and much more difficult to live in than a looser, more traditional environment. I like interiors where you can move things around."

Color photographs by Jay Steffy.

1. *The abstract swirl of a gold-leafed staircase leads from one fantastical level to another in this Madrid apartment designed by Jay Steffy.*
2, 3, and 4. *In the sensual sweep of the living area, emphasized here by the photographer's use of a special lens, the floor is mirrored, the ceiling gold-leafed. Velvet-covered seating on natural fieldstone platforms has the same fluid lines as the cement and brick walls. The window wall is made of sections of black and clear glass angled against each other. The curved gray shelves were intended to be used, but have been left empty to become sculpture instead. Directly below the staircase is a Gaudiesque open fireplace. The fat red columns conceal storage. The painting to the left of the fireplace is by Hans Hofmann.*
5. *The upper level was the roof terrace. Now enclosed, it is the master bedroom and bath. Here, the floor is fieldstone; the eiderdown-covered bed is angled on a carpeted platform. Beyond the stairwell, a marble tub clad in polished steel is set directly under a skylight.*

1

2

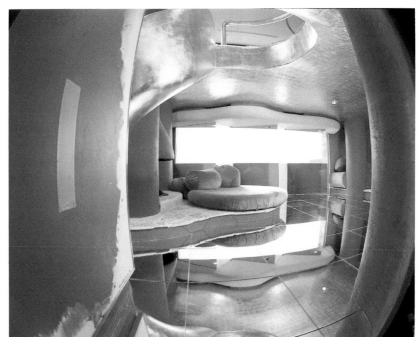

3

4

5

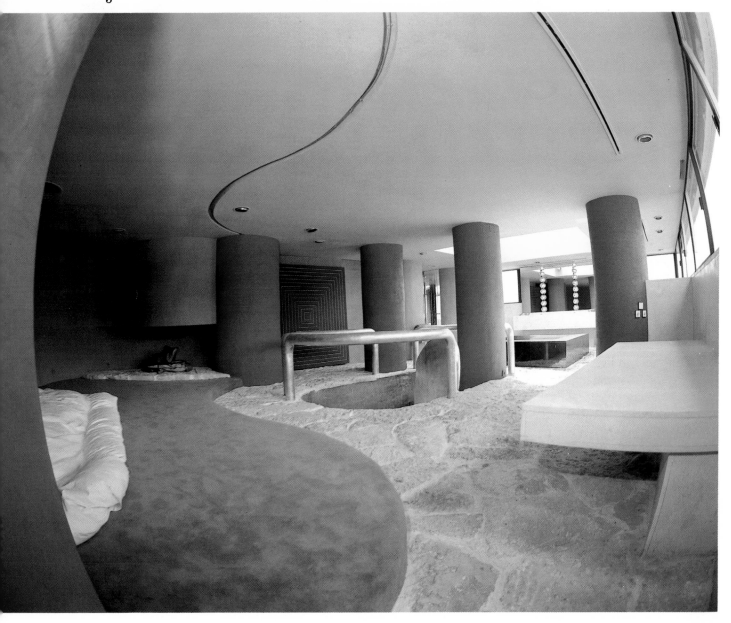

Mica Ertegun and Chessy Rayner (MAC II)

Mica Ertegun

Although in the past most interior designers were really decorators—talented amateurs who started by doing their own homes and helping friends with theirs—today most undertake some training before going into business on their own. Two people who did it the old way quite recently are Mica Ertegun and Chessy Rayner, partners in the thirteen-year-old New York design company, MAC II. Their only real experience when they formed the company had been in decorating their own homes. "I had a friend who always asked my advice when he moved from one apartment to another," says Mrs. Ertegun, "and Chessy had worked for *Vogue*. We were both looking for something to do and we thought, why not?"

At first they confined themselves to decorating—choosing fabrics and furniture for clients. But as their business grew, so did their professionalism. "Now, the first thing we do is a floor plan, and if moving walls, windows, or doors will make the whole scheme work better, we suggest it," Mica Ertegun says. "We are not architects, but we are past the stage of just being decorators. We are equipped now to handle blueprints and contractors."

Both agree that they still design initially by eye and instinct and that they can give clients only what they like themselves. While they do not confine themselves to any one idiom, they do insist that everything, whether antique or modern, be of top quality and uncluttered. "Too many objects confuse the eye," says Chessy Rayner.

But a MAC II interior today will be less stark and contain more color than one done ten years ago, perhaps because as designers they have gained confidence, but also because the prevailing mood is for softer, warmer surroundings. "We do reflect our clients' wishes," says Mrs. Rayner. "You can't make them live the way *you* want them to live. Every family in America lives differently. Some spend a lot of time in the kitchen; some like family rooms; some want a small room where they can shut the door on the world; some want a bedroom to be just that, others want it to incorporate a library or sitting area."

Then there are the clients who want—and like—things the designers hate. "A lot of men want one of those reclining chairs, which I loathe," says Mrs. Ertegun. "We try to talk them out of it, but if they insist, all we can do is buy the least ugly one and have it re-covered to *try* to make it work with the decor. Then there

are family things that people have lived with all their lives. They can make things rather difficult. But I think that anyone who's used to certain things should have them. And it's also part of the fun to try to combine them in a way that's not offensive. Sometimes we succeed better than other times."

MAC II caters to the client in other ways. The firm always offers alternatives in their presentations and lets the client make the final decision. When a job is complete, they will also add such snippets of information as the names of the best florists in the area and, if the clients are young and unsure of themselves, will help with such things as table arrangements for their first dinner party. "After all, if you want your work to look its best, these little things are important."

Neither woman foresaw their success. But the style they developed—a combination of Mrs. Rayner's acute sense of color and fabrics, Mrs. Ertegun's feeling for space and shape, and their upbringings which had taught each how to live well and with elegance—has appealed to an increasing number of people during the seventies. Indeed, in a MAC II interior, that indefinable sense of living well becomes almost as tangible as the contents of the room.

Chessy Rayner

A capacity for living well is something we all search for and few possess. It almost defies description, but it includes the ability to analyze what you need to make your life work the way you'd like it to, and then to satisfy those needs stressing simplicity and quality. The aim is always ease and comfort.

Mrs. Rayner and Mrs. Ertegun both possess this gift in their own lives, and they try to pass their knowledge on to the client. "You can't always change people's habits, but we do try to improve them," says Mica Ertegun. "Some people are very receptive and want to learn. Others don't. We have walked into homes a year after we have done them and felt like crying because the owners have filled them with things we detest. But what can you do? Beauty *is* in the eye of the beholder, and what's good to one person is bad to another."

There was no problem with the clients who owned the house shown here. It belongs to Mr. and Mrs. Ertegun. It is in fact a barn and still looks it from the outside —the original sliding doors, for example, remain behind the fireplace. Inside, the rooms were created within the existing arrangement—a double-height central living room flanked on either side by two-story haylofts. One hayloft was converted into the master bedroom and bath

above a small study and maid's or guest room, bath, and powder room. The other has two more guest rooms and baths above a dining room and kitchen.

Everything was kept as simple as possible. "I wanted to be able to close it for several months without worrying," Mrs. Ertegun says. The interior siding was in good enough condition to need nothing more than cleaning; the fireplace and skylights add their own clean lines, and vinyl tiling was used on all the floors. "I wanted a house I could just mop. Rugs go down in winter, come up in summer. The furniture was picked up here and there. There's nothing 'important.'" Upholstered pieces are deep and comfortable and covered in hard-wearing cotton. "Everything requires minimum maintenance."

The barn came with some property the Erteguns bought. Originally, Mrs. Ertegun wanted to ignore it and build a house. It was her husband who persuaded her to convert the barn. "If I were to build a house now," she says, "I would do exactly what I did here. It's ultra-practical, ultra-easy." That's what living well is all about.

Color photographs by Karen Radkai, courtesy of Vogue. *Photographs of Mica Ertegun and Chessy Rayner by Bill Cunningham.*

1. *The furniture for the dining room in this former barn was "picked up here and there," says Mica Ertegun. The chairs were bought locally, the apothecary's chest in England. Individual decanters are a favorite MAC II touch.*
2. *The central area of the barn is a double-height living room. The balcony leads to bedrooms. The fireplace and skylights were added. Furnishings are simple, with the emphasis on comfort and easy maintenance. The painting is by Morris Louis.*
3. *In the master bedroom, the floor, like those throughout the house, is covered with easy-to-clean white-vinyl tiles. The bedspread is a Liberty print; the paisley fabric on dressing table, chairs, shower curtain, and bed ruffle is by Pierre Deux.*
4 and 5. *The original beams and the wood siding of the barn are the main features of the study. Sofa and chairs are covered in a simple cotton print; the Indian marquetry desk was found in London.*

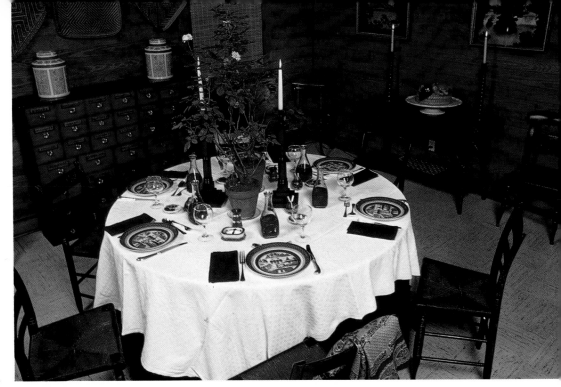

1

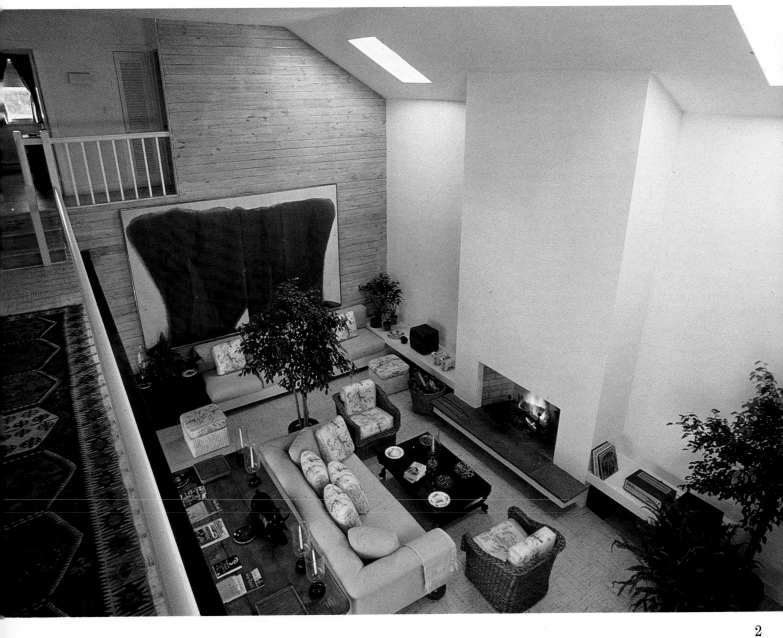

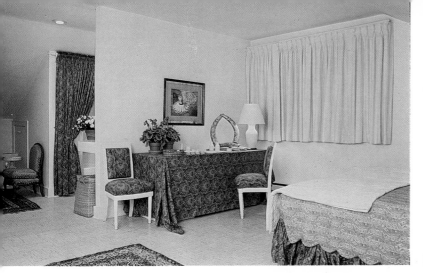

3

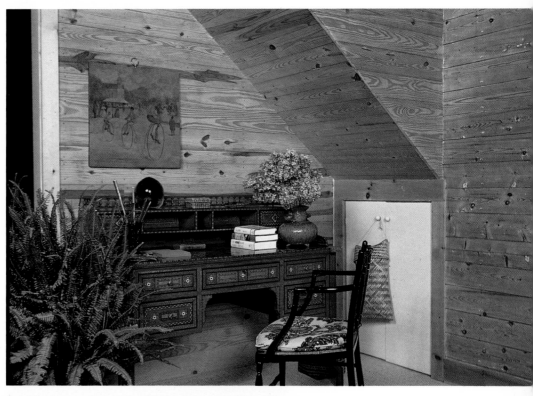

4

5

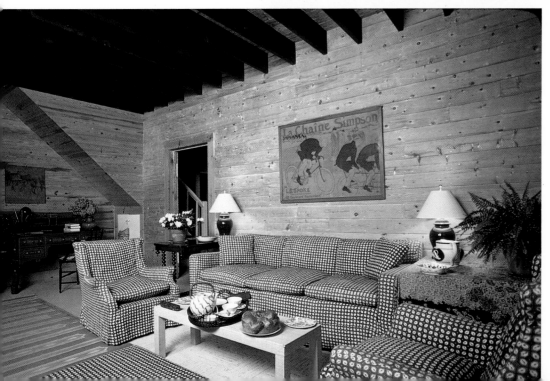

Renzo Mongiardino

Put "design," "Italian," and "architect" together in one sentence and they usually conjure up a picture of sleek interiors incorporating the latest labor-saving advances in technology. So at first glance the interiors of Renzo Mongiardino—Italian architect and interior designer— seem a throwback to the past—back, at times, as far as the Renaissance—incorporating as they do more decorative elements than most Italian interiors today. Mr. Mongiardino positively revels in tapestries, elaborate window treatments, moldings and cornices, marble (real and *faux*), gilding, and, very often, pattern piled upon pattern.

He has, in fact, little sympathy with the modern vernacular. "New houses have very little character. The contemporary is really not in my nature. I don't mind all of it, but I dislike such things as thick glass furniture with heavy legs. Also, such modern materials as glass, chrome, and Lucite are not, as many people think, easy to care for. They must be sparkling and clean at all times, and when they chip or crack you can't just mend one corner. You have to replace everything."

It was his dissatisfaction with the modern that made Mr. Mongiardino decide to concentrate on interiors rather than buildings when he qualified as an architect in Milan over thirty years ago. "I did design some houses," he says, "but I realized early on that I preferred

to take an old house and restore it. I am better at reconstruction than construction. But I am not a decorator," he insists.

"All my work is done with love and care in accordance with strict architectural principles. It's true that I always go back to the classical—that's the style I love best. But I don't copy it. I take an idea and develop it. I never do anything just for effect, and what I do is more practical today than ever before.

"Houses that I did twenty-five years ago only need a little touch-up now and then to still look good. My interiors are designed to age well, and houses are like people: they get older and they should age gracefully. If a house, like a person, is beautiful to start with, it will become more beautiful with time.

"Modern interiors can't do that. They are like women who refuse to get old. If they are not absolutely perfect, they look terrible. So I think I am simplifying life in the long run.

"In fact, the few houses that I did more as a decorator—concentrating more on color and contrast than on architectural integrity—are the ones that haven't lasted or are completely changed now."

Many of these were done in his early days as a designer when he lacked the confidence to stand up to a client. "I would do what they asked even though I didn't agree with it, and hope that it would all come right in the end. It never did.

"Today I only want to talk in general terms with any client. I want to discuss the problems and the general life style, but I don't want to listen to all the little details. When it comes to those, clients don't really know what they want. The framework is the important thing." Once the basic idea is agreed upon, the architecture is tackled. "If a door is in the wrong place or is the wrong shape, any kind of cosmetic disguise will be useless, because the lines will always be wrong."

What goes into a room depends on many things and varies widely according to the client, his possessions, and the location of the house. "I would never do the same thing for an old woman as I would for a young one, or for a Florentine as against a New Yorker. If the client likes Italian fourteenth-century painting, the colors of a room would be different from one done for someone who likes Picasso."

Some things, however, he would never do. "I won't do a wall treatment that will fade and look bad unless

it is kept clean, and I won't use matching wallpaper and fabric. The former always fades, and the latter changes color when it's washed or cleaned. They don't age well together."

Although he has been in business for more than three decades and says that each interior he has done has been measurably different from the last, Renzo Mongiardino does not think his work can be divided into "periods." Rather, it has evolved as he gained experience. "What I used to achieve with simple, but minutely detailed, effects—because I didn't know how to do the complex things—I now do with a bolder approach. I think now that a lot of little simple things are, in fact, more complicated than a few bold, big effects."

But he has always been a master at mixing pattern on pattern, a talent he thinks must be intuitive. "Of course, it's easier for me to do now than it was twenty years ago. But I find it no different than, say, the way Yves Saint Laurent uses patchwork and lots of color. He has a taste for it and is artistic, so it works beautifully. In other hands it would be a disaster."

The house shown here illustrates how Renzo Mongiardino can combine pattern both vividly and monochromatically. It belongs to his close friend, director Franco Zeffirelli who, Mr. Mongiardino insists, must share the credit for its success. Mr. Mongiardino has designed stage and film sets for many of Mr. Zeffirelli's productions, and, he says, this house was another collaboration.

"It is not a typical house or apartment. It is on the Italian coast, overlooking trees and the water." The ground floor consists of three arched, interlocking rooms, rather like a triptych, and it was agreed that these would become one large living and dining space for entertaining and relaxing. Another reason for keeping the rooms open was that the extension of the center room—the main living area—is a portico that leads in turn to the gardens and the view of the water. "Since everything is kept open, the whole effect is of being in an enclosed outdoor room."

The mix of pattern is extraordinary in its subtlety, depending as it does on the interplay of white on white. All the tiles were made locally and were laid to resemble an intricate carpet design. They were continued up the walls to strengthen the Moorish feeling evoked by the arched ceilings. Tiles were also studded "like stars" in the ceilings purely as decoration. The deep banquettes

piled with cushions encourage the North African motif, and the dining area with its ceiling fan, wicker, and palms is pure Casablanca. Shells piled as ornaments and eighteenth-century Venetian chairs bring the ocean closer.

The riot of pattern in the master bedroom could be controlled only by a master. "It was amusing for me to do it here," says Mr. Mongiardino. "Franco already had some of the furniture. It is made in Tunis of wood inlaid with mother-of-pearl. The Indian fabric is very pretty and actually geometric, so I worked out a design whereby it gives strong lines to the room. Once that was decided, we bought more of the Tunisian furniture to complete the room."

This house was different from most projects in that it was done with, and for, a close friend. But, says Renzo Mongiardino, each house presents its own problems. "In all the years I've worked, no two have ever been the same. That's the challenge that keeps me working. If I ever start seeing the same solutions to the same problems, I'll quit."

Color photographs by Robert Emmett Bright.

1 and 3. *A Moorish-Oriental influence is evident in the arched rooms of this Italian villa designed by Renzo Mongiardino. Two of this triptych of rooms are living areas, and both depend for color on flowers and changing qualities of natural light reflecting from their white interiors. Specially made white tiles were laid in intricate patterns on the floor and used decoratively on the walls. Recessed alcoves are filled with banquettes covered in ivory cotton and velvet and heaped with pillows. The forms of seashells used as objets d'art are repeated in the shapes of the eighteenth-century silvered-wood Venetian chairs. Ceiling fans keep the rooms cool in summer.*
2. *The third arched room is for dining and is simply furnished with a straw mat and wicker furniture. Palm trees are carefully lit, as sculpture would be. The room opens directly onto a terrace.*
4 and 5. *The pattern-piled-upon-pattern theme of the master bedroom stemmed from the Tunisian furniture inlaid with mother-of-pearl. The fabric is Indian cotton and was hung to give a paneled tent effect.*
6. *Part of Franco Zeffirelli's collection of Neapolitan majolica figures is grouped on a chest.*

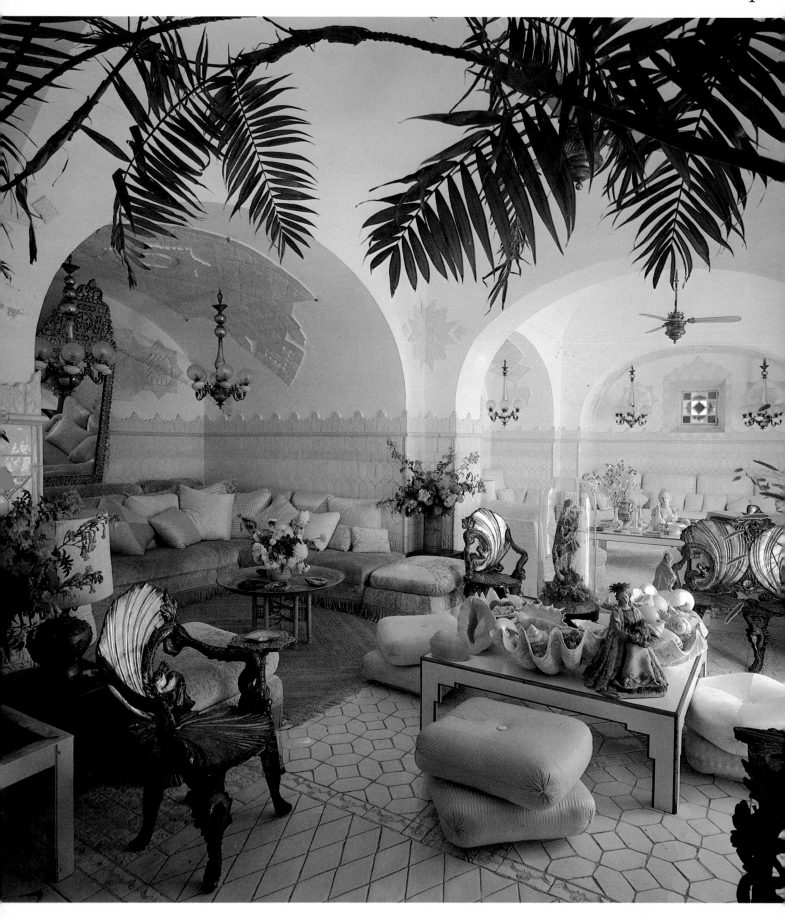

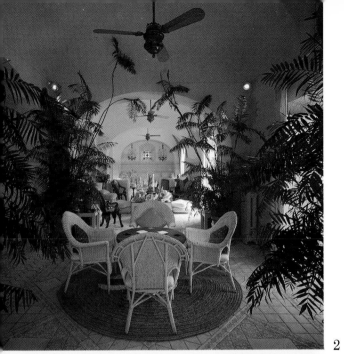

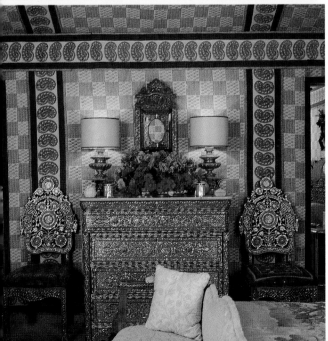

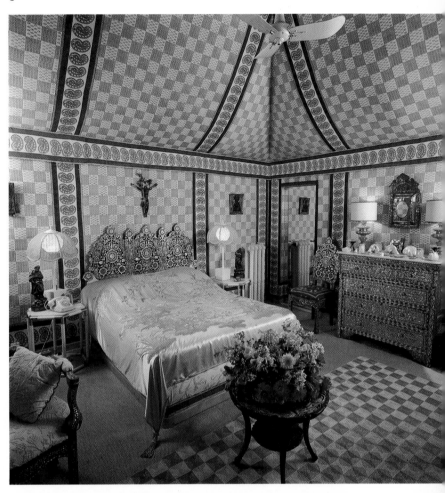

5

2

3

6

4

Gae Aulenti

Interior design has long been accepted as a serious profession in Italy. As far back as the sixteenth century, Michelangelo was decorating the interiors of the buildings he designed and often providing the statuary as well.

The postwar years in that country have seen such a renaissance in architecture and its related fields that the word Italy is now synonymous with modern design. Design is not a subject that is taken casually, though it occasionally has its whimsical side.

It is difficult to find an interior designer in Italy who is not a qualified architect. Not only do these people design the interiors of their own buildings, they also do not scorn to tackle someone else's structure, whether it's old or new.

Many also design lighting, furniture, and other products, regarding even the humblest accessory as part of the environmental whole. It is this all-embracing attitude, as much as anything, that has given Italy its preeminent position in the world of contemporary design.

One such architect is Gae Aulenti. Ms. Aulenti is as well known for the residential and commercial buildings she designs as she is for her chairs, lamps, tables, and storage units—and for her restoration and renovation of centuries-old structures. A leader among leaders, she also lectures on architecture, is a director of a design magazine, and is an industrial consultant. Her range is wide but her views are firm.

"Never decoration, only design," is her creed. She sees interiors as a series of problems that must be dealt with in a cerebral, rational way. She is passionate about her work but not emotional. "Creativity seems to me to be the strongest private passion that seeks to be rational. To elaborate forms is equivalent to creating emotional bonds."

Gae Aulenti interiors are geometric forms, restrained and orderly, whether based on the right angle (though Ms. Aulenti admits that "too many can be repetitive and a little dull"), the pyramid, or the arc. "These forms have always existed. There they are—the pyramid, the stairway, the cube, the arch of the Mayan temple. But our work today is quite different and is addressed to the connection among these forms—to relating them—to assembling our own images."

These images—which should also reflect the personality of the owner—are what Gae Aulenti creates in her work. She describes a house as "a container" for a

way of life, and furniture exists as part of the whole; it is "never just meant to fill spaces that are empty." She was one of the first architects to design a house devoid of conventional furniture, replacing it with platforms, cubes, levels, and shapes all sculpted from the space.

"It doesn't interest me to transform a surface or to fake it up with fabric or mirrors or marble," she says. "It doesn't interest me to embellish walls that remain bare and useless and without meaning until the furniture and paintings arrive. What does matter to me is to determine a space, to define a structure that in itself is already so finished and complete that when you enter such empty surroundings, they seem perfectly filled and you are comfortable there, living in an already resolved space.

"Later, naturally, you bring to it your own personality, your own things, and the house takes on the character of the person living in it. Nonetheless, the structure remains the stronger element."

This intellectual strength has always been present in Gae Aulenti's work. She graduated from Milan's Polytechnico in 1954 and immediately started her practice in that city. She still lives and works there. Though she quickly became well known in Italy, it was the American and European showrooms she designed in the late 1960s for such companies as Olivetti and Knoll that first brought her international acclaim.

This technical background is never very far from her thoughts. She designs industrial products and has long used industrial materials in her work. "Architecture," she believes, "is a positive thing that has its substance in the city, where nature is transformed through the exercise of reason. None of man's objects, whether monument or den, can escape its relationship to the city."

In the apartment shown here, on the top two floors of a seventeenth-century tower in Turin, Gae Aulenti has consciously promoted the relationship between interior and exterior. Her renovation makes the outside landscape an integral part of the overall design.

The original brick walls and the top floor's arched ceilings have been retained to serve as a framework for the restrained geometry of the new planes and levels she introduced. Their rectilinear emphasis is strong but not overpowering, and it is continued in the furnishings, which are cool and square, and in the staircases—a favorite Aulenti design element. Whether solidly grounded or free-floating, these make their presence felt as sculptural elements as much as utilitarian necessities. This ambiguity of purpose is also dear to the designer.

Although Gae Aulenti has been at the forefront of what many consider a design revolution during the last twenty years, she does not regard herself as a revolutionary. Rather, she is a realist. "I believe in a certain classicism," she says; "in naturalness of movement, in serenity of ambience, in primary forms. I do not like a false ease of movement. In a house, everything must function well, and nothing must be seen to be functioning. With technology today, one can really solve everything—and also conceal everything—with pure form."

Gae Aulenti has quoted Jorge Luis Borges to explain the way she works. "Nothing is built on stone, all is built on sand," he wrote, "but we must build as if the sand were stone." "I am decidedly against everything that is disposable, inflatable, deflatable, destructible," says Ms. Aulenti. "We must never build the ephemeral. I can give myself to my work only if I think of it as finished, definitive, motionless, without knowing whether it will be destroyed in a few months or a few years."

Color photographs by Carla de Benedetti.
Photograph of Gae Aulenti by Maria Mulas.

1. *A series of "floating" wood steps crosses all boundaries at the far end of the living room on the way up to the top level. Furniture is strictly modern.*
2. *Gae Aulenti has made the top two floors of this seventeenth-century tower into a streamlined and highly efficient home for the twentieth century. The view is framed in plate glass windows. Ms. Aulenti has uncompromisingly abutted stark structural changes and additions to the original warm brick.*
3. *An almost monastic pallet bed on a wooden platform is placed under ancient arches in a bedroom on the top floor of the tower. The platform holds storage drawers.*
4. *Lines and planes are sculptural elements as well as architecture in Ms. Aulenti's hands. The staircase, carpeted like the rest of the apartment in orange wool tweed, serves its purpose of leading to bedrooms but was also designed as an art form in itself.*

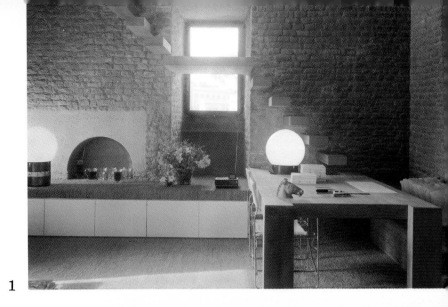

1

2

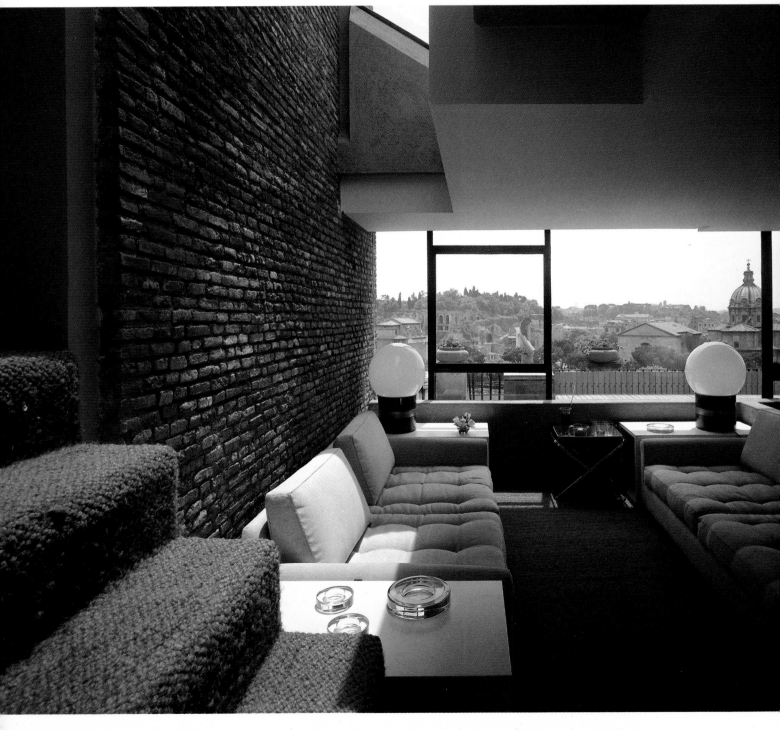

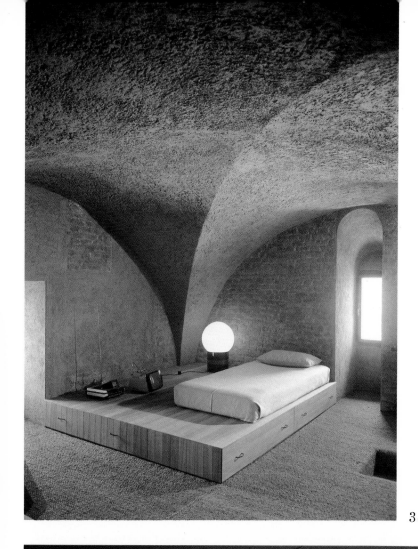

3

4

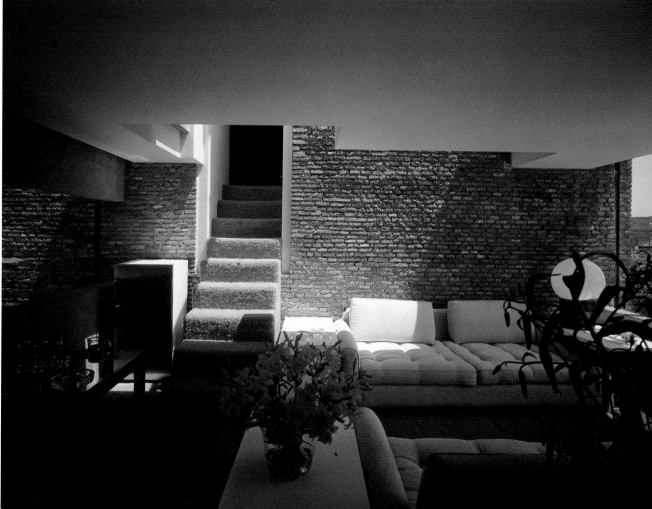

Victoria and Ronald Borus

Most interior designers will tell you that they exist to give a client what he or she wants. And most do—within the framework of their own style preferences. Victoria and Ronald Borus go one step further. Their hand is virtually invisible. Seeing one of their interiors, an educated eye may be aware that an expert has been at work, but it is almost impossible to identify which expert. "Increasingly," says Victoria Borus, "people come to us because they've walked into a house we've done and, while it's obvious that a professional has been at work, it's equally obvious that its owners are completely at home. We create rooms in which the owners clearly speak out, even if they were inarticulate when they came to us."

Says Ronald Borus: "We really have a need to become very involved with each client. I want to like them a lot. There they are, about to embark on a great and expensive venture, and suddenly we enter their lives: two people who are going to be involved with every gesture and every move they make. We have to become friends, because we need to understand what it is they would do if they had our experience."

"It's a tremendous luxury," adds Victoria. "Not just having a designer but having someone you can really talk to who will take the time to figure out what you're trying to say. Many of our clients still phone us before they buy anything, from a major art acquisition to placemats. It's not that they're unsure of themselves. They want us to share their pleasure with them."

And the Boruses do not accept clients unless they think the pleasure will be mutual. "We all have to see the same special elements in a house so we can do something we'll all get pleasure from," says Mr. Borus. "If we don't think we fit in, we won't take the job."

"Nor," says Victoria, "will we start with elements we don't like; a rug, for instance, that we don't like or think is not fine enough. We want to start a project with something good." They get rid of the offending item by persuasion. "We explain why it isn't right. We don't just say it has to go."

It's a technique that usually works, especially when it's reinforced by the completeness of the schemes Borus and Borus present to each client. Every function is taken care of in detailed floor plans, and, says Ronald Borus, "every single inch—colors, use of space, materials"—is settled before they start a job. Everything has to be under control, even if the clients don't really understand it.

"They will when they're living in it, but until then, they have to trust us. A lot of faith is involved."

Victoria and Ronald Borus met when they both worked for Angelo Donghia, married in 1970, and started their own design company in 1972. Both have natural talent ("I swear we could walk into a Quonset hut and arrange whatever furniture existed in a more pleasing way," claims Victoria), which was honed by their years with Donghia. "It wasn't so much training," continues Mrs. Borus, "it was the opportunity to work. You learned first to make a pretty pillow, then a chair, then a table. After that you graduated to designing an elegant doorway, and from that to bigger things. We learned to treat each element as a separate entity—that there are two sides to a door."

In the last ten years, the Boruses' design philosophy has radically altered. "At first, we thought that everything should be 'drop dead,'" says Victoria. "Everything had to have a new twist and fussiness. Now we realize that everything new becomes old and that after a year or two it either blends into the mainstream or becomes dated."

Another reason for the change is that their clientele is different. "More and more are professional people who use us as they would their lawyer or accountant," says Ronald. "They have excellent taste themselves, but they don't want—and haven't the time—to deal with contractors and spend months shopping for furniture. They hire us to take them straight to the best and to do all the worrying for them."

Because the Boruses see themselves so much as a conduit for their clients' tastes, it's very difficult to pin their work down to any idiom. But there are certain things, they believe, that are desirable in any room, no matter who lives there. "It's always desirable to fix the architecture—balance and symmetry are important in any design," says Ronald. "And, if you're going to sleep in a room, there's usually a best way to face. Theoretically, there are infinite ways of designing a space. But in practice, once we have organized its function, we look to the client for feedback. When you get right down to it, even great art is still a painting of certain dimensions —and how many different kinds of table are there? In that sense, we're dealing with the same mundane objects over and over again, and people all tend to live in similar ways. Designs very rarely come from a brainstorm, so what makes each unique is the client. We pick up

nuances very quickly, and specifics make our job much easier—even those that seem diametrically opposed to each other."

The design of the apartment shown here came from very definite—and very different—desires. The clients are a couple, each with strong and sometimes opposing points of view. Say the Boruses, "She wanted eighteenth-century English and American antiques; he wanted classic modern furniture. Both loved antique rugs, and they owned a growing art collection. But they also wanted the overall effect to be serene." Also, although every piece of furniture, except for a chest, a brass bed, a clock, and some chairs, was bought by the Boruses, the clients did not want the end result to look new. They wanted to be able to entertain twelve people "luxuriously."

The designers satisfied these varied desires by drawing from what they call "1920s Park Avenue colonial"—a vocabulary current at the time the apartment house was built. It is a refined, straightforward style that the apartment had lost over the years. The Boruses rebuilt virtually every room. The attention to detail was meticulous. "The owners," says Ronald Borus, "are perfectionists. When we paneled the library, the door turned out to be one-and-a-half inches off-center. They insisted that it be corrected." Nitpicking? Not to the Boruses. "They would have seen it every day."

This kind of fine detailing that goes unnoticed by the casual observer is increasingly important to both designers. "We worry about the perfect tile joint, the proportions of the smallest bathroom, and the extravagance of not having an excess screw or joint," says

Ronald. "We refine, refine, refine," says Victoria. The fact that they do very little work in what Ronald calls "postwar characterless buildings" helps, in that they do have something to refine. "We work with spaces that have their own identity. Once that has been stripped to its essence, furnishing is usually not a problem," he says. "Furniture," adds Victoria, "is movable by definition. We don't plan it to be fixed immutably where we put it."

Clients sometimes have difficulty understanding this. "We would never do a job where every single object was suddenly installed in one or two days. Some clients think there will come a day when everything, including themselves, will be moved in and they'll never have to call us again until something breaks. It isn't like that at all. They have to realize that once we give them the bare bones, they have to participate and understand that their home will grow with them. They are buying concepts, not rooms."

Color photographs by Michael Dunne.

1. *The master bedroom with its brass red and blue-chintz-covered chaise has a traditional air. The writing table is eighteenth-century English, and on the mantelpiece is a rare garniture de cheminée of Chinese export porcelain.*
2. *There is not one less-than-perfect tile in the kitchen. Light shines through a tempered-glass hood onto the range built into an eating counter.*
3. *The walls of this living room were painted vanilla to make a quiet background for modern classic furniture and a growing collection of modern art. With lighting designer Ralph Bisdale, Victoria and Ronald Borus installed a two-circuit track lighting system to accommodate new art. A Morris Louis painting hangs above the fireplace.*
4. *In the living room, a Mies van der Rohe chaise is a counterpoint to Queen Anne side chairs. The painting is by Milton Avery.*
5. *Precision was the key word in the library. The Boruses designed the English oak paneling. To achieve absolute symmetry the door was moved an inch and a half.*
6. *In the dining room, Mies chairs pull up to an eighteenth-century mahogany triple-pedestal table. The sculptured head is sixth-century Mayan; the painting is by Ellsworth Kelly.*

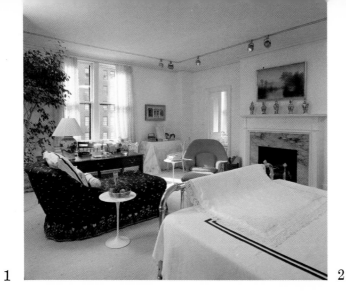

3

1

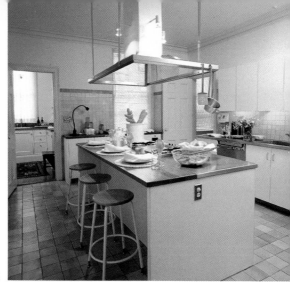

2

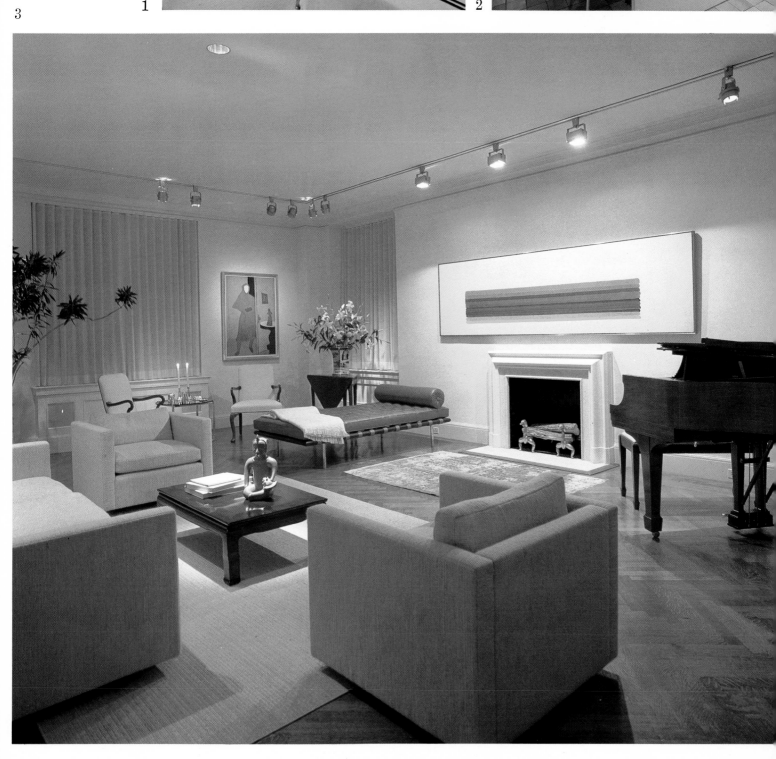

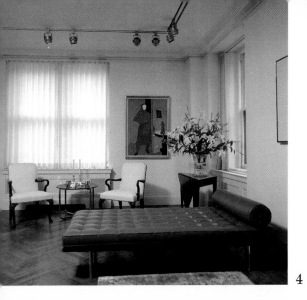
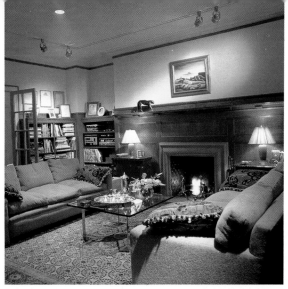

4

5

6

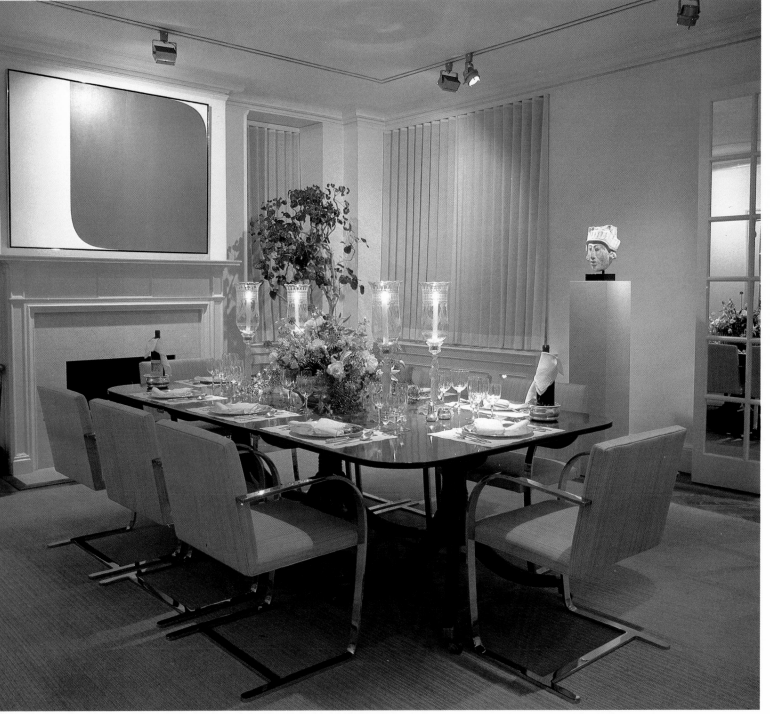

David Easton and Michael La Rocca

The last twenty years have seen the gradual closing of the gap between architects and decorators. Once poles apart—and proud of it—both are now borrowing increasingly from each other's disciplines. Few American designers, however, combine both arts as thoroughly as David Easton and Michael La Rocca.

Both thought of being architects but decided against it—Michael because he hated math, David because he enjoyed the history of architecture but little else. Both graduated from the interior design school at Pratt, which, they say, gave them the best of both worlds. "The interior design school was closely allied with architecture when we were there. The teaching was very much in the Bauhaus tradition, and that has been a great influence on our attitude toward design," says David Easton.

Both worked for several companies before forming Easton & La Rocca in 1971. Since then they have gained the reputation of being the compleat interior design team. Increasingly, now, they are designing houses from the ground up. "Naturally, we prefer that to an existing interior," says Michael La Rocca, "because we have total control."

Totality is important. Easton & La Rocca never work piecemeal. "When we show a client the sketch for a house, we also show the complete furniture plan. Then, before construction even starts, we show a sketch of the rooms showing the feeling of the decorations and the colorings. It's a complete treatment."

They work this way, both agree, partly because they are naturally methodical and partly because of their training at Pratt. Says Mr. Easton, "All the ideas inside our heads have to be sorted out before we put anything on paper. At Pratt we learned to walk before we ran and how to make order from the jumble of our ideas.

"Neither of us has a chaotic approach to either architecture or decoration. We lay things out in a very systematic, logical, traditional way. The basis of our work is really classical."

But no two designs are alike, because, says Michael La Rocca, "everything we do has to be appropriate for each client and for different architecture." That is where the decorating side of their work comes in. "There are much more ephemeral qualities to decorating than there are to architecture," says David Easton. "There's a point where architecture has to give way to emotional elements —luxury, comfort, delight—and there's no discipline that can control those. We're dealing with the unknown.

Even if a client knows more or less what he or she wants, you're still dealing very much in the abstract. If they say they like a particular rug, for example, and it's ugly, you've got to find out what it is they like about it. And force it out of them if necessary. Perhaps they say it's because it has lines, not flowers. You understand from that that they want a geometric rug. We have to have a sixth sense in addition to knowledge and discipline."

It is also important that the client asks questions. "Most clients are very badly prepared," says Mr. La Rocca. "They should ask to see our work; ask about presentations; how the business side will be handled; what our schedule will be—all very practical things. We in turn will give them sketches and floor plans, elevations, drawings of special cabinet work; will show colors, textures, carpeting in the first presentation. Once that is approved, everything is put in writing. It's important to be systematic. There are lots of good designers who aren't successful because they can't handle the business side."

Even when they are dealing with an existing space, Easton & La Rocca bring the same thorough approach to bear. "You really can't have a beautiful room unless you start with a beautiful space," says David Easton. Sometimes that can be achieved by moving windows and doors or changing lighting and hardware—not major changes in their book.

But in many cases, including the apartment shown here, they gut the space. "This was two apartments we made into one," says Mr. Easton. "The main point was to give the rooms that overlook the park a spacious feeling. To do that, we had to tear out walls and windows. It belongs to a woman who lives in it only part of the year, so we could take a lighter, more frivolous approach than if it was her year-round residence.

"She is also a strong, creative person who loves color and luxury. We wanted everything to be pretty but not infringe on the sense of quiet we wanted to create. So the colors are clear and strong, yet soft."

As with any Easton & La Rocca interior, the ideas came from many sources. The mirrored entrance hall evokes a shop entrance Mr. Easton and the client saw in Paris. Many of the antiques were found in London, and the rugs were specially designed for the apartment.

In this case, the client-designer relationship is so close that Mr. Easton will still buy things he finds on his travels, knowing they will be right for both the apartment and its owner. But he will not furnish any interior

completely. "A room should be well-decorated, not well-designed," he says.

Well-designed in Mr. Easton's vocabulary is not a compliment. He uses it to describe minimalism and high-tech, both design doctrines he dislikes. "I don't like machines for living. They are controlled environments into which people are placed. There is no sense of individual involvement. They may be beautiful to look at, but there's a total lack of any sense of comfort. And all that genre looks alike.

"There has to be room for a client to add; room for expression. I hate buying paintings for a client, for instance. Art is so personal and should be the client's contribution."

It is this recognition that architectural discipline should march hand-in-hand with the emotional considerations of decoration that Easton & La Rocca would like to make their epitaph. "We would like to be thought of as the designers who made residential architecture and decoration one."

Color photographs by Norman McGrath and Richard Champion.
Photograph of David Easton and Michael La Rocca by Anacleto Relaniza.

1. *The mirrored entrance hall of this apartment was inspired by that of a Parisian shop. The mirrors seem to widen the narrow space.*
2. *The dining room/den has cordovan crisscross lacquered walls and a durrie carpet specially designed for it. Bamboo chairs pull up to a linen-covered dining table/ desk with a view of New York's Central Park. A pair of eighteenth-century Chinese Foo dogs sit on Lucite supports.*
3. *The peach, pink, and yellow colorings of the bedroom are clear but soft. The walls are striéed; the four-poster bed is carved wood painted white. In the corner stands an Indonesian tribal figure.*
4. *The 30-by-21-foot living room is primarily for entertaining. The space is broken into two seating areas separated by a curious table found in London; its legs are English Regency, its top Italian with marble insets. Mirror is used judiciously around a window seat and on a chimney breast where it is overlaid by an eighteenth-century Venetian glass mirror. The carpet, designed by David Easton, picks up the colorings of the David Mauldin painting.*

133

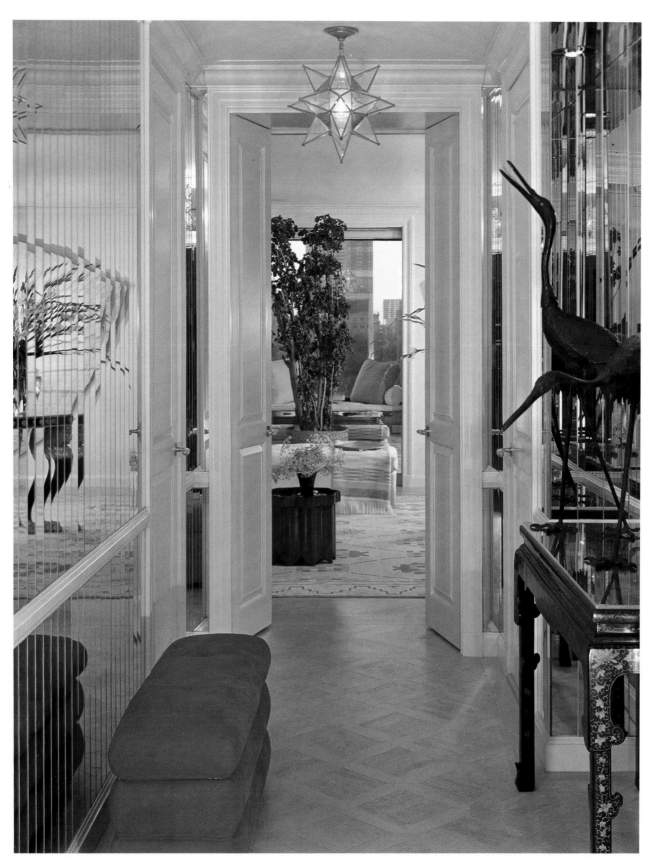

1

2

4

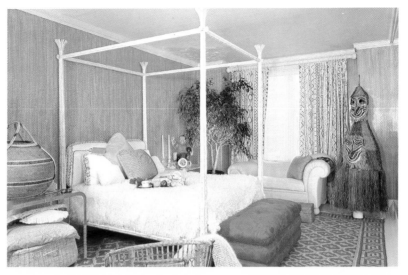

3

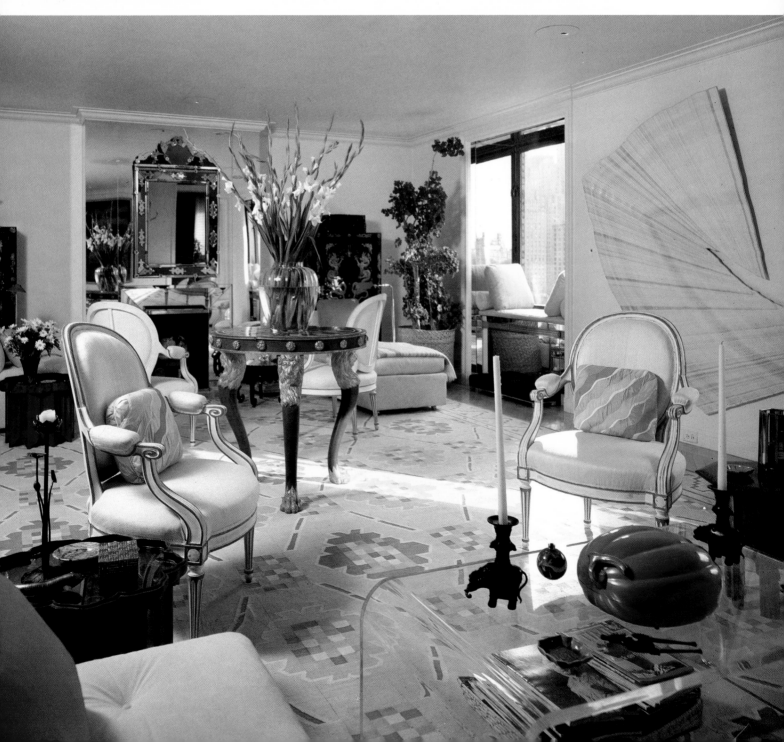

John Stefanidis

Words are dangerous things to have to use when describing the work of John Stefanidis. What is simple is also sophisticated; the austere is also gentle; what looks fresh and new is also timeless; what looks old has just been built. When one says that one of his interiors has a look of ease and effortlessness, one knows as the words are spoken that he probably gutted and completely redesigned the space to achieve that effect.

This contradiction is the mark of success as far as Mr. Stefanidis is concerned. "When I finish a room it should look as though it has had nothing done to it. Most of what I do is completely invisible when it's completed. The important things to me are those you notice only when they're wrong. That means proportion, scale, and light. I believe in good bone structure, not cosmetic surgery."

The fact that John Stefanidis invariably succeeds in his aim owes nothing to formal training. He had none. What he did have was a very cosmopolitan upbringing. He is Greek, spent his childhood in Egypt, studied at Oxford University, and worked in Milan before settling in England thirteen years ago.

His success stems from his innate sense of what is right. "I can't draw particularly well," he says. "But I can tell people exactly what to do. I always know exactly what things should look like, and that crystallizes in my mind's eye immediately. And my outer eye is trained in the sense that I can tell a good painting or piece of furniture even though I might be academically ignorant of the subject."

These two eyes—the inner and the outer—miss nothing. "Details are all-important when you are striving for the cleanness and elegance that comes from good proportions. If you are working within an existing structure, you have to respect the character of the building and its surroundings. What you see out the window is always going to be there. So many people miss that. Internally, the scale of a room has to be right, as do the little but not unimportant things, like seeing that the bath is not too high or the washbasin too low."

This concern for detail has nothing to do with fussiness and everything to do with harmony. A Stefanidis interior, wherever it is in the world, will always be just right for its setting and the people who live in it.

"So many people are frightened of involving an expert. They worry that their personalities are going to be swamped. But if you are not giving people a rubber

stamp interior, that doesn't happen. They can tell me their dreams and I can try to make them come true—within the framework of the architecture. The more personality a person has, the easier my job. It doesn't work the other way around.

"Of course, not everyone lives up to your expectations. If someone says he wants to collect pictures, you design on that premise. If he then doesn't do that, you get a beautiful but empty house. The structure, which is my main concern, should anticipate what will go into a room and the personality of the people living there."

Proportion and space are the two dominant words in John Stefanidis' design lexicon. "I wouldn't want to do a job where the space was wrong and couldn't be changed. I *could* do it and make it pretty. But that's very different from making it elegant. I am not a decorator, and I don't believe in expensive decoration unless it is on top of what is first of all a good structure. Palladio's 'Malcontenta' has beautiful frescoes which are an enrichment, but if you took them away you'd still have very good architecture.

"I think that applies to every space, and it's what I do best, because everything else—all the contents—are very relative and personal."

But John Stefanidis does not ignore furnishings. He gives them the same close attention he gives everything else. They are chosen or designed by him with an eagle eye for their "rightness" for their setting. The furniture and fabrics that he has designed in the last ten years have all stemmed from his need to provide what didn't exist—furnishings that would be tranquil and in harmony with the spaces he creates.

Early in his career, Mr. Stefanidis restored houses in the Greek islands, first for himself, then for clients. In so doing, he researched and respected the local architectural style and resuscitated traditional but almost forgotten building methods and crafts such as latticework and wood carving. In all these houses, some of which were rebuilt from the ground up, both walls and furniture look as though they have existed for centuries. In fact, almost everything is new and was made locally under Mr. Stefanidis' guidance.

The work shown here encompasses all the paradoxes that make Mr. Stefanidis' work whole. There is a sophistication to its simplicity, a gentleness to its austerity, a timelessness to its newness. Above all, there is an implicit understanding of what is right.

Color photographs by Michael Boys.

1. *The entrance courtyard of this house on the Greek island of Patmos looks much as it did when it was built over a hundred years ago. But John Stefanidis' imaginative use of lighting gives it a new nighttime beauty. The stairs at left lead to a rooftop terrace.*

2. *A guest bedroom combines simplicity with comfort. Furnishings are indigenous to the area. The iron four-poster bed is traditional to the islands, as are its white-gauze hangings. The bedskirt is edged with a Greek key design. The walls are whitewashed and left plain.*

3. *The making of latticework furniture is one of the old island crafts that Mr. Stefanidis has revived. In this living room, the furniture has been painted green, introducing the room's only touch of color. The white quilted sofa is piled with cushions all covered in locally made crocheted lace. The covering is rush matting.*

4 and 5. *An entrance hall and dining room are both floored in tiles made locally—another craft Mr. Stefanidis has revived. Walls are washed a traditional ocher color. Mr. Stefanidis put in the arch that opens the dining room to the courtyard.*

6. *More latticed furniture, this time painted blue, is used in a bedroom. The bed curtains are Turkish and hand-embroidered. Kilim rugs are on a scrubbed wood floor.*

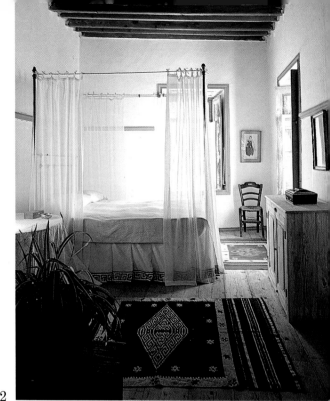

3 1 2

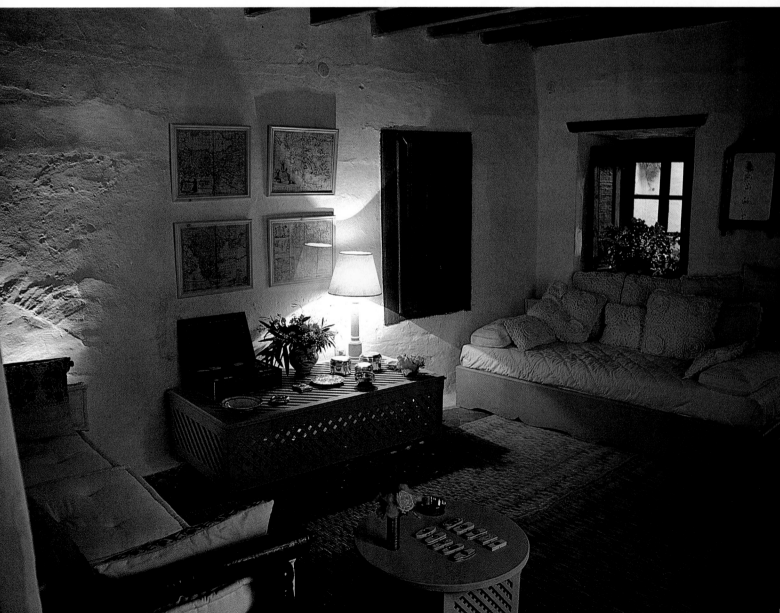

4

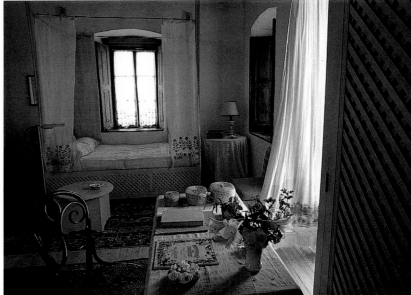

6

5

Eric Jacobson

German design reached its zenith with the Bauhaus, the school founded by Walter Gropius in 1919 to encourage creative design for the machine age and to emphasize its relation to function. The Bauhaus dictum that form should follow function has probably been the single most important influence on twentieth-century design and architecture. But after the Bauhaus was abolished in 1933, German design went steadily downhill to the point that, in today's West Germany, it is unrecognizable as a category or an influence. This situation does not disturb Eric Jacobson. Mr. Jacobson is a Swede who moved with his parents to Hamburg in 1954 when he was fifteen. "I am not," he says, "a German or a Swedish designer. If anything, I am European, but good design is international. If you can look at something and say 'This is American design' or 'This is Italian design,' then it's no good."

Mr. Jacobson was expected to eventually take over his father's paper and pulp business. To that end, he took degrees in psychology and business administration and did work for two years in the paper industry. But when he was twenty-eight, a relative asked his advice about her new house and his life changed direction.

"I realized I wanted to be a designer, either of fashion or interiors." His father was not enthusiastic about either. But, says Mr. Jacobson, while his father flatly refused his support if Eric chose fashion, he said he would help if he was serious about interior design. "So the choice was made for me."

His father's help included an introduction to an antique dealer who sent Eric to London for a year to learn the business and who, on Eric's return, joined him in buying a decorating firm. "They were very silk-and-satin," says Mr. Jacobson. "But they had wonderful workrooms. I bought the mechanical rather than the creative side." That was ten years ago, and the decade has seen the company change its name—to Eric Jacobson Designs—and its direction to reflect his design philosophy.

"At the start I used a lot of antiques, because that was what I knew," Mr. Jacobson says. "But now I'd only use them as accessories. I much prefer working with modern materials." What people are aiming for, according to Mr. Jacobson, is ease and comfort in their home—to have a haven away from the stresses of twentieth-century living. In his opinion no single design style can provide complete serenity. "A pure antique anything—whether it's Louis Quinze, Louis Seize, or Empire—is

like walking into a museum. Anyone with enough money can do that. It's not a question of design or taste." He also castigates such modern high-style movements as high-tech. "It's fantastic when you walk into it. It excites the eye. But it's so demanding of the people who live in it. You can't just sit there. You have to be colorful and 'designed' yourself.

"I like to mix things. I think it's the only way to give comfort and ease to the eye and the body. I do modern, but not fashionable, interiors. I'd never do anything that would tire quickly. I have clients who are still happy in houses I did for them ten years ago. Now I'm changing the curtains and upholstery, but everything else is still fine for them."

Mr. Jacobson prefers clients to treat him as they would any professional who provides a service. "A busy executive may be secure and have good taste but not know all the possibilities within the scope of that taste.

And why should he? Executives have no time, and their minds are occupied with other things."

Once he has learned as much as he feels he needs to know about a client, Mr. Jacobson wants to be left alone. "I want to walk into the room on my own. When I walk out of it, I know what it should look like. The furniture layout and colorings will be set. Accessories are flexible and will change as I go along. But I have learned through experience that my first ideas are the best."

His design decisions stem from the solutions he finds to a room's problems and from the limitations it sets. "There's always something," he says. "Even with the options available today, there are still not many alternatives for any specific room. There are always reasons why a lot of things won't work.

"I'm not aware of design from an architectural point of view—space, scale, and proportion. Architecture doesn't interest me at all. I wouldn't have any idea how to design a house from scratch, even for myself. But I can solve problems in existing architecture and make structural changes—though I still ask a contractor whether the roof will fall in if I move a wall.

"I don't necessarily give people what they want. I give them what I analyze is right for them and what they will want in years to come. They will change, and that must be anticipated. I've never had anyone unhappy about the result. In fact, when I started out, clients would tell their friends they'd done their house themselves. That used to upset me until I realized I ought to be flattered because it meant they were really happy."

While Eric Jacobson stresses that what he does is personal in the sense that each room is designed with a particular client in mind, he does dislike the fact that he can't keep the designer-client relationship as professionally detached as he would like. "You must keep a professional uninvolvement. Otherwise you'd be heartbroken every time you left something you'd finished. And when I finish a job, I do feel depressed. I think it must be rather like postpartum depression in a woman. A house is like a child. But I get over it when I start the next job, and when I go back to a house later on, I don't feel a thing."

This sense of personal detachment extends to his own apartment, shown here. "When I moved from my previous apartment, I brought only my paintings. I sold all the furniture with the flat. And I could leave everything behind in this apartment if I moved again."

What Mr. Jacobson finds much more difficult to get over is the client who wants to take charge halfway through a job, or the one who, once it's finished, adds a lot of objects. "I and my designs are very demanding, but I think it's very unfair to any designer not to let him finish something he's started. If I start something, I should be able to dot the i's and cross the t's."

Color photographs by Robert Emmett Bright.
Photograph of Eric Jacobson by Werner Bokelberg.

1. *In an impeccably restored turn-of-the-century apartment in Hamburg, Eric Jacobson has let the rooms—with their high ceilings, delicate moldings, and good proportions—speak for themselves and serve as an elegant backdrop for paintings. Detailing is so subtle as to be almost invisible. The walls, for example, are treated to a slightly rough texture resembling parchment. This gives them extra depth, and extra warmth to the lighting. A double drawing room opens off a long hallway. Like every room in the apartment, these are in Mr. Jacobson's favorite no-color scheme.*
2. *In one corner of the smaller drawing room, two tables display objects and serve as drink trays for entertaining.*
3. *Mr. Jacobson's Scandinavian origins show in a guest bedroom lined with light wood cabinets. A ladder is kept handy for reaching top closets. The bed has a suede coverlet.*
4. *The dining room, which opens off the larger drawing room, was originally a closet. Jacobson opened it up by installing glass-paneled double doors. The table setting follows the no-color creed—everything is white, silver, or crystal.*
5. *The long hallway is broken only by paintings and a sculpted wood chair of modern Italian design.*
6. *The smaller drawing room has banquettes covered with raw silk around two walls. Lighting is recessed behind them.*

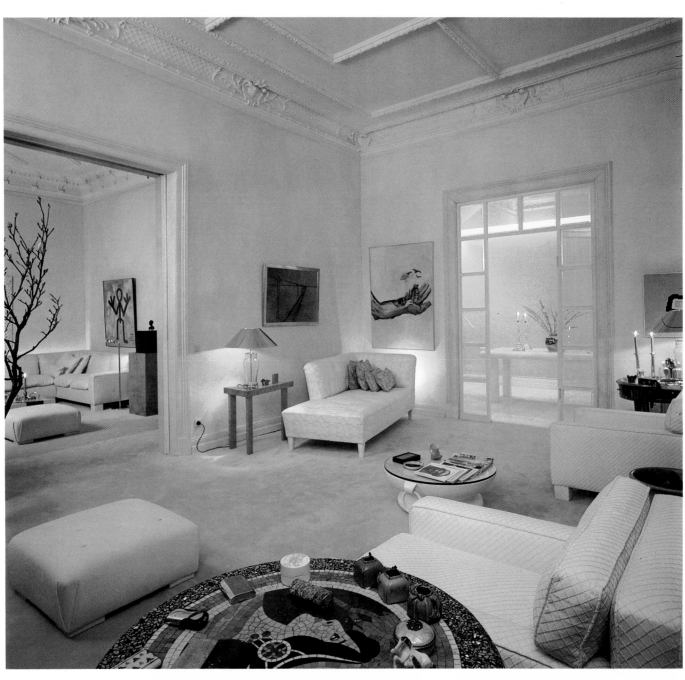

1

2

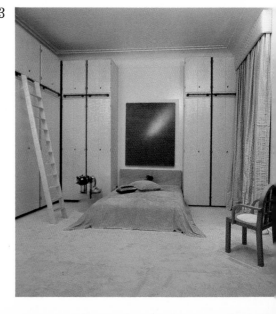

3

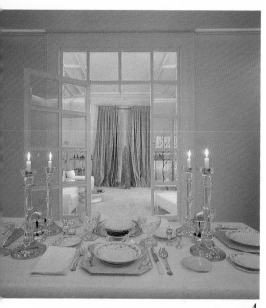

4

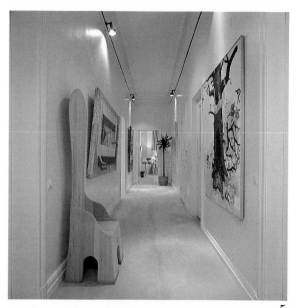

5

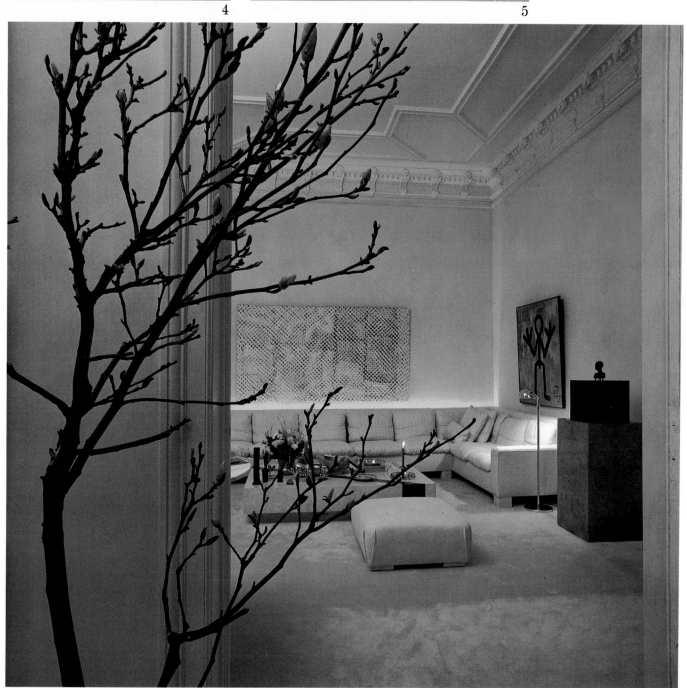

6

Beverly Jacomini, Richard Holley, and Katrine Tolleson

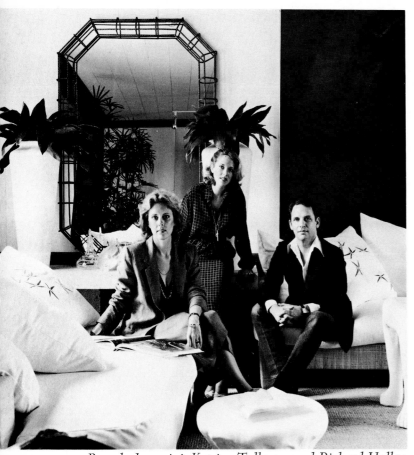

Beverly Jacomini, Katrine Tolleson, and Richard Holley

As any Texan will tell you, Texas has nothing to do with the rest of America. And there's a lot of truth to this claim. This is especially true where Houston, its largest city, is concerned. Almost overnight, Houston has mushroomed into a thriving metropolis which, unlike the rest of America, seems unaffected by gas crises or economic recessions. It just keeps right on growing.

But while its youth and speed of growth means that it is not hidebound by tradition, it also means that the city has grown unplanned and with no sense of identity. From a design point of view it is a city of triumphs and disasters. Most of the triumphs are commercial buildings, most of the disasters are residential.

Three designers who are trying to improve this picture and cope with the special demands made by Houston's tropical climate are the team of Beverly Jacomini, Richard Holley, and Katrine Tolleson. After three years in business together, they have evolved a style that is at once cosmopolitan and distinctly Texan. It springs from an acceptance of Houston's climate and an appreciation of the young, upwardly mobile attitude of the people who live there.

"It's very difficult to use color here," says Katrine Tolleson. "The Texas sun is so bright. Most houses are built to provide shade, which adds its own problems, and trees are left close to the houses for the same reason. So there's always a lot of green coming in through every window." Adds Richard Holley, "You've also got to know the mechanical things. Silk, for instance, will rot in the sun; chrome and brass will rust in the humidity." To cope with this, says Beverly Jacomini, "we use cotton, linen, and sisal, wood and stone that stand up to the climate, in a very simple, understated way."

That also happens to be the way Houstonians want to live. "They are young, hard-working, professional people who are traveled and sophisticated and don't want pretensions in their lives." Mrs. Jacomini continues. "And they realize that the climate affects everything here—the way they do business, the way they dress, the way they entertain."

To the designers, the answer is to emphasize clarity, simplicity, and durability and to use strong design elements. "Scale is the key word," says Mr. Holley. "It is larger here. We use fewer things but bigger ones."

Strangely enough, for such a wealthy, burgeoning city, there is still a dearth of good designers in Houston —a fact recognized by Miss Tolleson and Mr. Holley when they moved there from England three years ago. Both are American, but Katrine had grown up in Europe and Richard, although brought up in Texas, lived and worked in England. They had worked together in London for several years when they decided to move to America—Katrine because she had never lived there, Richard because the economic climate in Europe worried him.

They chose Houston because "it's definitely the most exciting city in America," and because they had met Beverly Jacomini some months previously. Mrs. Jacomini is a native Houstonian who had been running her own interior design company for fifteen years.

"If there is such a thing as predestination, this was it," says Richard Holley. "We were all talking about what we wanted to do over dinner one night and decided, on the spur of the moment, to go into partnership."

144

Each of the three brings different strengths to the team. "Beverly intuitively understands Houston and Houstonians and the subtleties of what you can do here and what you can't," says Mr. Holley. "Richard," says Miss Tolleson, "can solve any space problem. He always proves a design on paper first, and he's a stickler for detail." "Katrine has a terrific sense of color and pattern and is the psychologist," says Mrs. Jacomini.

Mr. Holley and Miss Tolleson also bring with them their European training and sense of tradition. "Architecturally, there is no historical reference in Houston," says Mr. Holley. "We can give the rather unrefined rooms you find here a sense of grandeur and architecture, of proportion and symmetry."

But tradition stops there. "A European interior is not right here," says Mrs. Jacomini. "This is not an urban city. Also, people here don't usually have furniture and paintings that have been passed down through the family. What works here is honesty, lack of pretense, and natural things."

The newness of everything in Houston also allows the three designers to switch the function of rooms without qualm. "There is a typical kind of ranch-house architecture in Houston," says Mr. Holley. "It has a living room and dining room across the front and a huge family room across the back. We've used the living room as a dining room for people who entertain a lot (and more and more are); we've turned the dining room into a library and the family room into the living room. Rooms don't have to be furnished according to a developer's decree."

However Jacomini, Holley and Tolleson decide to furnish a room, it is first worked out on paper by Richard Holley. "There's a solution to every problem. We never do anything that doesn't work, because we know, from paper, that it *will* work before we start. Things do change as we go along, but the bones stay. Once you have a basic structure, you can build from it in a variety of ways. I will work out how to sit twelve people in the world's smallest dining room, and then Beverly and Katrine will take it and decide on colors, textures, and patterns. Then we make a complete presentation to the clients so that they have the opportunity to say if there's something they don't like."

All three designers listen to their clients. "Whatever they want, it's our job to make it work" could be their motto—even if it means working with an idiom they don't like. "You can get stale working only with styles you like," says Katrine Tolleson. "It's a great challenge to take elements you haven't considered before and make them work. It broadens your scope." Adds Beverly Jacomini, "If we are worth our salt as designers, we can work with anything—even if the client's favorite colors are lime green and shocking pink."

"We also stress that we will use whatever the client has and wants to keep," says Mr. Holley. "We feel very strongly that you don't have to spend a lot of money on some things. Style doesn't have to cost eighty dollars a yard."

The apartment shown here is a typical Jacomini-Holley-Tolleson meld of the durable, the economical, and the simple. It was designed for a bachelor, and its furniture is scaled large even though the rooms are small. Like Houston itself, it is forward-looking, expansive, versatile; it contains many design elements but belongs to no particular school—which pleases the three designers. Like Houstonians, it is not trying to imitate anything else.

Color photographs by Jaime Ardiles-Arce.

1. *A small entrance hall in a Houston apartment is made dramatic by being painted midnight blue and left empty except for a spotlit example of tramp art: a catherine wheel of Players cigarette packages mounted on a wooden industrial-gear mold.*
2. *Jacomini, Holley and Tolleson removed a closet in the bedroom and mirrored what had been its back wall to make the whole room look twice its size. Wire shelving holds books. The double-size sleighbed is covered with a mover's quilt; more quilts were used for pillow covers. The side table is topped with fossil-bearing stone from Corpus Christi.*
3. *Upholstered furniture in the living area is covered in unbleached linen; the end tables are draped in more movers' quilts. The painting is by Joan Allensworth, a Galveston artist.*
4. *Since the living room also accommodates the dining area, one of its walls was mirrored to give the illusion of width. Wicker chairs can move from living to dining area as needed. The dining-table top is also fossil-bearing stone; the floor is covered with sisal matting. Dominating the room is a trompe-l'oeil example of artist Ron Bowen's photorealism.*

2

1

3

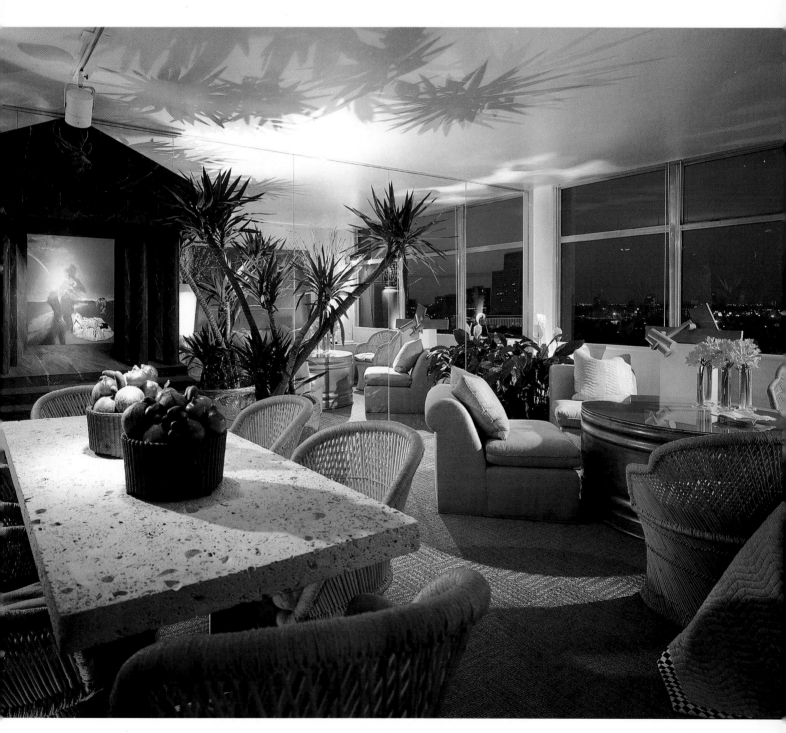

Stefano Mantovani

For Italian Stefano Mantovani, there are no in-betweens. "I like to do something simple and young for people with no money, or something opulent that would please a tsar for the rich," he says.

Nor is he interested in in-between people. "I want clients who have a strong personality and imagination. I like to work with a person's personality. Therefore, they must have distinct ones. That way, all my interiors are different one from the other because the owners' personalities are all different. If a client has no personality, you tend to repeat previous work, and that's a big bore."

Boredom, for himself and others, comes very high on Mr. Mantovani's list of dislikes. Irony, on the other hand, he loves. It spikes both his conversation and his work, along with a touch of the surreal and the theatrical, both of which stem from his early ambition to be a set designer. But, he says, "in those days I was very serious so I went to architecture school. That was too serious. It seemed much more practical to just start working. A friend of a relative of mine asked me to do the decorations for his daughter's coming-out party, and then she asked me to do her house. That was my start." Stefano Mantovani was twenty-three at the time, and he continued to work independently until he was thirty.

Then, displaying the paradox that is an essential part of him, he decided to go into partnership with three other designers because "by nature I am independent and a leader and I wanted to see if I could work with a group. It lasted four years and was good for me because I got the opportunity to design furniture—something I do a lot of now."

When he returned to working for himself five years ago, he found his outlook had changed. "When I first started, I was very eighteenth century; paintings and furniture had to be arranged just so. It was very overdone and too serious. What I do now is much more relaxed. I mix my modern furniture with old pieces, and, of course, there's the influence of Morocco."

Morocco had a very strong and immediate effect on Mr. Mantovani the minute he first set foot there eleven years ago. "It is a strange passion," he says, "for all the objects they have around them in their everyday life. Perhaps," he adds, only half jokingly, "I am a reincarnation of someone who lived there." Whatever the reason, there has been a definite Moorish skein running through his work ever since.

Also ever-present in his work are his desire to up-date the past and his wry sense of humor. "My furniture usually follows traditional shapes that I have seen in a book or on my travels, but I use modern materials. My first idea is always to make it in a slightly surrealist way to amuse people. I like to take an object that is usually very small and transform it, magnify it, by making it large. For instance, I've designed an enormous needle that is a bottle opener, a bobbin that is an ice bucket, and a button that can be a tray or cheeseboard.

"Sometimes people don't accept this. Then I give them something more classical and simple but with subtle irony. I make big boxes that look like enlargements of Fabergé miniatures to use as tables." As he says this it is clear that Mr. Mantovani relishes the additional and even more subtle irony present in the fact that the Fabergé pieces themselves were, in the first place, diminutions of larger objects.

But these are merely humorous punctuation points in Stefano Mantovani's overall design philosophy. "I think it's awful to create an interior that dates or something that is out of fashion after two years. I want to design rooms that still look fresh ten or fifteen years after they are finished. Always I am taking the client's personality and expressing it in a classical way.

"I use color for clients who are sure of themselves, because then *they* will choose the color: they will know what they like. But with clients who don't know what they like, I use neutrals. Later, when they have more confidence, they will choose whether or not to add color.

"Then I put the simple things—sofas and tables—into a room and add accessories after the client has seen the space with the main pieces in it. Very few people can read plans. They have to see the way things actually look.

"If I find I need something as I go along that doesn't exist in the market, I design it. But there is no 'Mantovani table' or 'Mantovani chair,' because each object is different—designed out of necessity for very specific surroundings."

Stefano Mantovani is not content with creating a background and leaving it at that. "I can," he says, "change the way clients live by showing them how to live in a comfortable way. And I like to teach; it's in my nature.

"For instance, there are rules for socializing. When you are receiving friends and introducing people to each other, large sofas around one coffee table are no

good. People can't move around. It's much better to have three smaller tables and groupings of chairs that you *can* move around. With the sofas-and-coffee-table grouping you would literally have to walk across the coffee table to talk to someone on the other side, and that's not done.

"I also tell young people to forget about a formal dining room. A dining room wastes space, and to sit formally and comfortably at dinner demands formal service, which never works properly without staff. Our life must get simpler. Have a table that will open out in one corner of the living room, or eat on sofas and chairs grouped around a higher-than-normal coffee table. You may have to change your menus and serve chicken, or cheese, or spaghetti, or salad, but you will be living in a comfortable way.

"Nor should you advertise your possessions. I like to see a good sculpture casually placed—never saying 'Look at me'—and if people notice it, that's wonderful. If they don't, who cares? Good design is discovering things, not showing them off."

Stefano Mantovani applied his thinking to his own surroundings which are shown here.

"Rome is a strange city," he says. "The best spaces are garages, but you can't live in them. A normal flat means small everything. Also, in an old building such as the one I live in, you can't knock down walls. Ideally, I would like to live in a large space with a terrace and lots

of light with just the objects that I love around me. But such a combination doesn't exist. So I had to adapt to what I could get.

"On the other hand, my personality requires something more classical and relaxed than modern. So I used a lot of white to create space and light, modernized the bathroom, kitchen, and a dressing room, and arranged my paintings and objects as best I could."

It is an arrangement that also illustrates another ever-present element in his work: his love of the theatrical. "When you open a door, it's like pulling aside the velvet curtain. If I am happy with what I see when I pull back that curtain, I say to the actor—who is the client—'Go in, work with the stage.' Like a director, I know when the set is ready for the actors to go in and the conversation to begin."

Color photographs by Robert Emmett Bright.
Photograph of Stefano Mantovani by Julie Bergada.

1. *For people who are sure of themselves, Stefano Mantovani uses color. Sure of himself, he floods his own bedroom with the glow of red-cotton-covered walls and glazed-cotton curtains. Indian cashmere paisley throws cover a chair and are made into cushions for the white Louis XV chaise.*

2. *The bathroom, like the rest of his apartment in Rome, is white. A collection of neoclassical anatomical pencil drawings hangs on the walls. The room is also used for relaxing—in the Louis XVI wing chair—and writing—at the Charles X writing table.*

3. *A white background also enhances the importance of an Austrian neoclassical chest with gilded and winged feet. The painting above it is an eighteenth-century French Romantic depiction of one of the Muses. On either side of the chest sit white-painted Chinese tables topped by Chinese pots.*

4. *In the living room, white is everywhere—on the walls, the wood-beamed ceiling, the cotton-slipcovered chairs and sofas. The floor is covered with sisal matting topped by kilim rugs for touches of color. The white-on-white scheme enlarges and heightens the modestly sized rooms.*

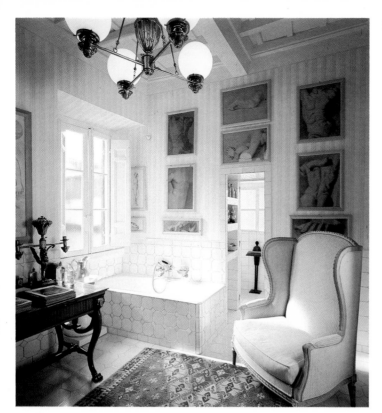

2

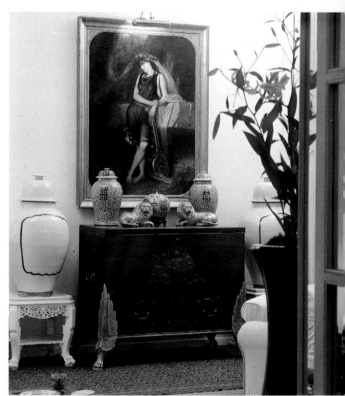

3

4

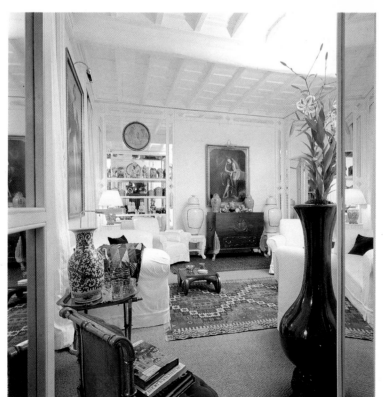

1

Mimi London and Dixie Marquis

Furniture made of wood is hardly new, but furniture made of trees left as close as possible to their natural shapes is one of the most distinctive design concepts to appear in the last decade. It was introduced eight years ago by the California design team of Mimi London and Dixie Marquis, and its influence can now be seen throughout America and in Europe.

Four-poster beds and chairs made of tree trunks stripped of their bark and seasoned but otherwise left alone, and tables made of tree stumps chosen for the beauty of their natural twists and gnarls, may seem more appropriate for log cabins, but in the hands of London Marquis they take on a sophistication that makes them just as natural a choice for a city environment.

Indeed, to Mimi London, it is more important that her designs be seen in the city than in the country. "It's much more of a fantasy. In the city we live with such hard-edged reality in a machine-made world. Very few people have felt the purity and the romance of the forests of the Pacific Northwest, and I wanted to translate that in a way that could be incorporated into everyday life."

Ms. London fell in love with the forests during a "mind-clearing" trip ten years ago. Returning to Los Angeles, she enlisted the help of childhood friend Dixie Marquis and together they set about the search for wood and the crafting of it into furniture. Both were totally ignorant of design principles—Mimi had been a model, Dixie an actress—but, spurred on by what Ms. London calls "an obsessive need to see how they would turn out," they made their first pieces for themselves. It was a look that quickly caught on. Now the wood comes from a burnt-out northwestern forest, and they have a network of scouts who alert them to new finds.

It didn't take long for London Marquis to go one step further into interior design. Partly it was because the whole philosophy behind the furniture—the idea of an open-air, soothing environment free of stress—made it a necessary progression. The furniture was so imposing that it demanded a sympathetic backdrop not often found in conventional interiors. Natural fibers such as wicker, sisal, canvas, and duck; materials such as slabs of travertine and fossilized limestone; primitive-looking ceramics, and pale, natural colors are necessary complements.

"I don't think I'd ever have evolved this design if I'd lived on the East Coast," says Mimi London. "The

Mimi London

scale is smaller there, and there are none of the enormous vistas we have in the West; none of that wide-open, anything-is-possible feeling that we have." It is a feeling that is key to their work. "We never suggest that clients use our furniture. We feel that would be presumptuous of us. But most come to us because they want that opening up of their lives and they feel the romance of it as we do.

"When we design for people, we see them become bigger, broader, wider, freer. They actually do become less stilted in the way they live and experiment more." The fact that people respond this way is no accident. "We try to develop an environment that is quiet. Most of us find our days too full; there is always too much going on. We want to create an atmosphere that will remind the clients of the fundamentals of life and let their own philosophies come through."

London Marquis do not believe in furnishing a room down to the last ash tray. "We have a great respect for people's homes," says Dixie Marquis. "They are the most personal of spaces, and we don't want to force ourselves upon them. If we dictated the accessories and art, that would be too restricting. But we do try to get the client not to add too much. So many people seem to fill up rooms, when the point of them is their space."

"Every space I see is too small," says Mimi London. "The first thing we try to do is balance it, using

furniture as weights and masses and keeping the space open and versatile. I can't stand a space that demands you move a certain way in it.

"Everything we do should simplify the client's life. From the physical point of view, the materials we use require very little maintenance, and they are also visually uncluttered."

A tendency to clutter one's life is not restricted to clients. "I think designers complicated things for themselves," continues Ms. London. "We are so enamored of the idea of being original that we've created a staggering number of choices. But the more secure we become, the more simple we can be. And as clients need to prove less, the more open they can be."

The London Marquis look is easily identifiable, but Mimi London does not see it as a fad. "I think we've been part of a major trend to the natural and that it will be assimilated as everything is. When the first sleek Italian chairs started appearing at the end of the fifties, no one thought of using them with traditional things. Now we take that for granted. The important point is that we are less rigid today and we don't have to immerse ourselves in one point of view to make a place attractive."

The house shown here was built in 1913 but lent itself naturally to the London Marquis style. "When we saw the redwood paneling—and even log beams—it was like finding a friend." London Marquis introduced their pale palette of natural tones of sisal, wicker, and wood throughout the house for a dual purpose. The house overlooks the Pacific, so everything used had to be able to withstand the ravages of salt air. Also, since the weather is cold and damp almost as often as it is warm and sunny, the designers were concerned that the rooms look warm and inviting as well as cool and open. The shapes and textures they chose have this chameleon-like ability, and, as in all their work, everything is simple and practical.

This house also points up a little-understood aspect of London Marquis designs. "A lot of people think of our work as aggressive and masculine," says Mimi London. "To me, it's soft and romantic, but not in the conventional sense. When I first designed the log furniture, I had a very romantic vision of either a noble Indian chief or a brave renegade pioneer. If you lived with that man in the 1800s in the West, what would you give him to make him happy? The furniture is strong, but it was designed for that man, not for me. At the back of it all was the very old-fashioned, feminine idea of pleasing the man in your life."

Color photographs by Russell MacMasters.

1. *The redwood paneling and beams of this Southern California house lent themselves naturally to the London Marquis design philosophy. In the living room, materials were chosen, as they were throughout the house, with one eye on the potentially damaging damp mist that seeps in from the nearby ocean. Carpeting is sisal. Banquettes covered in a white chenille weave fabric run along three walls, supplemented by wicker chairs and "mushroom" stools. The tables are cedar stumps.*
2. *All the decorative elements in this house come from nature. The hall table is a gnarled and twisted cedar trunk.*
3. *Beyond the hallway is the dining room with its stone-slab table and Paul Nelsen ceramic pears. Light comes from candles and a Japanese paper lantern.*
4. *Sisal and wicker continue in the bedroom, where the pine-trunk four-poster bed, though overscaled, does not look overlarge. The pale pine and cedar London Marquis furniture works with, not against, the redwood paneling installed over fifty years ago.*

Dixie Marquis

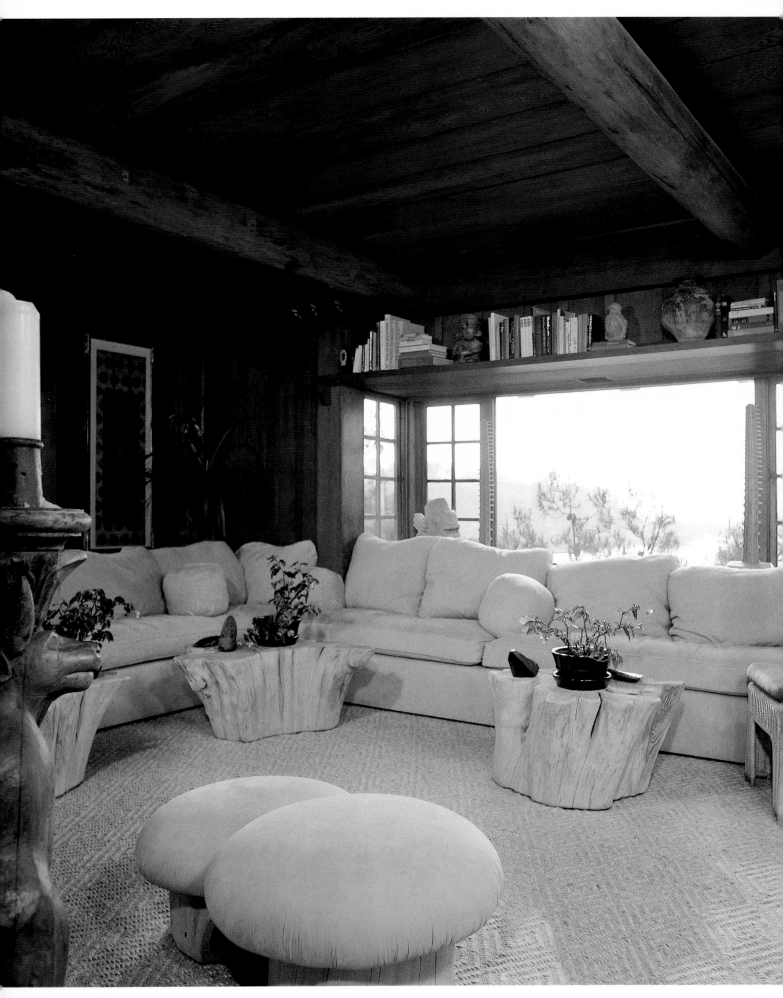

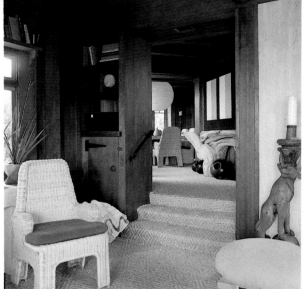

2

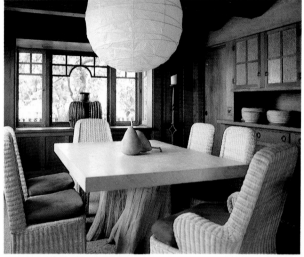

3

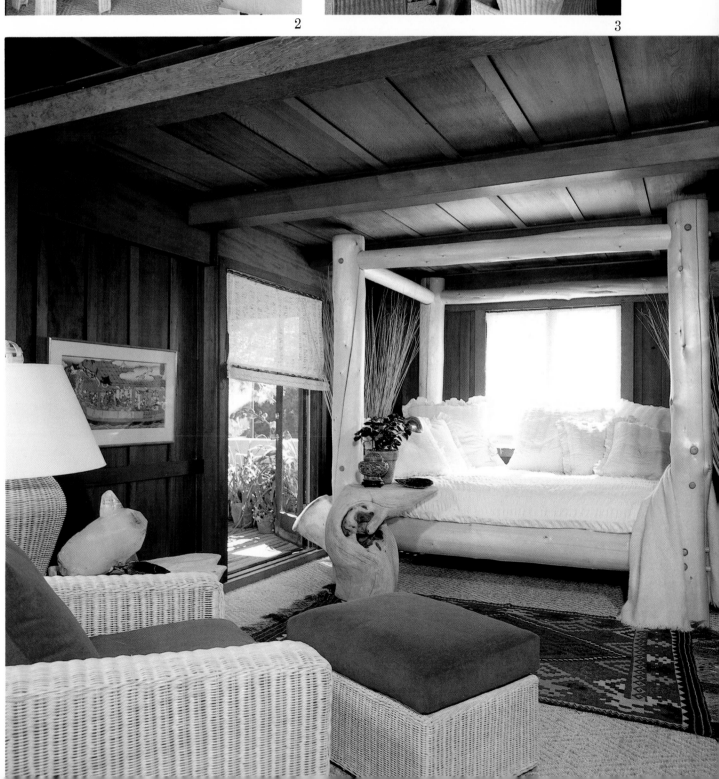

4

Antony Redmile

"I like the grotesque but not the macabre," says Antony Redmile. In person, Mr. Redmile, a mild-mannered, soft-spoken Englishman, could never be called grotesque. But his work certainly justifies the word. He fashions extravagant, opulent, surreal, eclectic, exotic, and often erotic objects and furniture out of horn tusks; ostrich eggs; animal pelts, bones, and skulls; and ivory inlaid with nickel silver, amethysts, malachite, shells, stones, and mother-of-pearl. They all add up to the most fantastical interiors seen in Europe since Ludwig of Bavaria.

Mr. Redmile does not so much design interiors as use rooms as the receptacles for his objects and furniture. "I prefer to work alongside an architect," he says. "I don't want to know about the basic structure. All I want to see is the architect's plan and be told the textures and colors of the walls. From that, I will provide the chandeliers, tables, chairs, mirrors, and so on. I don't always see the finished room. I don't need to."

But Mr. Redmile is not just selling high-style eccentricity. "However extravagant my designs are, they hew to the age-old classical rules of proportion, which

are still vitally important to any architect, designer, or decorator. Those rules still hold true because they were worked out to fit the proportions of human beings.

"Unfortunately, you get designers today who make furniture that you can't use or sit in because they have not observed those rules. I 'do my own thing' around that functional framework. Everything I make is designed to be used, even though it's often not easy for people to see that at first glance."

Antony Redmile came to "his own thing" gradually. Brought up among antiques (his parents are dealers), he rebelled against that world and headed toward modern design at art school. It was when he trained as a restorer of antique porcelain that he began to look once more at the past and to "see objects there that I liked for the first time. Growing up with them, I had learned about shape and proportion and the classical rules, but now I saw them in a new light. I became fascinated by the follies of the antique world.

"I had also let myself be influenced by the clean lines of Art Deco, the more free and flowing ones of Art Nouveau, and the sense of humor of the surrealist period of the thirties.

"Then my own style started to emerge. I design a look which has a sense of humor and which merges the antique with the modern. I am really recycling discarded ideas from the grottoes and hunting lodges of the nineteenth century. I don't copy old things, but it must be accepted that there is nothing new under the sun. I am doing my own interpretation of them."

Antony Redmile is not just recycling ideas. He is also recycling materials. Because so much of what he uses came originally from animals, many of which are now endangered species, he stresses that all the tusks, horns, ivory, and pelts come from existing Victorian or Edwardian objects found in attics or salesrooms. The ostrich eggs come from South African farms, and the antlers are culled from Highland moors. Almost everything he uses, he claims, would otherwise have no purpose.

Mr. Redmile is serious about his sense of humor. "People want more fun in their interiors now. We've gone through the very serious, clinical phase of design. I see myself getting progressively more involved with the fantastic and making even more extravagant pieces—mainly because our workrooms can handle them."

There are forty craftsmen working for Antony Red-

mile, and their standards are high. Mr. Redmile says he takes a jeweler's approach, insisting on quality and close attention to detail. And he likes his craftsmen to be creative. "I want them to have more than technique," he says. "I'm more than happy to let them try their own designs. The important thing is that they have ideas."

It is no surprise to discover that someone who believes so strongly in the extremes of style lives among them. His own house, shown here, has been "Redmiled" throughout.

The living room, like all the rooms, is an eclectic phantasmagoria of his own designs mixed with antiques. The coffee table has massive Egyptian-inspired legs of nickel silver and is topped by a glass-covered Victorian collection of seashells. Two huge elephant tusks mounted in silver stand on either side of an eighteenth-century Chinese lacquer pyramid which houses a collection of skulls. A picture by Lely hangs above a white carved-wood and leather surrealist chair of a woman's form.

The dining room contains Redmile-designed chairs of moose antlers and zebra skin around a relatively simple Elizabethan oak table. The room is entered through double doors paneled in nickel silver, framed with polished black horn, and inlaid with cabochons. The handles are walrus horns mounted on silver.

In Mr. Redmile's bedroom, elephant tusks guard the bed with its coverlets of fur skins and brown velvet. A brass "witch's ball" is set in the ceiling and surrounded by a sunburst of fifty eighteenth-century Indian sabers. The door is flanked by a pair of Italian carved monkeys, one playing the flute, the other a fiddle, both surmounted by a ceramic clamshell designed by Mr. Redmile to hold a lamp. A large mirror surrounded by silver and inlaid with ivory and mother-of-pearl neatly proves Mr. Redmile's point that there's nothing new under the sun: it was not designed by him but dates from the eighteenth century and was found in Damascus.

Mr. Redmile's kind of design has, to say the least, a very specialized appeal. But to him, "It's important to create things that other people aren't. I think, for instance, it would be marvelous today to do the kind of fantasy work that Cellini did in the sixteenth century. I hate the bland and the boring in design. That's not making any kind of effort."

Color photographs by Michael Boys.

1. *Controlled exoticism reigns in Antony Redmile's living room. Beige walls and carpeting make a calm background for objects and furniture made of glass, nickel silver, horn, ostrich eggs, malachite, seashells, and bone —and a pair of classic Le Corbusier chairs.*

2. *Drama in a guest bedroom comes from a red-swathed ceiling and a family heirloom: the eighteenth-century four-poster bed which dominates the room. The painting is an adaptation from a Persian miniature, made in Mr. Redmile's studio and studded with semiprecious stones. Its frame is made from seashells.*

3. *An eighteenth-century eagle table by William Kent stands against a mirrored wall in the dining room. Above it is a chandelier made of antlers. Reflected in the mirror are an Elizabethan oak dining table, Redmile-designed chairs, and another eagle table which supports an antique albino turtle shell mounted in silver.*

4. *In the master bedroom there is a Greek-inspired mural of warriors and horses painted by Antony Redmile. The bed is covered with a brown velvet spread and a fur throw. Quarter-circles of Indian sabers arranged in the four corners of the ceiling are motifs derived from a central sunburst composed of these weapons.*

5. *A second view of the living room reveals further evidence of eclecticism. An American patchwork quilt and a painting by Lely flank a collection of objects. In the foreground are a 1930s surrealist carved-wood and leather chair and a glass-topped table with a nickel-silver palm-tree base designed by Antony Redmile.*

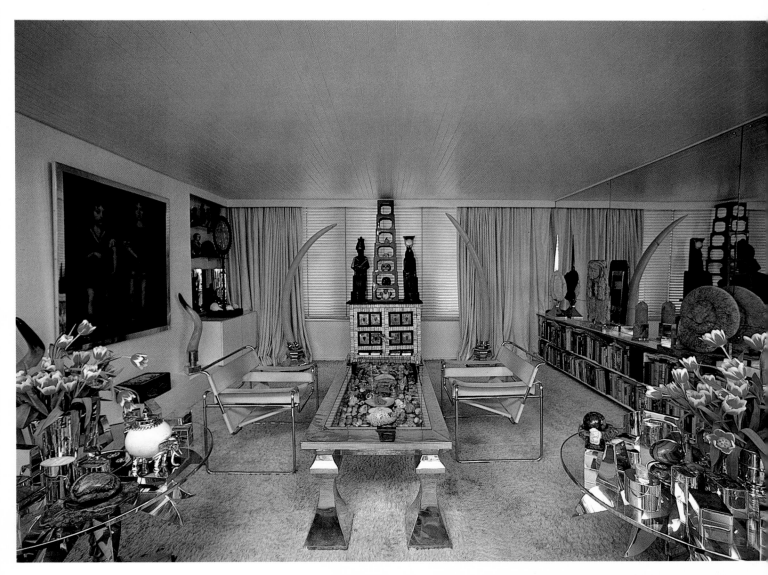

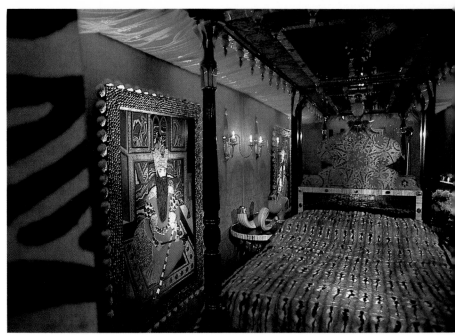

2

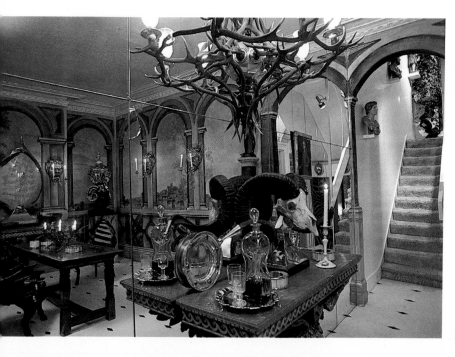

3

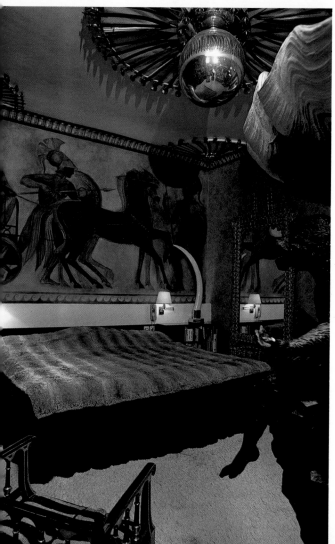

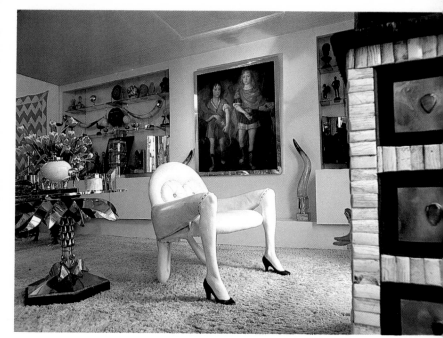

5

4

Bruce Gregga

Chicagoan Bruce Gregga became an interior designer relatively late in life at the age of thirty-six. Before that, his career had included brief spells in the menswear business and in advertising and ten years representing photographer Victor Skrebneski. But his talent for design had shown itself at a very early age. "When I was eleven, I redid my mother's dining room as a surprise for her. I painted all the chairs white, put pale blue silk on them, and hung white sheets on brass rings at the windows," he says. When she had left the house that morning, the room was red and brown; when she returned, she was not amused.

Lacking encouragement at home, Bruce Gregga let his design ideas remain a fantasy as he progressed, without any clear aim or enthusiasm, through school and two years of college. "Knowing what I know now, I realize that if I'd been given a boost as a child, I would have been an architect."

As it is, he is completely untrained in the formal sense and works purely visually and by instinct. But he says he thinks architecturally. "I prefer designing spaces rather than furnishings. I love furniture, but if you have a beautiful space, what do you need furniture for?"

Mr. Gregga jumped off the deep end by opening his own interior design office after a trip to Russia. "I just decided it was time. I had been designing studio sets for Skrebneski, and some friends had asked me to help them with their apartments. It wasn't difficult. I had clients and was making money right from the beginning."

This spontaneity is still with him. "There is very little form within my concepts. This makes it difficult for the people in my office, because floor plans are never close to the finished result. All of a sudden I'll overscale a pair of sofas, and then the whole design has to be pushed and shoved around."

However disorganized he may think he is, his work does not reflect it. His belief that space should make its own impact imposes an automatic discipline on the furnishings. "I like a few important pieces, not a lot of things."

The pieces he does use can belong to almost any period or style. "I don't have a basic design concept, because I love so much. I love English, French, Italian, and contemporary furniture. And I use a very broad range of fabrics. I love natural things that you want to see and touch and smell. I like using things in offbeat

ways, and I love curious pieces. Everything I use, I love for itself. I don't think I've ever repeated myself."

But Bruce Gregga doesn't really love everything and today's lighting is a special bugbear. Apart from Hansen lamps, which he uses frequently—"I've been called the swing-arm lamp king"—there is very little he likes. "I hate what track lights do to a room; I'm tired of downlights; the maintenance factor of recessed cans makes them a disaster; you can't use fluorescent light except in kitchens and closets, and even then you don't see your food or clothes in their correct colors. Lighting is the biggest problem in design today."

Few designers would try to incorporate as many periods and styles in a single design as Mr. Gregga does but to him, mixing things is second nature. He's not sure how he does it, but he does know when it's wrong. "I like a house to have a quiet feel to it. If something jars you or jumps out at you as you walk through the rooms, that's wrong. But that doesn't mean you can't use bright colors. As long as they are used in gradations of tone, they can be serene."

He usually prefers, however, to work within a neutral palette. "I don't think of color very often except to

introduce it through a piece of porcelain, or a tapestry, or a painting—as an accessory." There are two reasons for this, and both of them are practical.

"With today's higher costs and smaller spaces, rooms increasingly have to be multipurpose, and so does furniture. Especially if you're designing for a family, it helps if a family room can turn into a dining room or a party room as the occasion demands, or if a bedroom can also be a sitting room. So I like furniture to be able to move from one room to another according to need. That's easier with neutral colors.

"Also, and again especially if children are involved, furnishings have to stand up to a lot of wear and tear. Obviously, the material you use is important, but so is the color. Neutral tonalities last longer visually than exotic colors. But I have done houses in bright pastels if that's what the client wanted and it seemed right to me."

It takes all kinds to make a client. ("I don't like the namby-pamby ones," says Mr. Gregga. "I like the strong, difficult ones—they make me a better person.") But Bruce Gregga firmly believes that a client's taste doesn't change. "They may change their backgrounds from Louis Quinze to Mies van der Rohe, but their taste will still be the same. If you travel, you might have one wardrobe for hot climates and another for cold, but the same colorations and shapes will go with you."

The house shown here was designed for a very special client, Mr. Gregga's mentor and close friend, Victor Skrebneski. In addition to the interior design, Mr. Gregga was able to give full rein to the architect in him. It is really three houses: a carriage house that Mr. Skrebneski already lived in, his adjoining studio, and an addition designed by Mr. Gregga to incorporate the two sections.

"Victor asked for light and space. He wanted an uncluttered, unencumbered, Miesian box. He has excellent taste and knowledge, collects art with an astute eye, and I had bought most of the furniture for him before I did the house. I started him off with two pieces of French furniture, and from that has grown a wonderful collection. I've given him a lot more shape and pattern than he ever thought he would live with."

The structure itself is very cool and spare, with travertine floors, pale walls, and twelve-foot-high single-pane windows hung with sliding mirrored shutters. Within this, Mr. Gregga has mixed the French furniture with Giacometti tables and lamps, Chinese and Thai pieces, modern glass and chrome, and Mr. Skrebneski's mostly abstract art collection.

In Mr. Gregga's hands, this unlikely combination becomes a serene mixing of period and styles. "I would like more than anything to be an innovator," he says; "to be able to take ideas and things that are very old and handle them in a fresh, contemporary way." Though Bruce Gregga doesn't think he is such a person, that's a pretty good definition of what he has done here.

Color photographs by Tony Soluri.
Photograph of Bruce Gregga by Victor Skrebneski.

1. *A typical Gregga mix: an Albert Gleizes painting hangs above the satin-covered sofa; the coffee table is twentieth-century chrome and plexiglass; a celadon and ormolu jar sits on a French gilt pedestal table; the side chair is Louis XV.*
2. *The cool travertine of the living-room floor continues into a skylit porch. The skylight is domed and slides back to let the outdoors in when the weather is warm. The satin-covered sofa is in a favorite Bruce Gregga neutral color. The porch furniture is covered in lavender cotton. The standing lamp is by Giacometti.*
3. *In the dining room, a Rudolph Bauer canvas is flanked by two Régence chairs. The contemporary table is brass topped with glass. On it are two eighteenth-century Meissen porcelain cranes.*
4. *In the living room, a cream, yellow, and purple Chinese silk rug defines a seating area. A Régence sofa is covered in brown satin. The chairs on either side belonged to fashion designer Norman Norell. The marble-topped gilt table is also French Régence.*
5. *The bedroom has a Louis XV daybed recessed in the French manner. The walnut paneling is also Louis XV. The coromandel screen is seventeenth-century Chinese.*

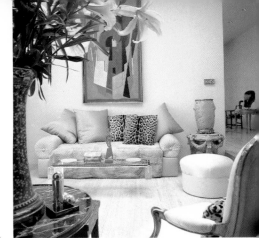

1

2

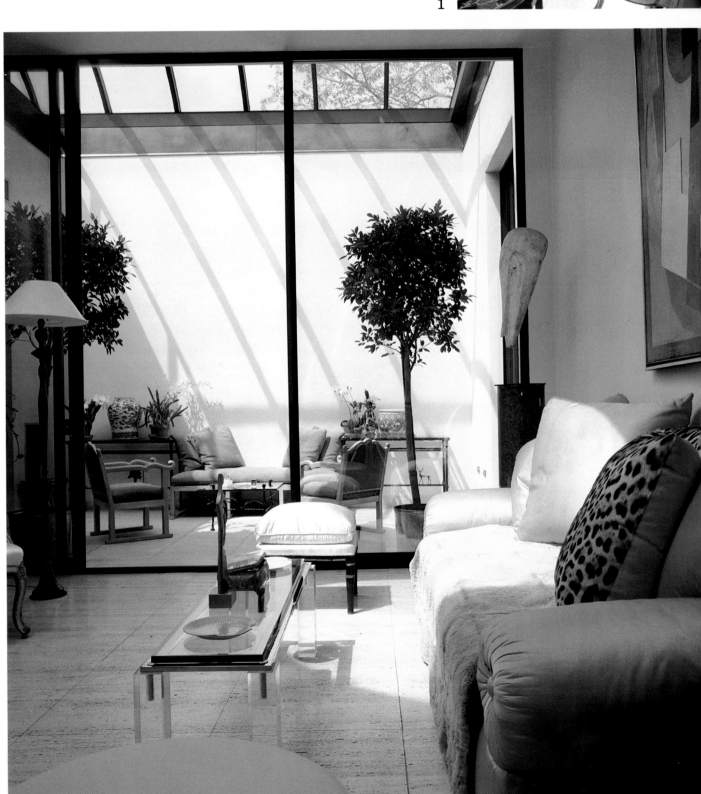

3

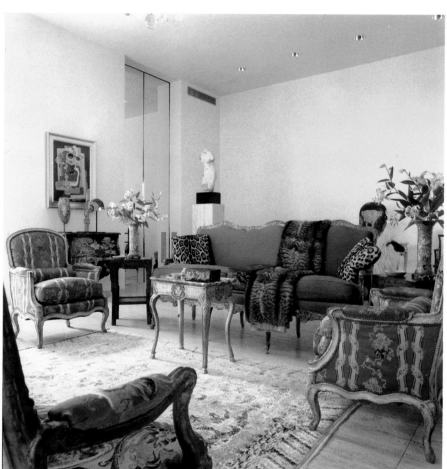

4

5

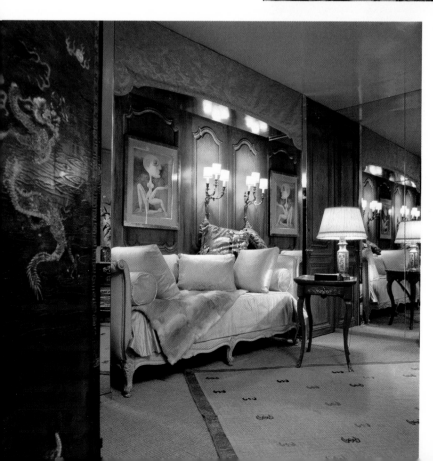

David Mlinaric

In 1977, when Britain's National Trust needed a replacement for the late John Fowler to advise them on the restoration of the houses under their aegis, they chose David Mlinaric. That is no mean compliment. The National Trust is responsible for maintaining some of Brit-ain's most important historic houses and could choose from among half a dozen talented and knowledgeable designers.

Mr. Mlinaric brings to his National Trust work the same combination of a highly trained mind and instinctive insight that has made him successful in his private interior design practice.

The training came from a three-year interior design course at the Bartlett School of Architecture at London University. This laid great stress on the historical aspect of design and architecture—although, says Mr. Mlinaric, "I had no idea at the time how important that would become in my professional life."

His instinct for what's right comes, as it does for so many English designers, from the surroundings in which he grew up—and from "looking, looking every day. It never ends."

The best interiors, Mr. Mlinaric believes, never evolve from preconceived design ideas. "Ideas come into one's head at irregular times," he says. "And they're always controlled by the client and the house. Of course, one can have several ideas for the same room, but there's always one that comes through more strongly than the others. That is the scheme I will propose first. I'd rather not present alternatives and then choose the one everyone likes best.

"All the rules of proportion, balance, and scale make sense only when related to a specific building. I feel very uncomfortable when I see an interior that doesn't respect its surrounding architecture. It's very distracting. Of course, sometimes you are dazzled and astonished by the unexpected, but I don't like to see things mutilated.

"I've worked in the modern idiom, but I'm not really happy with it. I'm much happier re-forming a set of traditional shapes and the atmosphere that comes from that. I used to like things much more extreme—searing color schemes in strange combinations and jumping contrasts. Now, I like quiet and comfort. But I don't like luxury and opulence. I like everything I do to be effective, but I don't like anything to be done just for effect."

This philosophy is clearly evident in the way David Mlinaric decorated his family's country house, shown here. It is a three-story Elizabethan manor house he bought in 1969. It had been saved from falling down completely by its previous owner, but it was still in poor

condition. "He had got the fabric of the first two floors in shape, but he hadn't touched the third floor. Because he had condensed his life into two floors, he had cut rooms in half. We had to put them back the way they had been and gradually rehabilitate the top floor. It was a question of taking things out rather than putting them in.

"It's not really a large house, so we chose to have practically every room the same color and let the furniture and the proportions of the rooms come through on their own. We kept everything very underplayed and haven't used much furniture; just things we inherited and some pieces we bought locally."

David Mlinaric applies and adapts these personal standards to the work he does for clients. "I get to know the people I work for very well. Since I've been doing this for seventeen years, there are a lot of people I worked for early on who have come back as their lives and circumstances have changed.

"The clients' requirements and the way they relate to the building—the function and the plan—are all important," Mr. Mlinaric believes. That relationship gives one the indication of how much—or, more often, how little—the building should change.

"That can be interpreted on many levels, the simplest being such basics as whether the clients are going to have a dining room with tables and chairs in the conventional way or not. Or whether they're going to have a bedroom, bathroom, and dressing room; or no dressing room; or a dressing/bathroom. Until I have those things worked out and a floor plan done, I don't think of color or visual effects.

"The choice of furniture usually comes from what people have already. In England, no one likes to chuck out all his old stuff, and what people want to keep relates to them in the same way that the house does. After all, they bought both furniture and house because they liked them. So one sees a thread of continuity in what they already have, and that's the raw material from which you will build or subtract. Most people in England don't want transformations. They want things to be what they consider 'suitable,' and I give them that in a restrained, orderly way."

The way in which Mr. Mlinaric works requires time. Two years, he says, is the average time he spends on a house. "One gets the basics and then builds up slowly. Very few people can afford to completely redo a house at one go, thank goodness. One shouldn't fill rooms up with furniture just because it's in the shops this month. It takes time to find the piece that's just right for a particular place or client. I'm interested in the client rather than the job. The discriminating client will want to wait."

Color photographs by Derry Moore.
Photograph of David Mlinaric by Graham Harrison,
© Daily Telegraph *Colour Library.*

1 and 2. *David Mlinaric turned the third floor of his Elizabethan manor house in England into simple but pretty guest rooms. The original oak posts and beams were left exposed, and the rooms were furnished with a mix of English and French country pieces.*
3. *The brick-paved dining room with its huge fireplace and gateleg table is dominated by a wood and plaster wall hanging which has so far defied identification. "It is old, but no one knows what it is or where it came from," says Mr. Mlinaric, who found it in a junk shop. It combines a representation of compass points with cornucopias, cherubs, a fish, a dove complete with olive branch, and plaster trumpets and military banners.*
4. *The master bedroom had been two rooms under a previous owner. Mr. Mlinaric restored it to its original size. The furniture is a mixture of things bought and inherited.*
5. *Sloping walls and oak beams give this guest room innate charm. Furnishings are plain but comfortable; walls are whitewashed pale green.*
6. *The living room stresses comfort. Curtains are flame-stitch-patterned wool hung on wooden dowels. Oriental rugs are scattered on plaited rush matting. On the Irish Chippendale side table stand two lamps with shades made from ordnance survey maps of the surrounding area.*

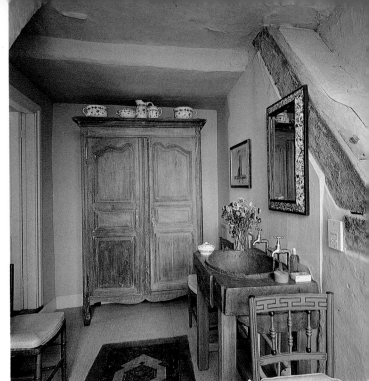

2

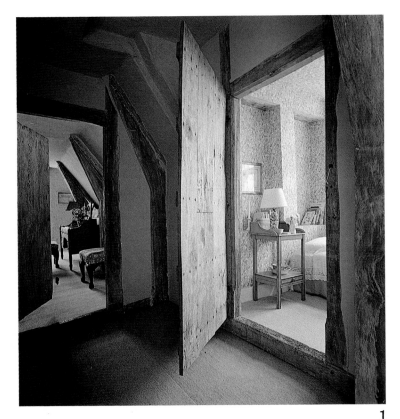

1

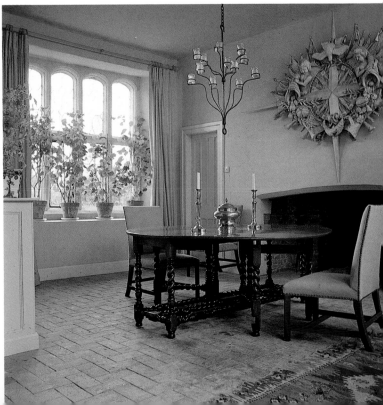

3

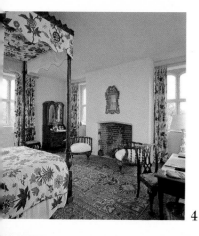

4

5

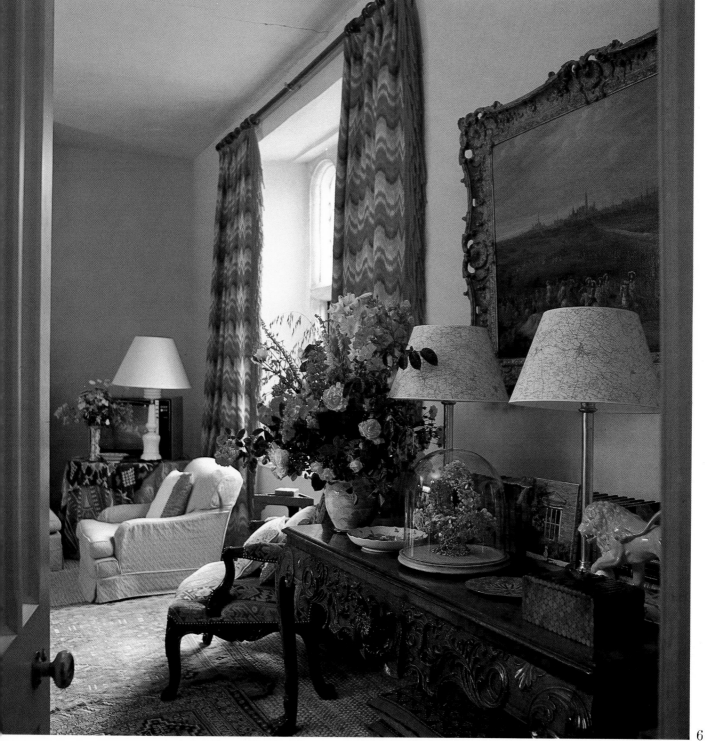

6

Geoffrey Bennison

In many respects, Englishman Geoffrey Bennison belongs to the old school of decorators. He works by instinct and hates floor plans. "If a client absolutely insists, I will do one, but I kick against the rigidity you get in a room that is designed on a drawing board and then put into practice," he says. "If you do a job completely to a predestined scheme, it always looks constipated. You've always got to have a little bit of your own rubbish around."

By rubbish he does not mean mess. "I mean the personal objects that everyone has that they love. They are not extraneous to the client's life, so they're not extraneous to what I create for people.

"I use a lot of objects but—and I do compare this to minimalism—everything I put in a room is necessary. If you took one or two pieces out of any room I've done, the whole thing would fall apart."

One has to look beneath the layer of accessories in a Bennison design to see that more than cosmetic decoration has been done. But every scheme is based firmly on logic. "I start with the space—what's wrong with it and what I can do to improve it. Sometimes walls can be moved or ceilings lowered or raised. Other times you have to adapt to the building—there's nothing you can do about a supporting wall—but either way, I never start to inflict myself on a room until the shape is the best it can be.

"Then there are the client's needs. I listen to clients, but they must give me a logical reason for what they want, just as I must give them logical reasons for what I want to do. There's no room for the arbitrary or capricious."

Once general agreement has been reached on the space and its purpose, however, Mr. Bennison lets his instincts take over and moves on to color and furnishings. "I work in a very amateurish way," he says. "I can't tell at the beginning what a room will look like at the end. Ideas come in different ways. Sometimes, if I'm doing several rooms in a house, what I do in one may influence what I do in another. It's a kind of groping around. I like to have time to sit and think and try different colors and furnishings. I put things in and take them out right up to the end. In fact, I like to get a big job finished two weeks ahead of schedule so I can use that fortnight to see if anything needs changing. I know that sounds amateurish, but I know when it's right only when I see it."

What are right to Geoffrey Bennison are warmth and luxury in colors and textures and good antique furniture. He mixes them in a style reminiscent of the Renaissance—elaborate curtains and tapestries, dark woods and gilt, shapes upon patterns—a mélange that ought to make the eye dizzy. But he knows when to stop. Just when it all seems too ornate, he pulls back.

His style—controlled eclecticism—stems very much from Geoffrey Bennison the person—though it wasn't always controlled. After getting his diploma from London's Slade School of Art, he was dogged by illness through his twenties until, when he was thirty-two, his bank manager explained to him that his debts outweighed his assets and he'd better do something about it. Always a lover of beautiful objects, he had picked up what he calls "some pretty things" over the years. They were his only tangible assets, and he decided to take them to Bermondsey market and sell them. "Of course," he says, "I didn't know what to charge, so I just put on a higher price than I had paid, and they all sold. And I found I adored it. So I started buying and selling, and that led to one shop and then another, and that's still a large part of my life and business."

He still buys the way he has always done, acquiring these things that appeal to him without regard to style or

period. The sole criterion is quality—about which he is fanatic. At any given time his shop is crammed with screens picked up in a junk shop, chairs from a country-house auction, paintings found in flea markets, tapestries discovered in Italy or France.

The shop led inexorably from finding single objects for people to putting together whole roomfuls for them. "That," he says, "is when the control came in—having limitations set by space and by clients' requirements—and learning to compromise. Compromise is very important—as it was in this flat in London for a publisher.

"He wanted a large drawing room for entertaining, a library with room for lots of books, a dining room, a large bedroom for himself, and two guest rooms. That was all very well, but the space wasn't there. To have a library, he would have to give up one guest room. I asked him one question: 'Do you want to be comfortable, or do you want your guests to be comfortable?' He voted for his comfort. So the guest room is tiny—there's no way a guest will be comfortable in that room. But it was his choice.

"He is a man who likes to entertain with a sense of performance, so there had to be some theatricality in the public rooms. But at the same time they had to be serious—he is a publisher, after all. So when you arrive you walk into this large red room, and it does have an immediate impact, but there is also a sedateness to it. It's a serious room.

"The flat itself is very strange. The ceilings were much higher than they are now—and they're still high—and the rooms were narrow. The whole place looked like a series of depressing caverns. I lowered the ceilings, and that helped enormously except in the dining room. The dining room is a failure. I knew it would be. It's so long and narrow it's an unfriendly room. I suggested that we open it up to the drawing room and use lots of small tables for dinner parties. But he insisted, and the results are exactly what I said they would be."

Even with that major difference of opinion, the work went smoothly. The client's requirements and budget were agreed on, and Mr. Bennison was free to get on with the job with no further interference. "That's the best kind of client to have," says Geoffrey Bennison; "someone who has taste but employs a decorator in the same way one would a tailor or dressmaker—*expecting* you to produce something that suits them and employing you because they actually want you to do the *work;*

not because they want you to give them confidence—they already have that."

Color photographs by Michael Boys.

1. *This spacious drawing room overlooking the Thames in London was designed by Geoffrey Bennison from four small rooms. The original small-paned windows were replaced by large sheets framed in gilded bronze, and the walls were painted a warm red to point up the owner's books and paintings. Above the Louis XV fireplace hang three of the owner's collection of Italian Mannerist paintings.*
2. *The dining room opens, via mirrored doors, into another area of the drawing room, one that can easily be converted into extra dining space for large parties.*
3. *One wall of the long and narrow dining room is hung with a seventeenth-century Brussels tapestry. The chairs are eighteenth-century Irish giltwood. The mirrored doors help give depth to the room.*
4. *The walls of the master bedroom are covered with a wallpaper made from a seventeenth-century design to Mr. Bennison's color specifications. The snowflake-patterned brown-and-beige carpet is continued in the adjoining library.*
5. *Another view of the drawing room shows more Italian Mannerist paintings. These were an important factor in Mr. Bennison's design decisions. "I had to provide the best background for them."*
6. *The library walls are painted glossy black and lined with bronze-edged bookshelves. The desk at the window is English Regency inlaid with brass. Above the marble fireplace is a Francis Bacon painting of Pope Innocent X.*

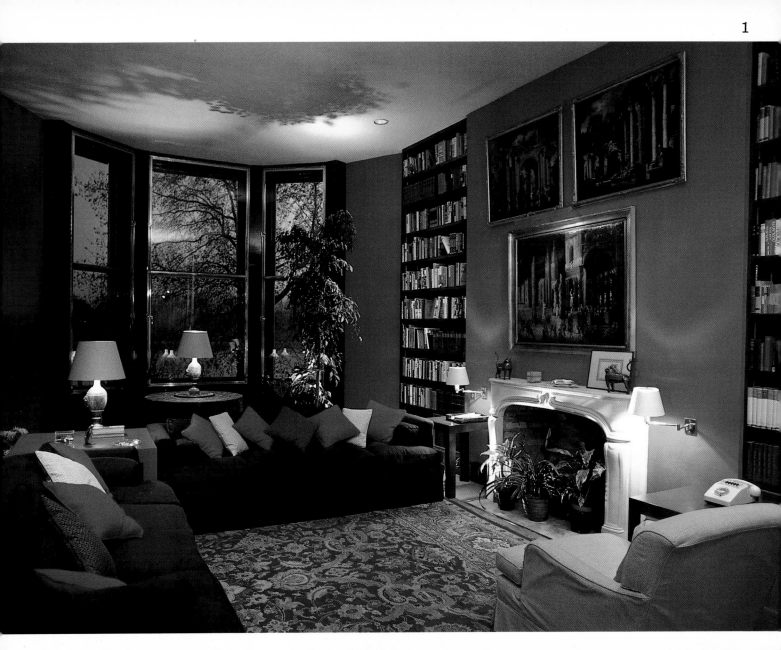

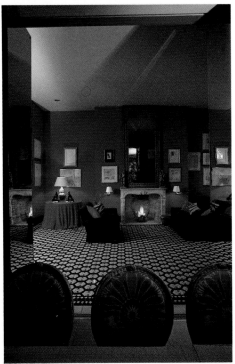

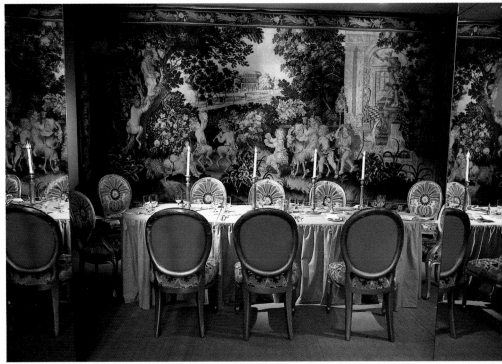

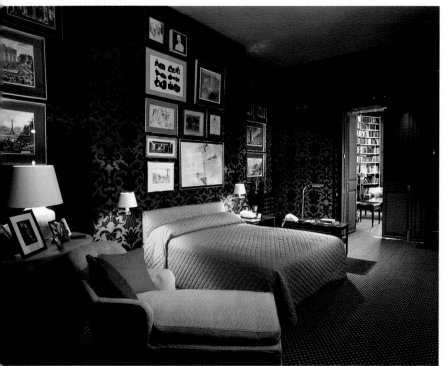

4

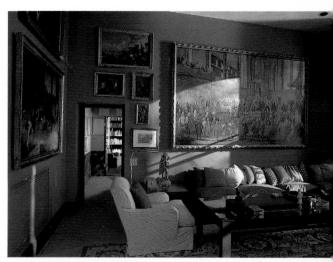

5

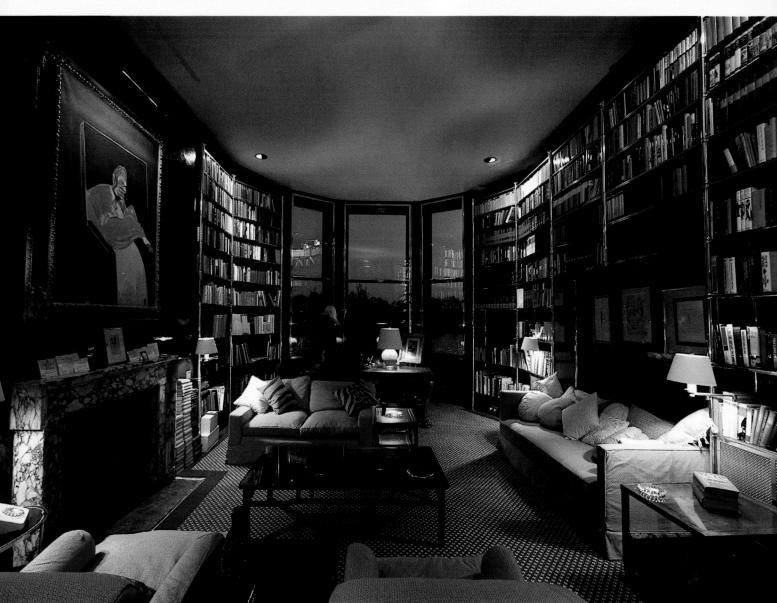

6

Robert Metzger

"I'm a compulsive buyer," says Robert Metzger, a New York designer known for his eclectic interiors. "Thank God I can buy for other people and get some of it out of my system. When I go into a store and see something I like, my first thought is always, 'Where can I use it?' When I decide I can't, I then think, 'Who can I sell it to?'" But Mr. Metzger's urge to buy is always discriminating. He doesn't fall in love with just any old thing—though it usually is an antique.

"Antiques are the things I truly adore. I think there's nothing that softens a room, that creates a mood, a quality, a life style, better than beautiful antique objects, whether they're European, American, or Oriental."

Robert Metzger always did want to have an antique shop or go into the world of fashion. "But both were like telling my mother I wanted to be a ballet dancer. Both my parents believed in business as a career." So he majored in business at New York University and spent two years as an investment analyst on Wall Street. "I enjoyed it," he says. "But I couldn't see staying there long enough to collect my gold clock."

He used a Christmas bonus to finance a four-month trip to Europe. "I went to every great house, every museum," and he returned determined to follow his inclination. "I took a two-year course at the New York School of Interior Design and then, at the end of 1964, went to work for Olga Erlanger in her New York antique shop.

"It was the best way in the world to learn. Book knowledge is fabulous for basic information, but the only way to really learn about antiques is by handling them—literally. You get a kind of street knowledge from the feel of them that fleshes out your book knowledge." In addition to a buying trip to Europe every year, Mr. Metzger did the bookkeeping, checked auction houses and private sales, ran the workshops, sold to customers, and designed the shop's windows every three weeks.

It was the window displays that led Robert Metzger to become an interior designer. "I'd never really thought of it as a business," he says. "But people who knew I did the windows would ask me to bring a piece of furniture they had bought to their homes. Once there, I was the cheapest decorator in the world. For the price of a maraschino cherry and four salted pecans, I would rearrange the whole room around the new piece. But I loved it. I was getting exposure to some fabulous homes, and the owners really were my unwitting guinea pigs. I was able to get my feet wet and become sure of myself before I went on my own."

He decided to make the change in 1971. The antique shop had to move to a new location, and Mr. Metzger—although by now he was an associate in the company—decided it was time to move on. "I just felt it was time for a change, and I had decided that I didn't want the feeling of being locked into a shop six days a week. Three people had already asked me to do their apartments, and it seemed a good idea to try while I was still young enough to recover if I fell."

The eclecticism that is characteristic of a Metzger design derives in part from his voracious appetite for the good of almost any style, though he doesn't like Victorian gingerbread, Swedish modern, or "anything from the fifties." But it also comes from necessity.

"I was trained to believe that whatever you bought, you should be able to sell, if necessary, for as much or more than you paid for it. But a room furnished with only that thought in mind looks like an eighty-seven-year-old woman. You *have* to buy an upholstered sofa that has no value, and you *have* to glaze or lacquer your walls, or stencil your floors and spend some 'unreturnable' money to create a background for these fabulous objects.

"Also, good antiques are becoming harder and harder to find, and no one can afford to live that way any more. I've spent eighteen months looking for a set of twelve dining room chairs for a client, and the only ones I saw in that time that I wanted were twelve Louis Seize side chairs that sold at Sotheby's for $57,000. So, unless you are prepared to settle for reproductions, which

I hate, you are forced into nineteenth-century furniture —which always has a little bit too much done to it—or into the contemporary."

The contemporary also has its pitfalls, according to Mr. Metzger. "Everybody is trained today to like the new. But ten years after you've had your home decorated that way and you want to change, you find you have spent thousands of dollars on new junk. Lucite tables and that sort of thing are worthless. Also, there's a total lack of quality in things made in America today, because the man who does fine veneer and lacquer work is paid the same as the man who slaps down Formica kitchen cabinet tops."

The way to avoid ending up with rooms full of worthless possessions is, according to Mr. Metzger, to invest in as many antiques as possible—he suggests Biedermeier, Charles X, and English Regency as still affordable—and in contemporary art. For other furniture, buy the best you can afford, he says. "You only lose on junk and second-rate furniture and art. It is true that no one can afford to buy anything cheap.

"That's why, as a designer, I feel a responsibility to direct clients and make sure they spend their money on the right things, whether it's a wonderful chair or screen of whatever period, or a modern painting or sculpture. Then we have to take those things and create a look around them."

The right look comes, says Mr. Metzger, from a marriage of minds between designer and client. "It has to be that way to work. You will know more about a client after two meetings than his or her best friend does. If the rapport is not there, or if they are not honest with you, you must walk away. There are enough things that can go wrong in interior design—mistakes in the workrooms, truckers dropping things, strikes, delays, articles lost in shipping—without starting off out of sympathy with each other."

Mr. Metzger draws up a floor plan at the start of a job, "though I've never done one yet that looks like the finished room. But it is the guideline for scale, proportion, and color—the three essentials that give harmony to a house. Once those are right, you can mix in any styles—Indian with Chinese with French."

There are two basic kinds of clients, Mr. Metzger says: those who are actively involved in the scheme, and those who aren't. The owners of the New York town house here fell into the latter category. "But they knew what they wanted. They had definite likes and dislikes. The bones of the house are Georgian in style, and even though they didn't want to use antiques, I tried to stay within that mood.

"Whenever I do a house I look at the lady who will live there and concentrate on what will make her look good when she's entertaining. I want to make the best background for her. In this case, she's very beautiful, so I wanted to make the color palette exciting— aubergine, peach, green, sky blue, and white."

The living room is low-key. The dining room already had its superb paneling, and Mr. Metzger did sneak some antiques—Hepplewhite wheel-back chairs—into the room along with a stronger color scheme. The foyer, which is between the living and dining rooms, picks up colors from both to become a visual as well as physical bridge between the two.

Furnishings are the mélange Mr. Metzger is known for. But, he insists, "it's not *my* look. I can work in any style. I'm flexible but not wishy-washy. I do have an ego —all designers do—but I interpret the clients' wishes always. It's not my look, or their look—it's ours."

Color photographs by Jaime Ardiles-Arce.

1. *In the living room, Robert Metzger painted the walls beige, with moldings picked out in ivory. They form the low-key background for an Indian Amritsar rug, sofas covered in a textured material of wool, linen, and cotton, and a table covered with lacquered linen. Two Louis XV bergères are covered in the same aubergine chintz as the balloon shades.*

2 and 4. *The dining room had paneled walls which Mr. Metzger painted in two shades of peach with white. The painting above the mantel is by David Hockney. Hepplewhite wheel-back chairs surround a table with a lacquered-linen surface and gunmetal and brass base. The green, peach, and white rug is an antique durrie. Under the window is a smaller table used when the clients dine alone. The motifs of the table and curtain fabric are taken from a Charles X period design, and a textured-cotton print covers the chair seats.*

3. *The entrance foyer is between the living and dining rooms. A Kenneth Noland painting hangs above a parchment-finished console table. Beneath it is a small gothic stool. In the foreground, on a kilim rug, stands a Joel Perlman iron sculpture.*

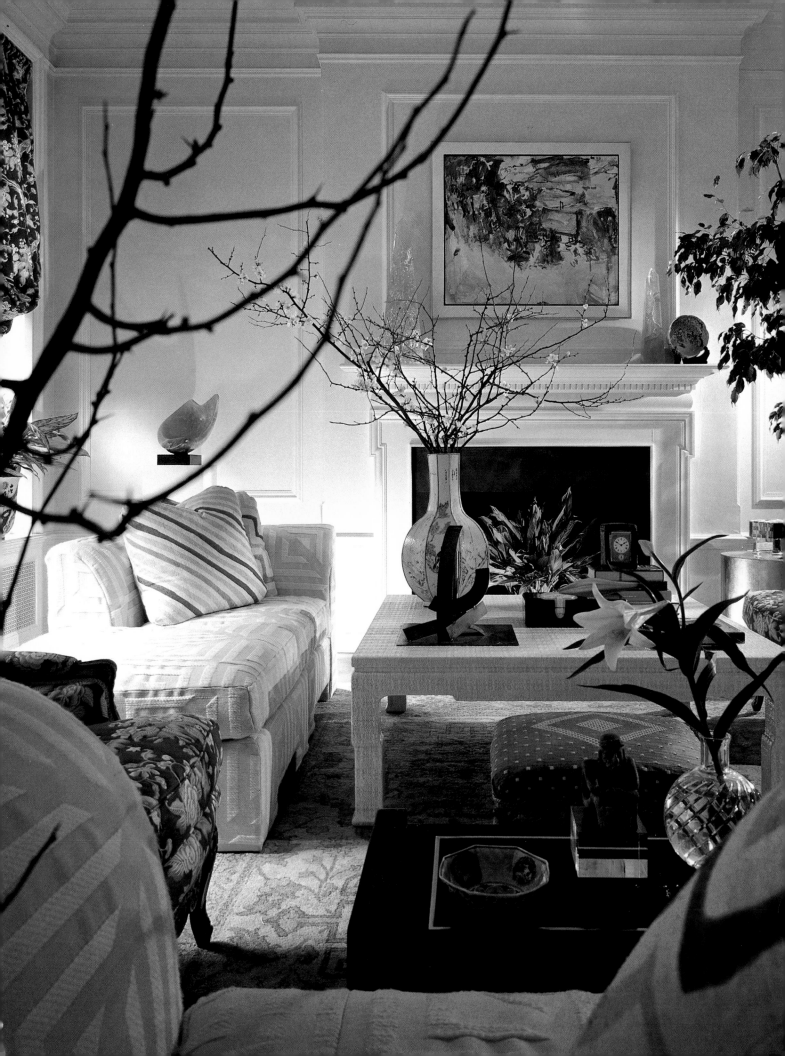

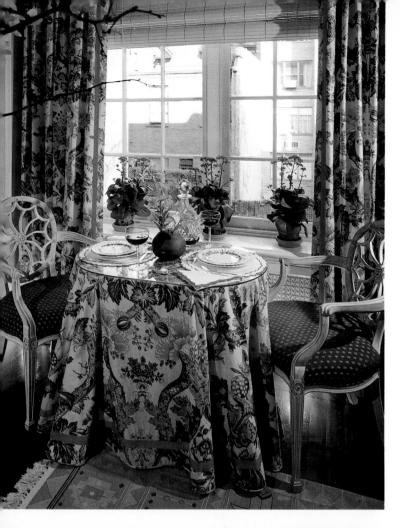

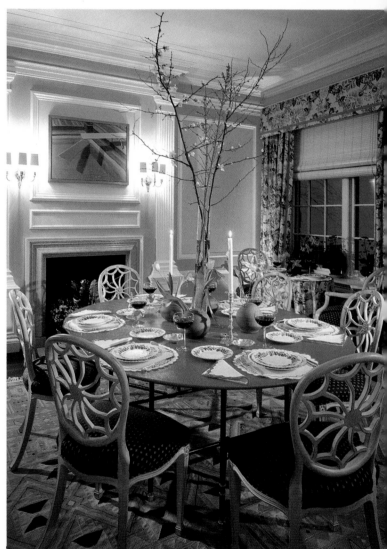

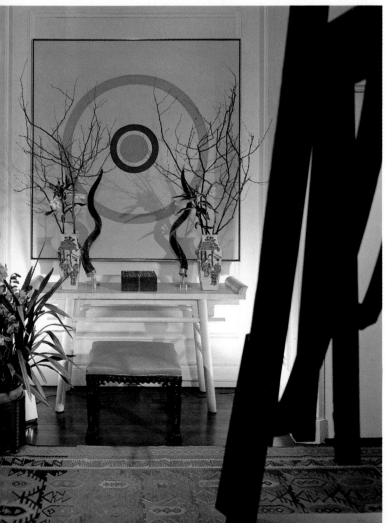